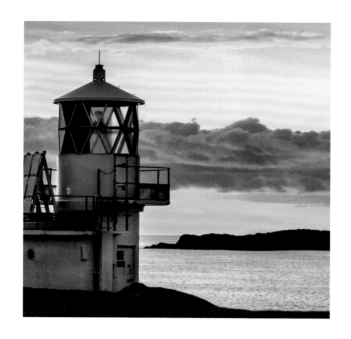

LIGHTHOUSES
OF EUROPE

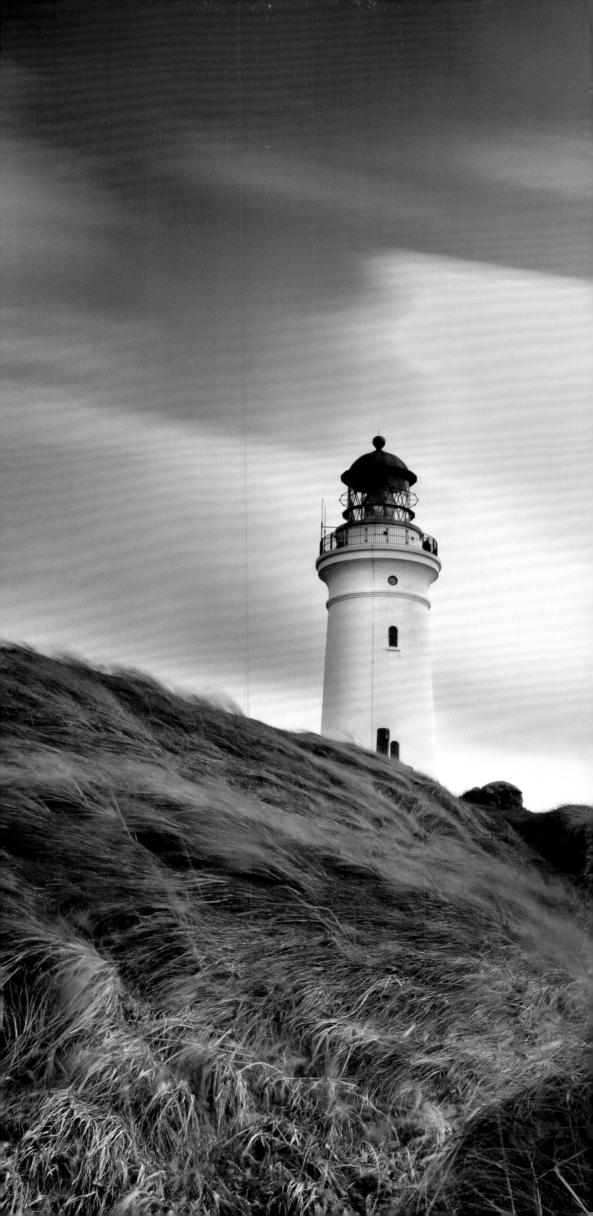

LIGHTHOUSES OF EUROPE

THOMAS EBELT

ADLARD
COLES

LONDON · OXFORD · NEW YORK · NEW DELHI · SYDNEY

ADLARD COLES
Bloomsbury Publishing Plc
50 Bedford Square, London, WC1B 3DP, UK

BLOOMSBURY, ADLARD COLES and the Adlard Coles logo are trademarks of Bloomsbury Publishing Plc

First published in 2017 in Germany as *Lichter über dem meer* by Delius Klasing Verlag

First published in Great Britain 2018

A catalogue record for this book is available from the British Library

Library of Congress Cataloguing-in-Publication data has been applied for

ISBN: PB: 978-1-4729-5761-0; ePub: 978-1-4729-5874-7; ePDF: 978-1-4729-5875-4

2 4 6 8 10 9 7 5 3 1

Designed by CE Marketing

Printed and bound in China by C&C Offset Printing Co

Bloomsbury Publishing Plc makes every effort to ensure that the papers used in the manufacture of our books are natural, recyclable products made from wood grown in well-managed forests. Our manufacturing processes conform to the environmental regulations of the country of origin.

To find out more about our authors and books visit www.bloomsbury.com and sign up for our newsletters

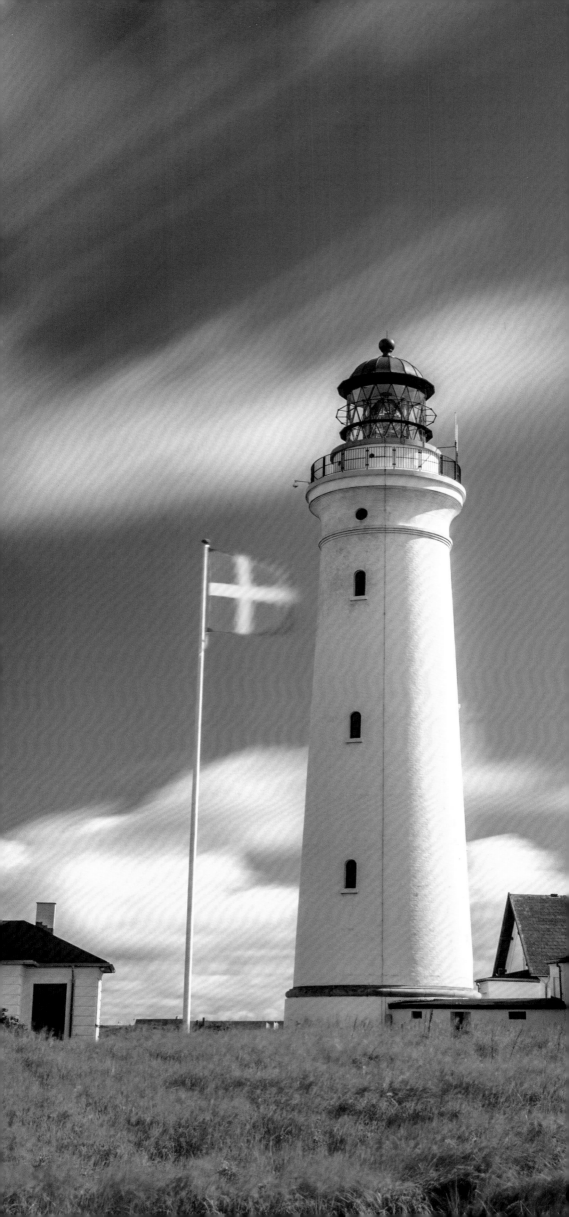

CONTENTS

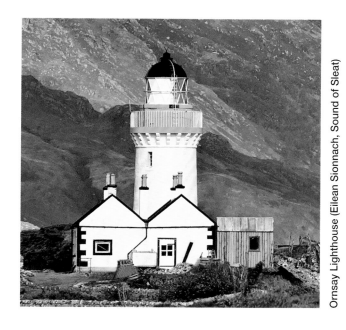

Ornsay Lighthouse (Eilean Sionnach, Sound of Sleat)

FOREWORD

Recording of an apparently real radio communication:

American: *'We recommend that you change your course 15 degrees north in order to avoid a collision.'*

Canadian: *'Negative, you must change your course 15 degrees to the south in order to avoid a collision.'*

American: *'This is the captain of a US Navy ship. I repeat, change your course.'*

Canadian: *'No. I repeat, change your course.'*

American: *'This is the air carrier USS* Lincoln *speaking, the second largest ship of the US Atlantic fleet. We are accompanied by three destroyers, three cruisers and several support vessels. I demand that you change your course 15 degrees north, I repeat, that is one five degrees north, or counter-measures will be undertaken in order to ensure the safety of this ship.'*

Canadian: *'We are a lighthouse. Your call.'*

In order to produce this illustrated book, I concentrated on lighthouses along the coasts of 17 European countries. I focused the lens of my camera on those lighthouses which are architectural highlights and that also fit well into the surrounding landscape. On my itinerary were journeys to Scandinavian countries such as Iceland, Norway, Sweden and Denmark, as well as trips to Great Britain, Ireland, the Netherlands, Belgium, France and Portugal so as to cover the North Sea and Atlantic coasts.

Along the North Sea and Baltic Sea coasts, Germany is a great place to start when it comes to the subject of lighthouses. Here there are many classic photogenic examples which regularly appear in novels, travel guides, postcards, calendars or advertisements. When it comes to architectural lighthouses, the Danish East Coast presents the traveller with examples on the one hand of the Kingdom of Denmark and, on the other, the structural hallmarks of the Prussians. Further to the east, Poland and Estonia also have maritime architectural delights to offer along their coasts.

With regard to the landscapes and lighthouses of the Mediterranean countries, Italy, Malta and Spain display, in comparison to Northern Europe, exciting and interesting contrasts which present a special challenge: the proportions of light are different and difficult to capture with the exception of the first quarter-of-an-hour after sunrise and the last quarter-of-an-hour before sunset. For this reason I travelled to these countries

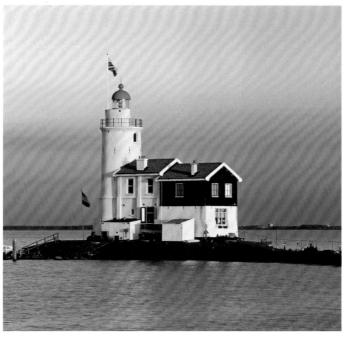

Marken Lighthouse (Markermeer, North Holland province)

in winter and spring when the sun is relatively low. With the intention of capturing exceptional images I pulled out all the stops: I got up before sunrise to ensure that I would be on location at first light and searched for unusual perspectives. I often ended up spending the night in my car at the targeted lighthouse in order to be on the spot and ready to go with the best light.

Even in bad weather conditions I was constantly searching for the ultimate shot, for example, at daybreak in Scotland which only lasts a few seconds. If I failed to get the right shot, I would return to satisfy my desire to achieve the most stunning image. These are my current favourites. As you might expect, this is a completely subjective collection of the fascinating variety of the lighthouses of Europe, with the aim of photographically capturing the architecture in relation to its natural surroundings and the prevailing weather conditions at the time.

As far as the organisation of the travel itinerary was concerned I started with Germany, and tried to set the course anti-clockwise towards the Baltic Sea. Then I diverted to the North Sea, circled around Great Britain and continued via Ireland and Iceland to France where I took an easterly-directed detour to the Atlantic Coast from north to south and finally into the Mediterranean. It was not always possible to follow this route due to the circumstances and the particular lighthouses of a country.

Definition of lighthouses

Kullens Lighthouse (Kullaberg, Scania, Øresund province)

All lighthouses consist of a beacon at its top with the purpose of guiding the seafarer at night and indicating dangerous rocks and other navigational hazards. They also play an important role in small craft navigation since they can be used for a visual fixing of position. Smaller lights on breakwaters and in restricted waters help provide guidance, allowing navigation where safe water passages need indicating and to provide safe access to unfamiliar harbours.

Every lighthouse possesses its own light characteristics. Sometimes it has a coloured sector e.g. RWR – a light which is predominently white but with red (danger) sectors either side of the safe water channel. The light may flash with a steady rhythm, or have a long, quick or very quick flash. The time is given in seconds from the flash of the light to its next flash, together with the characteristic of the flash. For example: Fl10s – one flash in 10 seconds; GpFl (3) 17s – a group of 3 flashes within 17 seconds. The height above sea-level of the lantern is given in metres e.g. 75m. The distance that the light can be seen at sea-level is given in nautical miles (1 nm = 1,852 km) e.g. 22M. Today the range of most lighthouses lies between 5 and 25 nautical miles. The lighthouse position is always stated in degrees and minutes of latitude and longitude. All these details are shown on charts used for navigation – together, if relevant, with any sound signal the lighthouse may emit in poor visibility.

Some lighthouse history

Isola di Lévanzo Lighthouse (Aeolian Islands, Strait of Sicily)

Lighthouse keepers used to live and work in the lighthouses, but with the exception of a few lighthouses all are operated automatically today. The earliest beacons used open fires burning coal or wood. Sometimes they used a bascule to move the beacon. In 1782 François Pierre Ami Argand (1750–1803), a physicist from Geneva, invented a lamp with a cylindrical wick which air could flow through and around, increasing the intensity of the light produced. The Argand lamp was a forerunner of the later petroleum lamp and replaced, together with a parabolic reflector, the old workings. Later, before electrification of the lighthouses in the 1920s, gaslights were used.

At the beginning of the 19th century, Augustin Jean Fresnel (1788–1827) was commissioned by the French government to develop a revolutionary new lens composed of prisms (Fresnel lenses) which concentrated light beams in a particular direction whilst allowing the lens to be much thinner than a conventional lens. With compact construction and relatively light weight, the Fresnel lens provided a very high light yield, helping the light from beacons reach considerable distances.

Since the construction of what is thought to be the world's first lighthouse (built around 280 BC) on Pharos Island situated off Alexandria, Egypt (one of the Seven Wonders of the Ancient World), to the building of the most modern lighthouses, a great deal has changed from a technical viewpoint. Yet from this first example, lighthouses came to be called pharos and the science dealing with lighthouses is still known as pharology.

THE BALTIC SEA

Germany

Germany is a federal state of 16 provinces in Central Europe and has borders with nine neighbouring countries, the most in Europe. In landscape and geology Germany has everything to offer the tourist. North Germany has diverse coastal landscapes and islands, as well as forests, lakes and rivers, of benefit to tourists and locals alike. Central Germany has low mountain ranges, forests and the Rhone and Mosel rivers. The beautiful Elbe river, the forest of Thüringen and the Elbe Sandstone Mountains in Sachsen can be found in East Germany, whilst South Germany presents wonderful high mountain regions in the Alps and Lake Constance.

Germany has many lighthouses on the Elbe, the North and Baltic Sea coasts and on the islands which, in architectural terms, are hard to beat for variety. The constructions range from the composite cast iron plates of the Isselburger Hütte in Münsterland (seen at Westerheversand, Hörnum/Sylt, and Pellworm Island) to the structural style seen in Denmark (such as the lighthouse in Kampen/Island of Sylt). For many the classic picture of the red-and-white lighthouse comes to mind. In some lighthouses here it is even possible to exchange marriage vows. One special and unusual instance of pharology in Germany is the magnificent lighthouse situated 900 km away from the sea, in Lindau on Lake Constance, with its Bavarian lion and a breathtaking Alpine scene in the background.

1. Kiel-Holtenau Lighthouse (Kieler Fjord)

The Kiel-Holtenau North lighthouse is situated at the northern entrance of the sluice to the North Baltic Canal in Kiel-Holtenau and operates as an entry beacon. This breakwater beacon was handed over by Kaiser Wilhelm II to world traffic on 21 June 1895 after the opening of the North Baltic canal. The lighthouse represents both a navigation aid and a memorial. The octagonal extension, the 'Three Kings Hall', is a memorial to the three governing North Sea Baltic Canal kings: Wilhelm I, Friedrich III and Wilhelm II. The lighthouse was built by the firm Puhl & Wagner. In celebration of the 100th anniversary of the North Baltic canal, the Kiel-Holtenau North lighthouse was completely renovated; since then the octagonal substructure of the brick tower has also been used as a wedding venue. Due to the ornate building style at the turn of the nineteenth century, this is considered to be one of the most beautiful lighthouses in Germany.

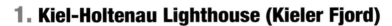

54°22'9.3"N 010°9'14"E | Oc(3) WG 12s | 20m | 11-8M

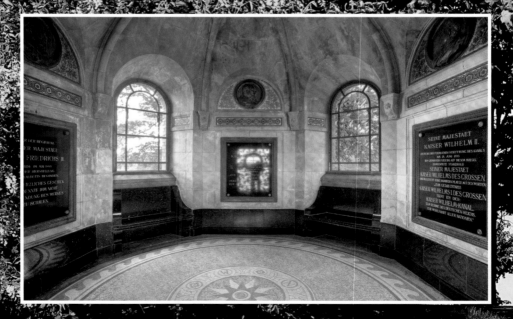

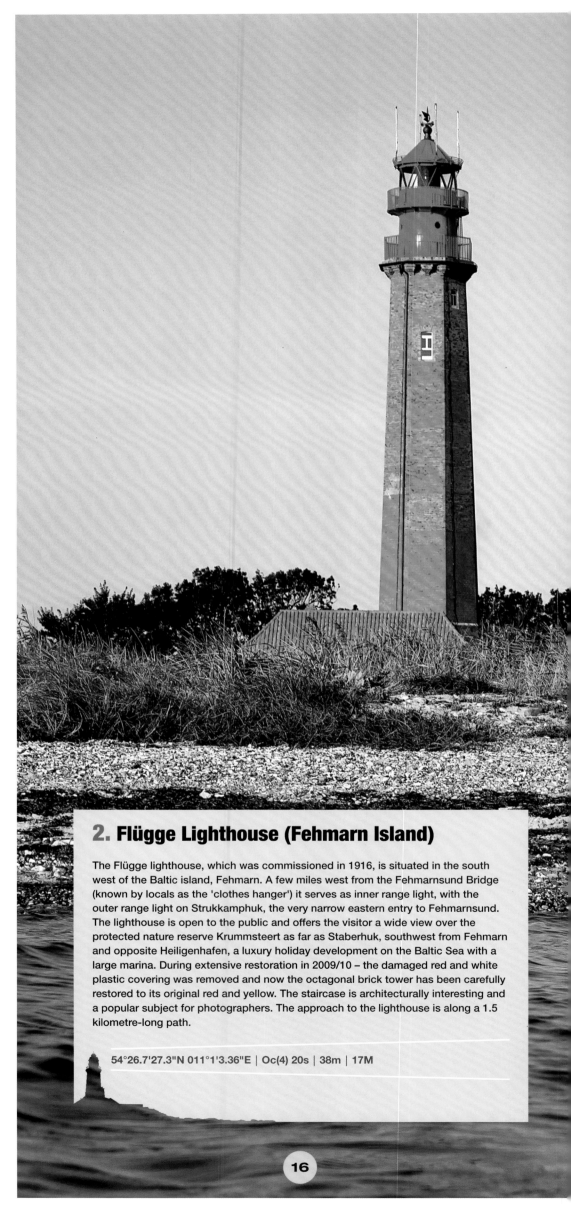

2. Flügge Lighthouse (Fehmarn Island)

The Flügge lighthouse, which was commissioned in 1916, is situated in the south west of the Baltic island, Fehmarn. A few miles west from the Fehmarnsund Bridge (known by locals as the 'clothes hanger') it serves as inner range light, with the outer range light on Strukkamphuk, the very narrow eastern entry to Fehmarnsund. The lighthouse is open to the public and offers the visitor a wide view over the protected nature reserve Krummsteert as far as Staberhuk, southwest from Fehmarn and opposite Heiligenhafen, a luxury holiday development on the Baltic Sea with a large marina. During extensive restoration in 2009/10 – the damaged red and white plastic covering was removed and now the octagonal brick tower has been carefully restored to its original red and yellow. The staircase is architecturally interesting and a popular subject for photographers. The approach to the lighthouse is along a 1.5 kilometre-long path.

54°26.7'27.3"N 011°1'3.36"E | Oc(4) 20s | 38m | 17M

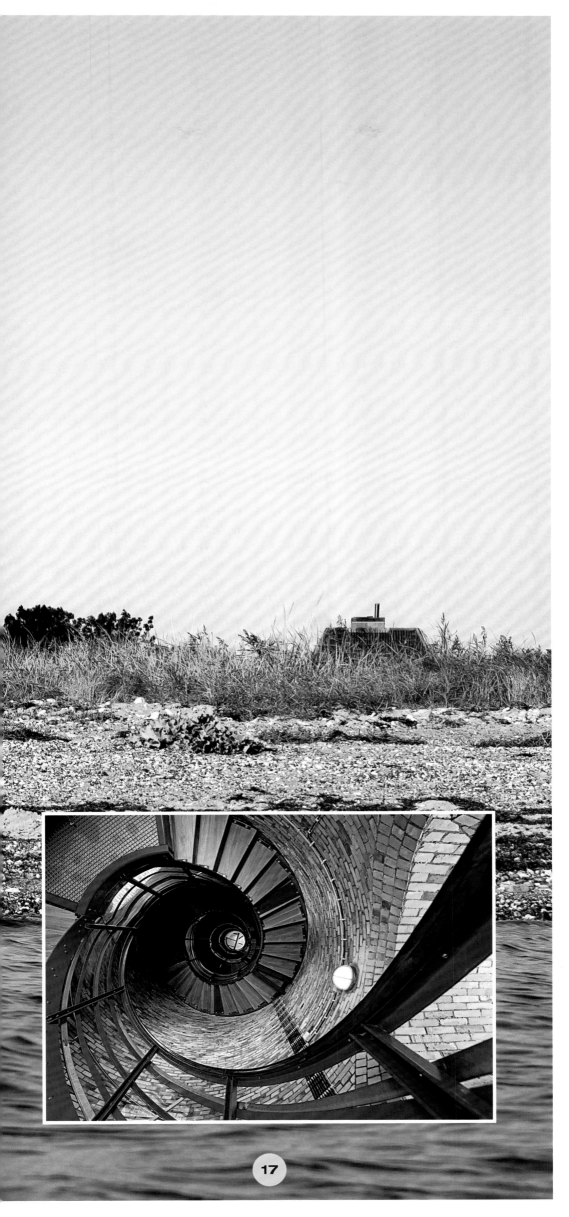

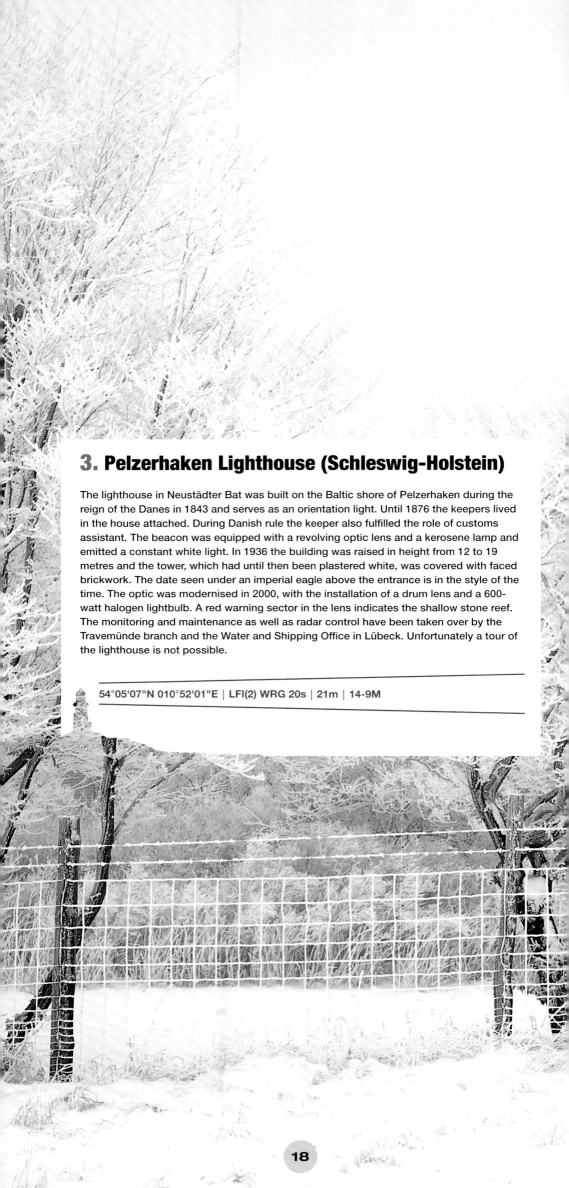

3. Pelzerhaken Lighthouse (Schleswig-Holstein)

The lighthouse in Neustädter Bat was built on the Baltic shore of Pelzerhaken during the reign of the Danes in 1843 and serves as an orientation light. Until 1876 the keepers lived in the house attached. During Danish rule the keeper also fulfilled the role of customs assistant. The beacon was equipped with a revolving optic lens and a kerosene lamp and emitted a constant white light. In 1936 the building was raised in height from 12 to 19 metres and the tower, which had until then been plastered white, was covered with faced brickwork. The date seen under an imperial eagle above the entrance is in the style of the time. The optic was modernised in 2000, with the installation of a drum lens and a 600-watt halogen lightbulb. A red warning sector in the lens indicates the shallow stone reef. The monitoring and maintenance as well as radar control have been taken over by the Travemünde branch and the Water and Shipping Office in Lübeck. Unfortunately a tour of the lighthouse is not possible.

54°05'07"N 010°52'01"E | LFl(2) WRG 20s | 21m | 14-9M

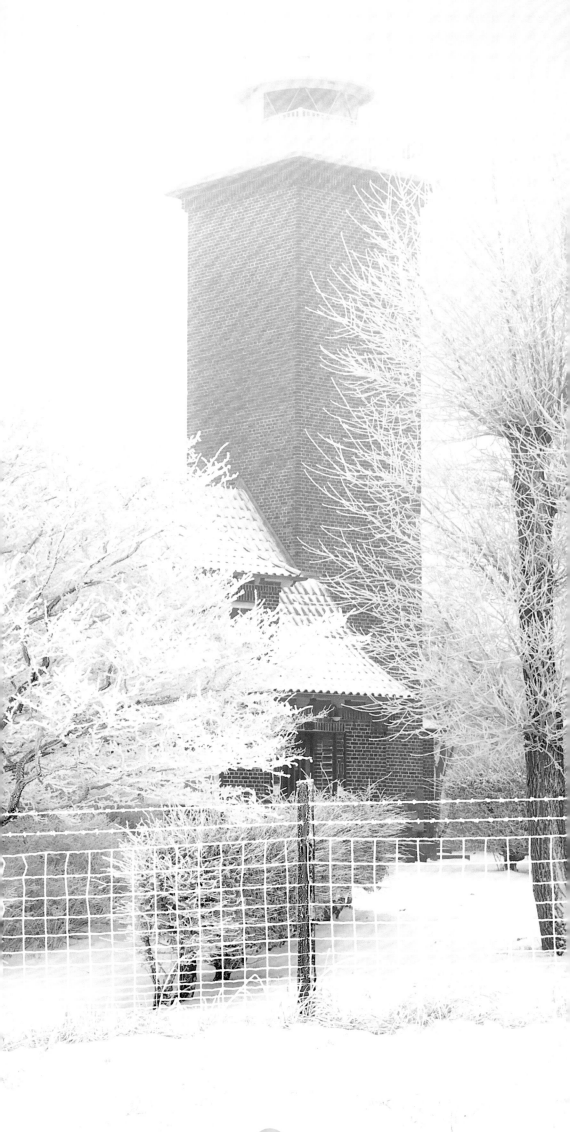

4. Old & New Lighthouses, Travemünde (Schleswig-Holstein)

Some record-breaking details to start: the old lighthouse was built in 1539 and is Germany's oldest beacon, having performed its duties until 1972. The new beacon on the roof of the 118-metre-high Maritime Hotel is, with a navigational beam height of 114.7 metres, the highest navigational beam in Europe and was lit in 1974. The old beacon was built by Dutch builders, and was fuelled by firewood. The open fire was later replaced by hemp oil, the light optimised by gold-plated hollow reflectors. After the upper section of the beacon was burned down following a lightning strike, the building was renewed in classical style and equipped with kerosene lamps. The electrification of the beacon followed in 1903 with the installation of electric arc lamps and optical equipment in the form of a drum lens and a revolving reflector beam, before the lighting capacity and range of the beam was replaced with 1,000-watt bulbs and a cylindrical concave mirror in 1937. This lovely old lighthouse was already registered in 1922 as a technical cultural monument. Nevertheless, 50 years later the beacon had to be deactivated because the newly-built 118-metre-high Maritime Hotel hid the old tower from view. The launch of the new beacon on the roof of the newly-built hotel followed in 1974. A complete renovation of the old cultural landmark followed in 2003/04: about 12,000 stones were replaced, a complete new supply of funds followed and the inside was newly plastered. The necessary investment of 250,000 euros was supplied by the Water and Shipping office of Lübeck. The old lighthouse consisted of over eight storeys including a maritime museum which provided a glimpse into the history of lighthouse technology. In order to reach the observation gallery it is necessary to climb 142 steps. The effort is rewarded by a fantastic view over the old town of Travemünde, the large ferry boats, the bay of Lübeck as far as Grömitz and the coasts of Mecklenburg-Vorpommern.

53°57'44"N 010°52'51"E | Fl WR 4s | 31m (old lighthouse), 114.7m (new lighthouse) | 19-15M

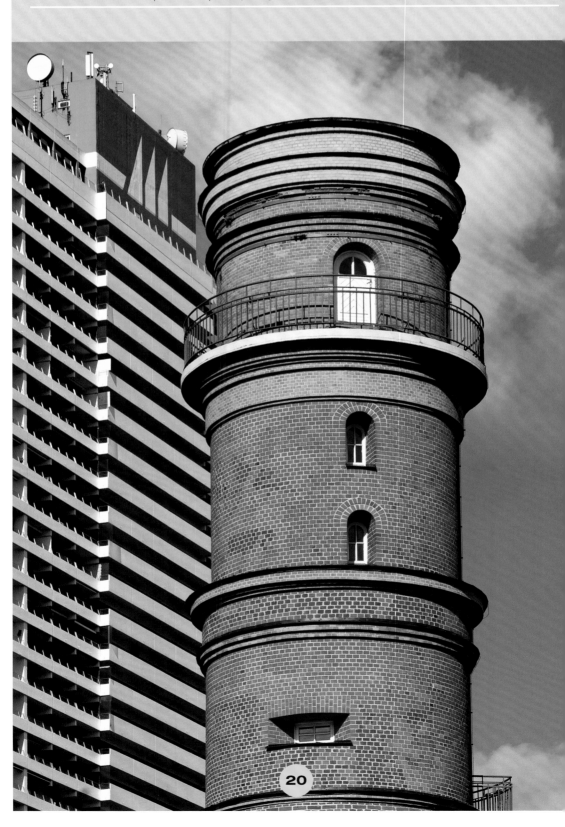

20

5. Old Lighthouse (Schinkelturm) & New Lighthouse on Cape Arkona (Rügen Island)

The Schinkel tower (named after the Prussian architect and town planner Karl Friedrich Schinkel) is a prominent lookout point on Cape Arkona on the Wittow peninsula at the northern point of the island of Rügen. The square-based tower commissioned in 1828 is the second-oldest lighthouse on the Baltic coast after the old lighthouse in Travemünde. The rooms of the three-storey brick building are used for offices and storage space. Its light had a range of 8 nautical miles and was composed of 17 silver-plated copper parabolic reflectors, each containing a burner with individual rapeseed oil container. Modernisation in 1872 led to the installation of six additional lamps fuelled by petroleum and a year later the burner was converted completely to petroleum. The electrification of the lighthouses at the turn of the century resulted in the beacon in the old lighthouse being deactivated in 1905. Thanks to Schinkel being highly recognised by the State Construction Commission of Prussia, the demolition of the old tower was delayed. The new lighthouse was built directly next to the Schinkel tower.

After time-consuming restoration work the Schinkel tower was opened to the public on 11 June 1993. The space was used as a museum and an observation deck. A branch of the registry office is also situated there and each marriage is immortalised by a small plaque on the floor of the tower. From the observation deck the visitor can enjoy a glorious view over the landscape of the island of Rügen and the Wittow peninsula. In clear weather it is even possible to make out the Danish island of Møn with its striking chalk cliffs. The newly erected lighthouse, whose beacon replaced the current beacon in the Schinkel tower in 1905, consisted for years of two carbon arc lamps which were rotated on a turntable before two modern 1,000-watt special lightbulbs replaced them in 1996. With the help of a reflector and Fresnel system its light can be seen up to a distance of 22 nautical miles. The complete apparatus in the red and two-storied lanterns of the new lighthouse is worked by a turntable and emits a set orientation beam every 17 seconds consisting of a succession of three flashes.

Both towers can be visited. There are 86 steps to be climbed up to the observation post and 176 steps to the top of the new lighthouse.

54°40'47.3"N 013°25'57.3"E | GpFl (3) 17s | 66m (Schinkelturm), 75m (New Lighthouse) | 22.5M

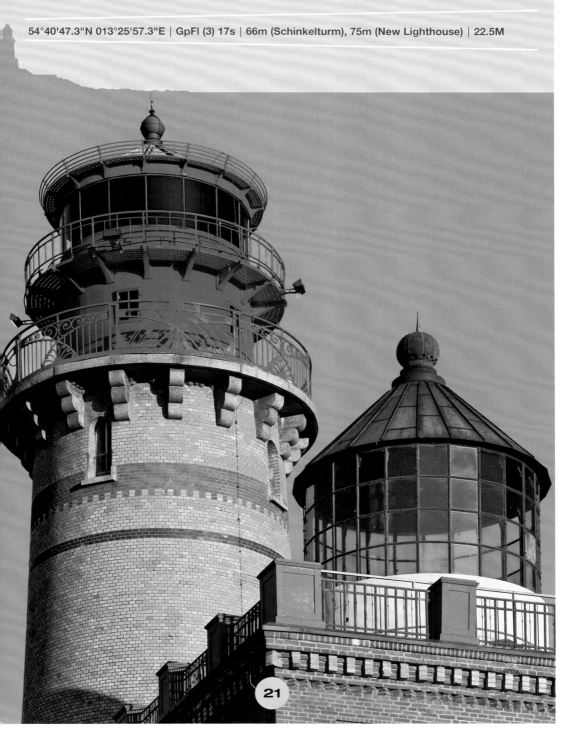

21

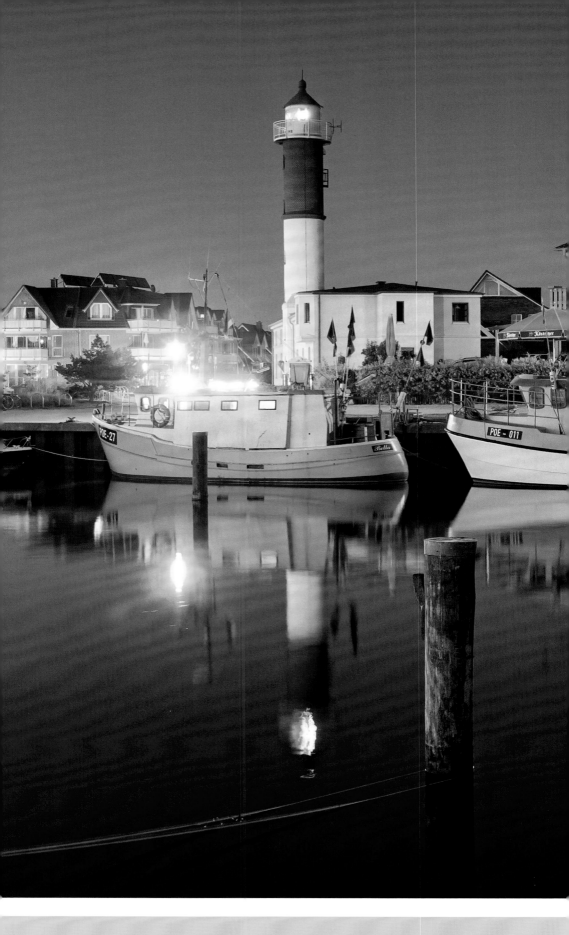

6. Timmendorf Lighthouse (Insel Poel)

The Timmendorf Lighthouse, a guiding and cross light, stands in the small, tranquil Timmendorf Harbour on the island of Poel on the northwest Mecklenburg Baltic coast. Built in 1872, the lighthouse marks the entrance to the Wismar Bay by the shallows of Hannibal and Lieps. The tower was extended by 3.6 metres to today's height of 21 metres in 1931: the additional section consists of red-brown bare brickwork in contrast to the white-painted foundation. A new outside staircase and a newly-built round lantern was added to this extension. In the same year the kerosene lamp-operated beacon was replaced by a drum lens and an electrical light source. From 1996 to 1997 it was necessary to stabilise and partly restore the masonry on the brick tower, which was under a preservation order. The light technology was also renewed during these renovations. It now consists of a polished drum lens with

circulation aperture and a dual lamp-changing device fitted with 400-watt halogen metal halide lamps. At times the lighthouse succeeded in achieving worldwide fame: in 1975 the postal office of the German Democratic Republic issued a 5 Pfennig stamp representing the Timmendorf Lighthouse.

53°59'31"N 011°22'36"E | Iso WRG 6s | 21m | 16-11M

7. Westmole Lighthouse, Warnemünde (Mecklenburg Bay)

The lighthouse on the west pier of the entrance to Warnemünde harbour, built in 1985, was relocated to a newly-built jetty in 1998. At the same time, on the east pier, an almost identical red and white painted lighthouse was built. As a lateral sign both towers indicate the entrance to the Unterwarnow, coming from Mecklenburg Bay, and the entrance into the overseas harbour at Rostock. Since the building of the lovingly-named 'twins' the black-and-white lighthouse, built in 1963, has been situated on the premises of the International Horticultural Exhibition 2003 in Rostock.

54°11'13.2"N 012°05'20.4"E | Iso G 4s | 14m | 6M

Poland

Poland is the sixth largest country in the European Union. The capital and largest town is Warsaw. Poland was a member of the Warsaw Pact under Soviet influence until the country experienced a political and economic revolution in 1989, thanks to the Solidarity Movement. Poland has been a member of the EU since 2004. As well as the official Polish language there are many minority languages which have been officially recognised since 2005 including Kashubian in the region of Danzig, German, Hebrew, Armenian, Tatar, Romany, Russian and Slovakian. The centralised state is subdivided into 16 voivoideships or 'counties'. The voivoideships of West Pommern, Pommern and Ermland-Masuren border the 528 km long Baltic Sea coast.

It stretches from Swinemünde on the islands of Usedom and Wolin in the west, up to Krynica Morska on the Vistula Spit in the east. The largest harbour towns are Gdingen, Danzig and Swinemünde on the Baltic Sea and Stettin on the Stettiner Haff. The best-known Baltic resorts are Kolberg, Misdroy, Horst, Swinemünde and Zoppot. The climate in west and north Poland is mostly dictated by the ocean (a moderate sea climate supplied with damp air from the Atlantic), while in the south and east, the continental climate dominates with dry Eurasian air.

In spite of the many coastal regions, islands and spits on the Baltic Sea only 18 active lighthouses are currently operating in Poland; all other navigation structures were either destroyed or their lighthouses deactivated.

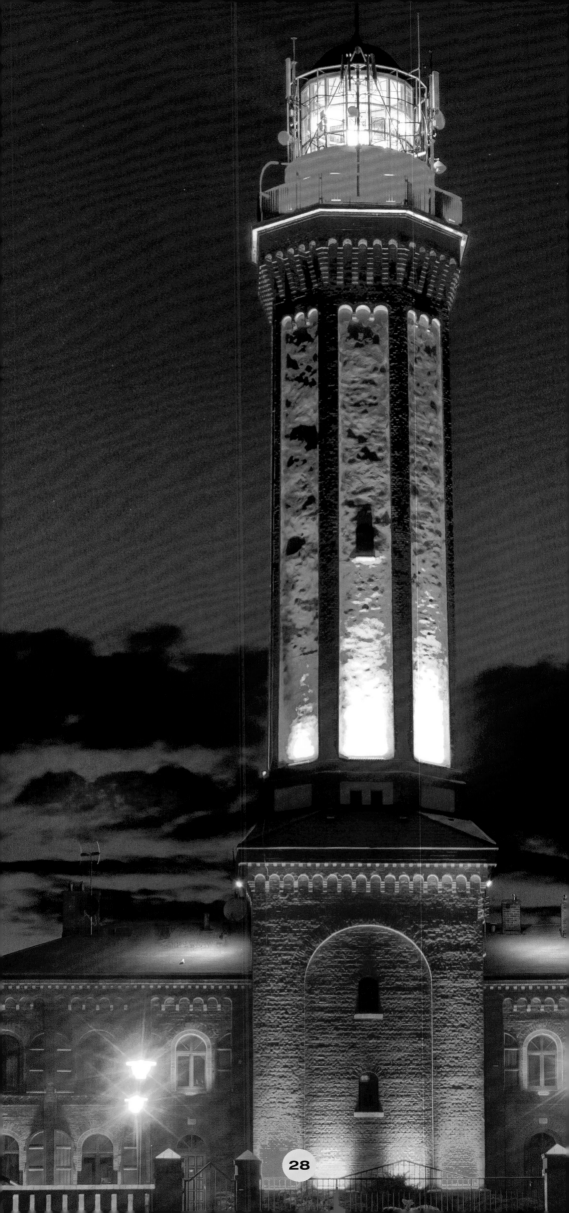

8. Morska Niechorze Lighthouse (West Pomerania, Pomeranian Bay)

The 45-metre-high Morska Niechorze lantern is the landmark of the north Polish Baltic resort Niechorze. It stands at the highest point of a wooded cliff on the Baltic Sea. The lighthouse was established on 1 December 1866. Protection was built in advance in the form of breakwaters as well as a solid foundation so as to avoid the erosion of the substructure. It was only thanks to this hydraulic-building measure that the sliding of the tower into the Baltic Sea could be prevented in the long term. In the early years the beacon was operated by four rapeseed oil lamps. The annual consumption of rapeseed oil was estimated at around 2,000 litres, which quickly proved to be too expensive and also very demanding in terms of upkeep. For this reason the beacon was supplied with electrical power from 1920 onwards. Shortly before the end of the Second World War the lanterns were shot to pieces by the Soviet army, but were restored to their original state after a relatively short time, according to old construction plans. Due to this, operation of the beacon was resumed in 1948. The beacon optic was upgraded with a 1,000-watt lamp in order to improve the range of the light beam in the darkness of the Baltic Sea.

Those willing to make the effort to climb the 200 steps of a steep staircase up to the apex of the tower will be rewarded with a magnificent view over the shifting sand dunes of the Baltic Sea coast and, with luck, over to the 52-mile-distant Danish island, Bornholm. For lighthouse enthusiasts the Miniature Park, with its faithfully reproduced models of all the lighthouses on the Polish Baltic coast, organised according to their original positions, will also be of interest. The park also has a café and a souvenir shop.

54°05'41"N 015°03'50"E | Fl 10s | 63m | 20M

9. Morska Kołobrzeg Lighthouse (Kolberg, West Pomerania)

The first lighthouse in Kolberg was built in 1666 but the beacon was only lit when a ship neared the harbour. 200 years later in 1866, the beacon was fuelled with rapeseed oil in order to enable greater use and ensure better safety for shipping. After the destruction of the lighthouse by Soviet troops on 19 March 1945, the building of a new one became necessary. The new tower was placed in the old Münde Fort. Broken up stones from the old tower were used for the construction of the new military property.

54°11'11"N 015°33'16"E | Fl 3s | 33m | 16M

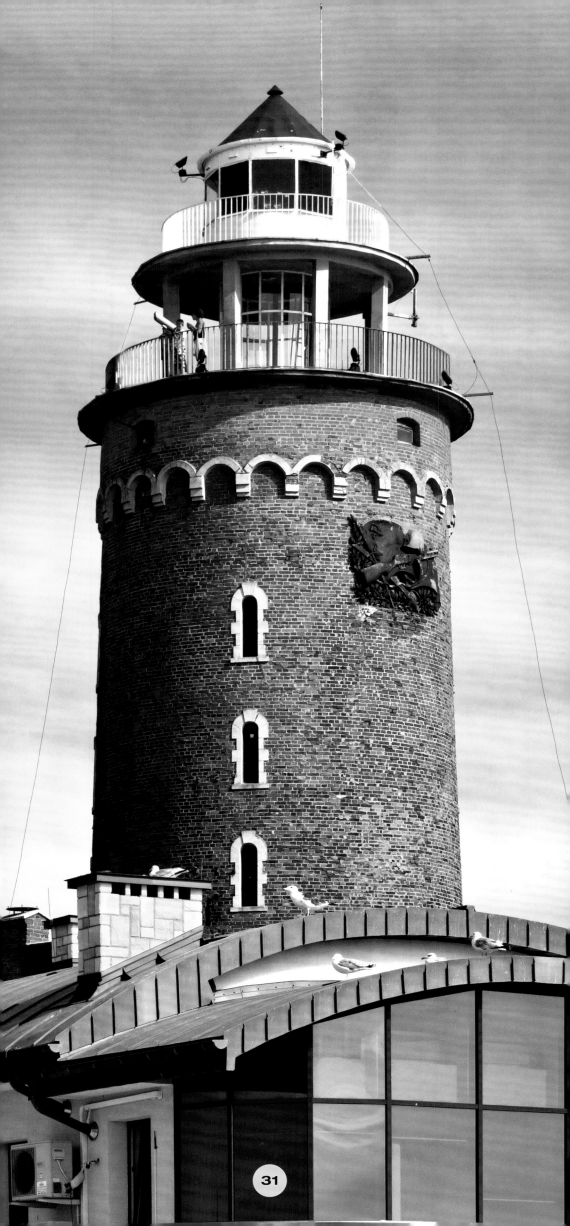

Estonia

The former Soviet republic of Estonia lies on the eastern side of the Baltic Sea. This still new republic reestablished its sovereignty in the wake of glasnost and perestroika in August 1991. The country is smaller than the northern German state of Lower Saxony, but its coastline stretches for 3,794 km, characterised by many gulf estuaries and inlets (Riga Bay, for example). The largest islands are Saaremaa and Hiiumaa.

The three most beautifully-situated and interesting lighthouses from a scenic and architectural point of view (Tahkuna lighthouse, Kõpu lighthouse and Ristna lighthouse) stand on Hiiumaa, a popular holiday destination for inhabitants of the capital Tallinn throughout the year.

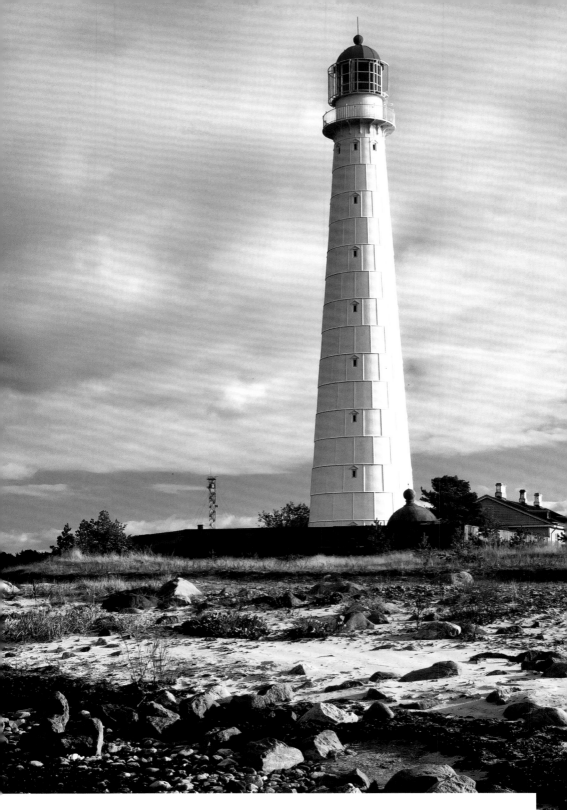

Estonia is the northernmost country of the Baltic and borders on Latvia in the south, Russia in the east and on the Baltic Sea in the west. The climate in Estonia is moderately cool to cold, with frosty winters and moderately warm summers, with average temperatures of 16.5°C in July and -6°C in January. With 1.3 million inhabitants (as of 2016) Estonia has only around 200,000 more inhabitants than the city of Birmingham. The population density, with 31 inhabitants per square kilometre, is very low in comparison to other European countries. Due to the close relationship between the Estonians and Finns, Estonian culture is very much aligned with Finland and the West (having close ties with German companies and universities for example).

Nature lovers are kept happy by Estonia's many unspoiled forests, rough coastal landscapes and the abundance of national parks.

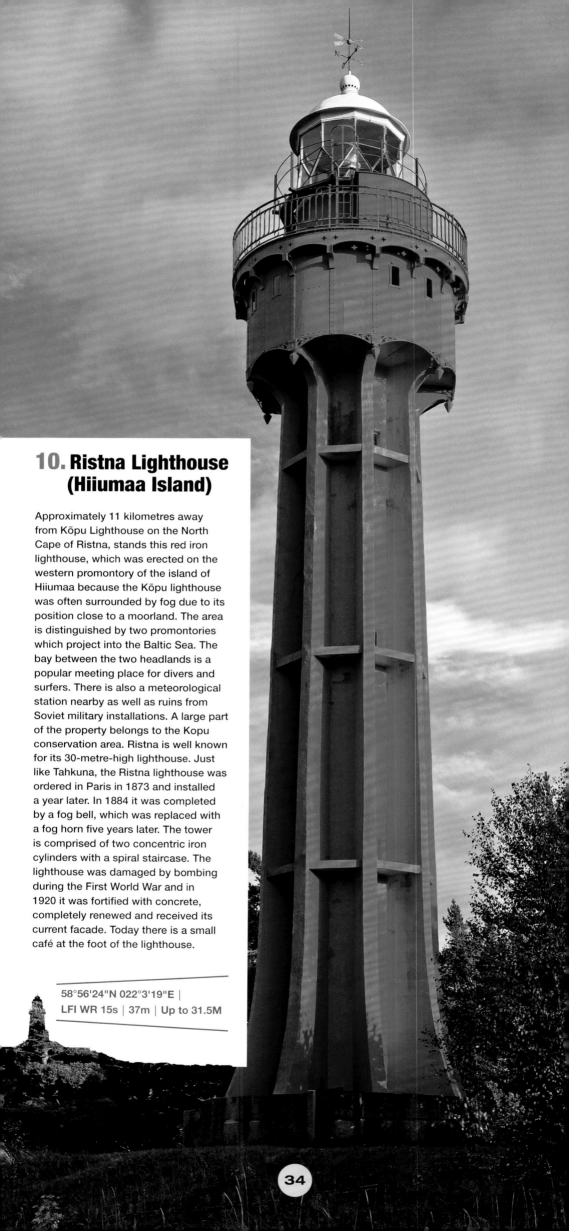

10. Ristna Lighthouse (Hiiumaa Island)

Approximately 11 kilometres away from Kõpu Lighthouse on the North Cape of Ristna, stands this red iron lighthouse, which was erected on the western promontory of the island of Hiiumaa because the Kõpu lighthouse was often surrounded by fog due to its position close to a moorland. The area is distinguished by two promontories which project into the Baltic Sea. The bay between the two headlands is a popular meeting place for divers and surfers. There is also a meteorological station nearby as well as ruins from Soviet military installations. A large part of the property belongs to the Kopu conservation area. Ristna is well known for its 30-metre-high lighthouse. Just like Tahkuna, the Ristna lighthouse was ordered in Paris in 1873 and installed a year later. In 1884 it was completed by a fog bell, which was replaced with a fog horn five years later. The tower is comprised of two concentric iron cylinders with a spiral staircase. The lighthouse was damaged by bombing during the First World War and in 1920 it was fortified with concrete, completely renewed and received its current facade. Today there is a small café at the foot of the lighthouse.

58°56'24"N 022°3'19"E | LFI WR 15s | 37m | Up to 31.5M

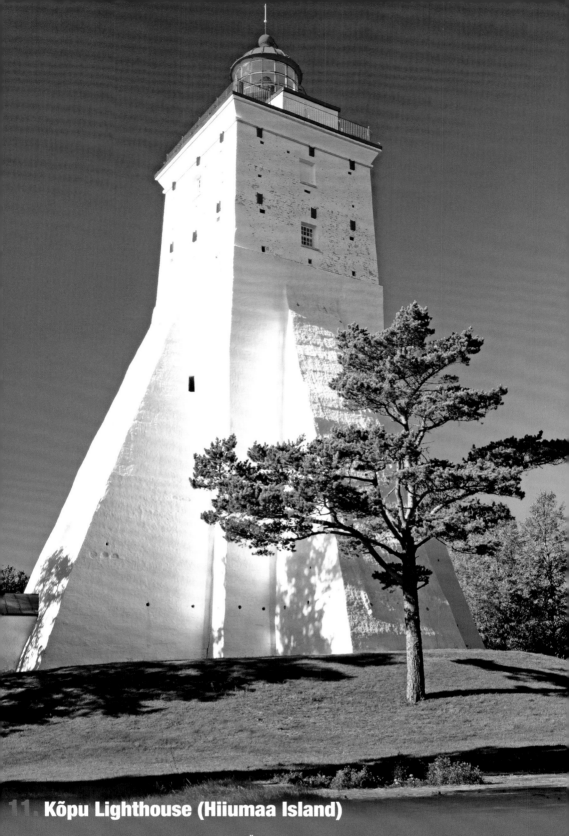

11 Kõpu Lighthouse (Hiiumaa Island)

Kõpu Lighthouse (formerly known in Swedish as Övre Dagerort fyr) is one of the most famous landmarks on the Estonian holiday island Hiiumaa, and the third oldest operational lighthouse to be found worldwide. The tower has a square foundation and the side supporting walls stand at the four main points of the compass. In clear weather its light can be seen up to a distance of 65 kilometres. The lighthouse stands on the Kõpu peninsula which stretches west along the island of Hiiumaa, and was built in 1531 on a 67-metre-high elevation – the highest point on Hiiumaa. The lighthouse is, with a signal height of 102.6 metres, one of the highest in the Baltic Sea. In 1490 in order to reduce the number of shipwrecks on the Hiiu sandbank, representatives of the Hanseatic League requested the building of a lighthouse. The Bishop of Ösel-Wiek, who had a stake in this property, granted the city council of Tallinn the necessary building permission in the year 1500. The building work began in 1505 and lasted, due to several interruptions, 26 years until the lighthouse was finally completed in 1531. In 1659 the tower was extended to its present height. When responsibility for the lighthouse transferred to the Russian administration in 1805 there followed extensive renovation, such as the building of a stone stairway in the south tower support. In 1845 the optical equipment was covered in wood cladding with smoke flues. At the beginning of the 1970s repeated repairs were necessary due to the progressive deterioration of the tower's outer walls. In 1989/90 the building was covered with a layer of reinforced concrete which strengthened the walls and ground supports. The Kõpu lighthouse is today open to the public and, as well as its nautical function, serves as an observation tower with a wonderful vista over the Kõpu peninsula and the Baltic Sea.

58°54'57"N 022°11'59"E | Fl(2) 10s | 102.6m | 35M

12. Tahkuna Lighthouse (Hiiumaa Island)

The lighthouse in Tahkuna is, with a height of 42.7 metres above sea level, the tallest beacon on the Estonian Baltic Coast. The village, inhabited by only two people, is situated on the north point of the island of Hiiumaa, the second-largest island of Estonia. This island was a much desired health resort, even when the Soviet Union and the states of the Warsaw Pact were forming the Eastern Bloc and the West held its breath during the Cold War. Takuna lies approximately 15 kilometres southwest of the island's capital Kärdla and is above all known for its lighthouse, set in a delightful Baltic Sea landscape. The tower, constructed from prefabricated cast iron pieces, was bought from the Russian government at the World Fair in Paris in 1871 and assembled in 1873/74. To the south of the lighthouse stretches a beautiful conservation area with widespread forests and abundant dunes, which are attractive to hikers. Behind the lighthouse a memorial by the sculptor Mati Karmin provides a reminder of the children who drowned nearby on the ferry *Estonia* on 28 September 1994. The sculptor's work includes a bell attached to a pendulum, which starts to ring in strong wind.

059°5'29"N 022°35'10"E | LFI(2) 15s | 43m | 18M

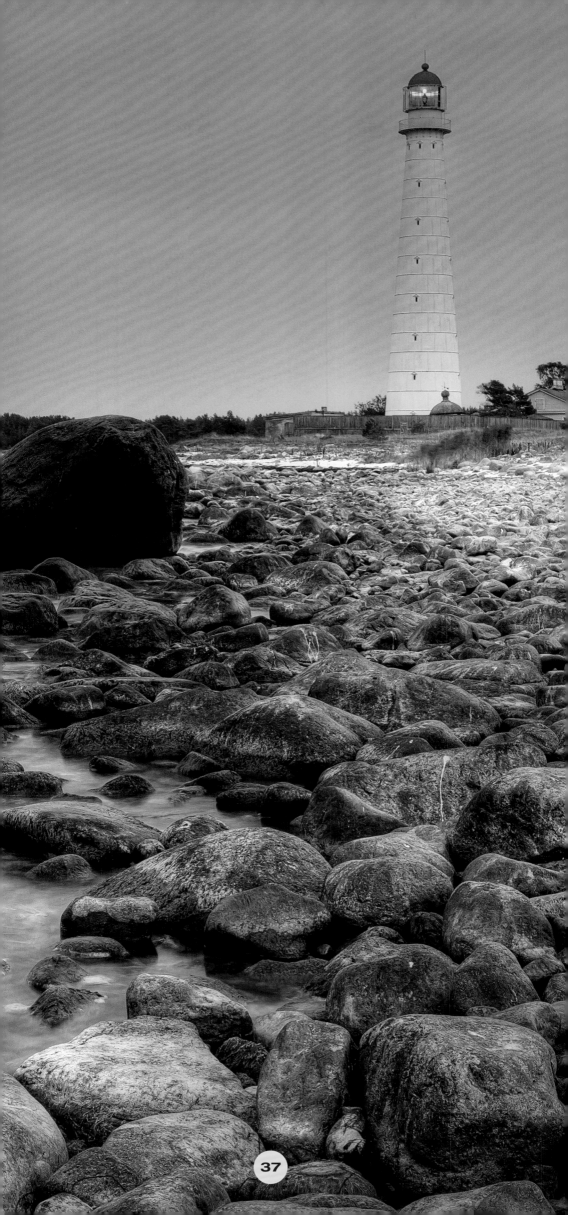

Denmark

Denmark (known as the 'gateway' to Scandinavia from central Europe) comprises over 7,314 km of coastline due to its many islands (443, only 73 of which are inhabited) and bays. Denmark's southern border with Germany forms the only land border, with a length of 67 km, otherwise the kingdom is bordered by the North Sea and the Baltic Sea, the Skagerrak Strait and Kattegat. The western-most point is situated at Blavand Huk in Jutland, and the Ertholm Islands (18 km northeast from the 'Sunshine Island' of Bornholm) mark the easternmost point. The northernmost point is Grenen at Skagerrak, and Gedser (Falster Island) marks the southernmost point of Denmark and also of Scandinavia. Since the year 2000 there has also been a land route from Denmark to Sweden via the Öresund Bridge.

The political system in Denmark is characterised by a multiple party system with several parties represented in Parliament at any one time. The Danish government is mostly a minority government supported by one or more coalition parties. The framework for the Danish Constitution was originally confirmed in 1849. The word 'Denmark' was engraved on the famous Jelling Stones by the Vikings in AD 900. As well as Jutland, Fünen, Zealand and the many other islands in the Danish waters, the Faroe Islands in the North Atlantic and Greenland, part of the North American continent, also belong to Denmark, but they have their own autonomous administrations.

On the coasts of Denmark stand many architecturally interesting lighthouses which, in the south, represent the Prussian building style. Further north the regal building style prevails. The Rubjerg Knude lighthouse, which stands on a shifting dune in Jammer Bay on the North Sea, is considered the most beautifully-situated lighthouse in Denmark.

13. Hammeren Lighthouse (Bornholm Island)

The Bornholm granite lighthouse stands on the 70-metre-high Ørnebjerg on the northwest point of the island, at the centre of one of the most beautiful natural landsapes near the ruins of Hammershus castle. On clear and sunny days it is possible to enjoy a magnificent view of the Ertholm Islands or the south Swedish coast from the 21-metre-high round granite tower. From the observation platform (91 metres above sea level, which is very high by Danish standards!) it is possible to look directly at the hand-polished Fresnel lens imported from France. In summer the lighthouse can be visited free of charge. The lighthouse has guided the way for ships between the north point of Bornholm and the south point of Sweden since its launch in 1871. The beacon was deactivated in 1990 because ships' navigation was taken over by satellites and low-lying clouds often obscured the light. After over 20 years new tenants of the lighthouse keeper's house acquired a permit from the Danish shipping office to rekindle the light at their own cost – if less bright than in the old days.

55°17'12.4"N 014°45'33.6"E | 91m | Deactivated in 1990, today lit with low light (not for shipping)

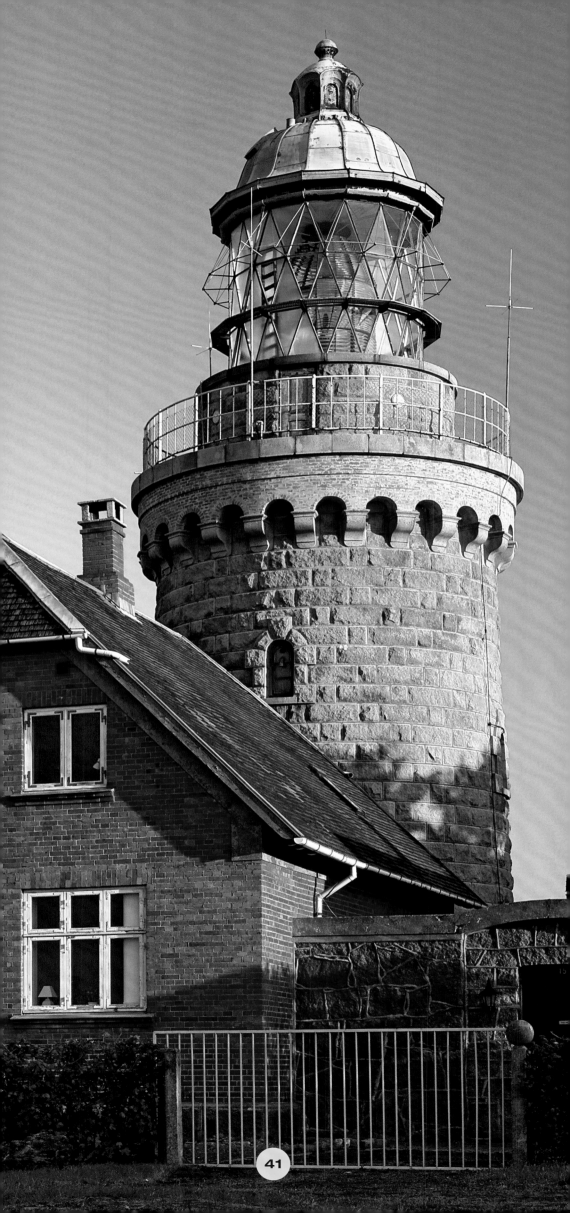

14. Svaneke Lighthouse (Bornholm Island)

The square sandstone tower on the northeastern point of Bornholm was launched in August 1920 and electrically automated in 1947. It is situated on a headland near Svaneke, Sandkås Odde. The flat rock coastline in front of the lighthouse offers a very appealing landscape. The lighthouse, including keeper station, is restored and modernised and converted into holiday accommodation. This is a very special holiday home which is situated near both breathtaking nature and the picturesque Svaneke harbour.

55°07'54.3"N 015°09'09.5"E | 91m | Deactivated in 2010

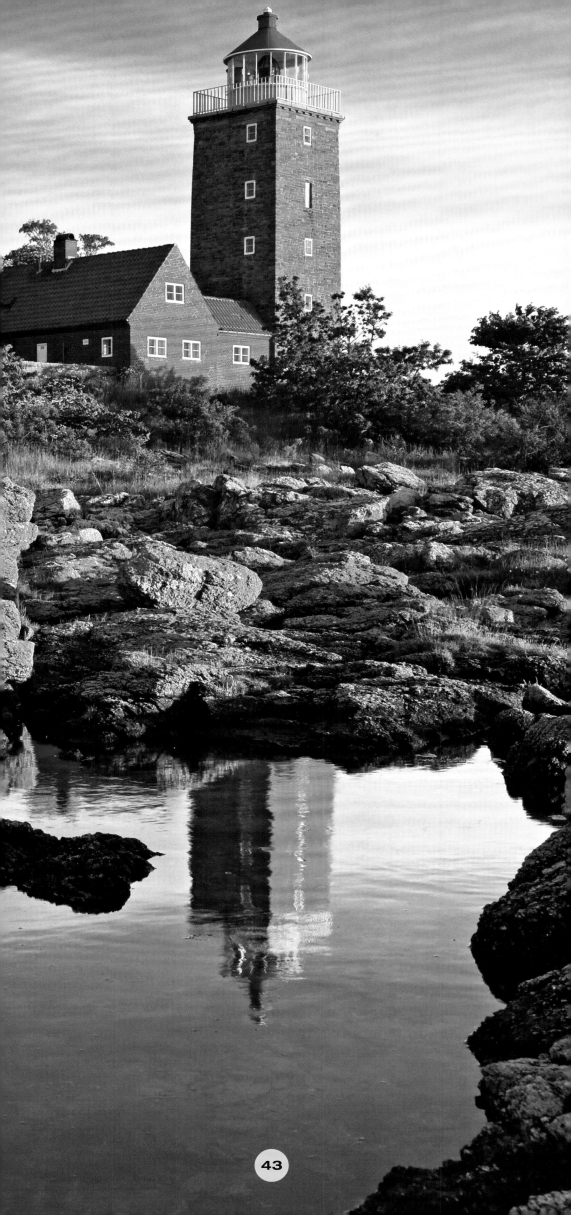

15. Taksensand Lighthouse (Alsen Island)

The Taksensand beacon indicates the northern approach to the ferry port, Fynshav. Together with the Traneodde beacon the red warning sector also marks the shallows in the small belt where depths of between 0.7 and 0.5 metres can quickly become fatal for larger boats, yachts and ships. The white-painted 19-metre-high lighthouse, set on an idyllically convenient pebble beach, was built in the year 1905. In 1953 the tower was reduced from its original height of 32 metres to 19 metres. In 1920 the lantern was changed to a kerosene incandescent light burner which was then later replaced by a gas burner in 1947. The lantern itself was restored in 1989.

55°00'40"N 009°57'84"E | Oc(2) WRG 12s | 15m | 15-11m

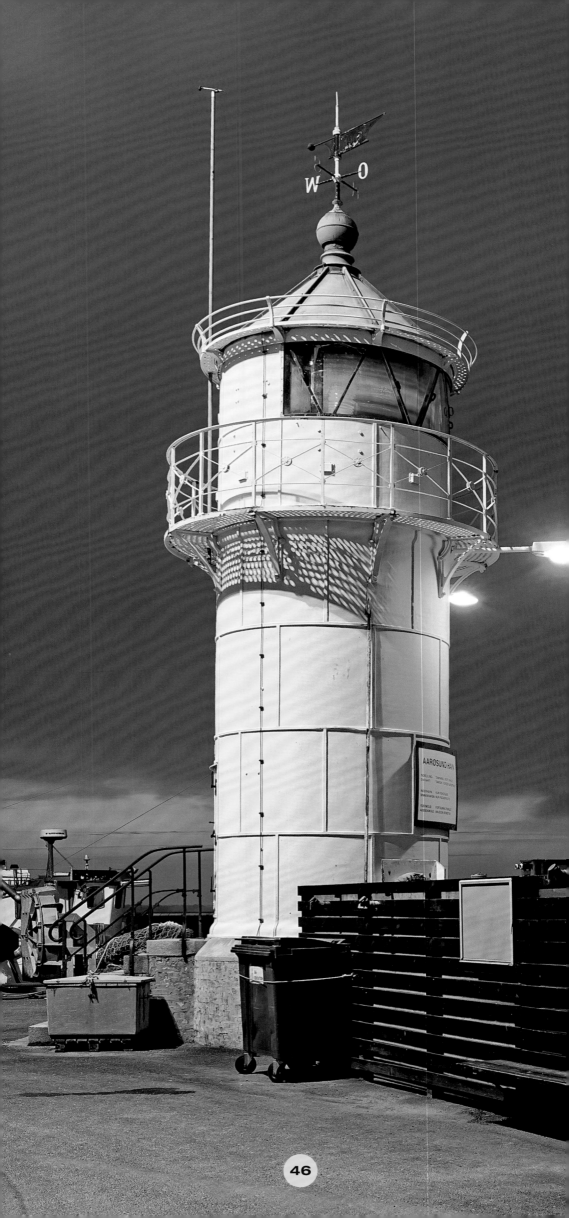

16. Årøsund Lighthouse (South Jutland)

The dreamy harbour town of Årøsund lies between the east of the town of Haderslev in south Jutland and the island of Årø. At the head of the southern pier, between the new yacht harbour and the terminal from which the ferries regularly cross to the small island of Årø, stands the Årøsund lighthouse, built in 1905 in the same style as the lighthouses Årø, Gammel-Pøl and Traneodde (they all bear the hallmarks of the German master plumber and entrepreneur Julius Pintsch). The harbour in Årøsund is of a modest size: the elegant hotel, the harbour snack bar, the ferry terminal and the yacht harbour can all be viewed from the lighthouse. In 1777 the beacon was established. In those days postal shipping across the small channel to Assens on the island of Fyn, approximately eight nautical miles away, was key. The original beacon was later replaced by the iron segment construction of Julius Pintsch from Fürstenwalde, near Berlin. The light of this white tower, together with the light on the island of Årø, guides sailors to the safe route in the narrow waterway (only 600 metres wide) between the island of Årø and the mainland.

55°15'43.7"N 009°42'44.1"E | Oc WRG 5s | 9m | 10-8M

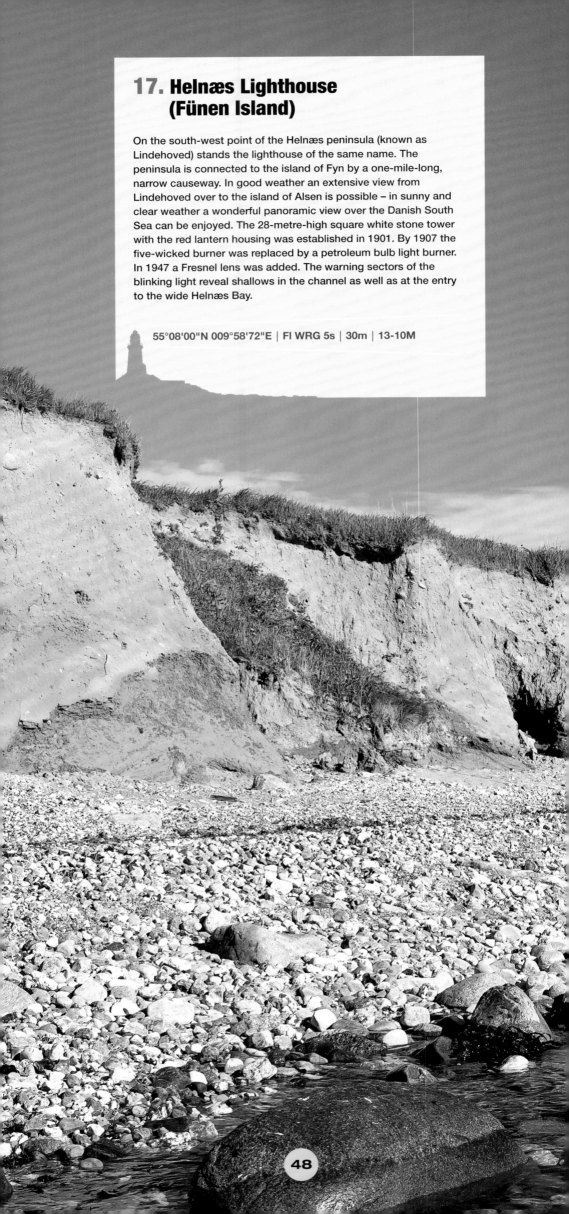

17. Helnæs Lighthouse (Fünen Island)

On the south-west point of the Helnæs peninsula (known as Lindehoved) stands the lighthouse of the same name. The peninsula is connected to the island of Fyn by a one-mile-long, narrow causeway. In good weather an extensive view from Lindehoved over to the island of Alsen is possible – in sunny and clear weather a wonderful panoramic view over the Danish South Sea can be enjoyed. The 28-metre-high square white stone tower with the red lantern housing was established in 1901. By 1907 the five-wicked burner was replaced by a petroleum bulb light burner. In 1947 a Fresnel lens was added. The warning sectors of the blinking light reveal shallows in the channel as well as at the entry to the wide Helnæs Bay.

55°08'00"N 009°58'72"E | Fl WRG 5s | 30m | 13-10M

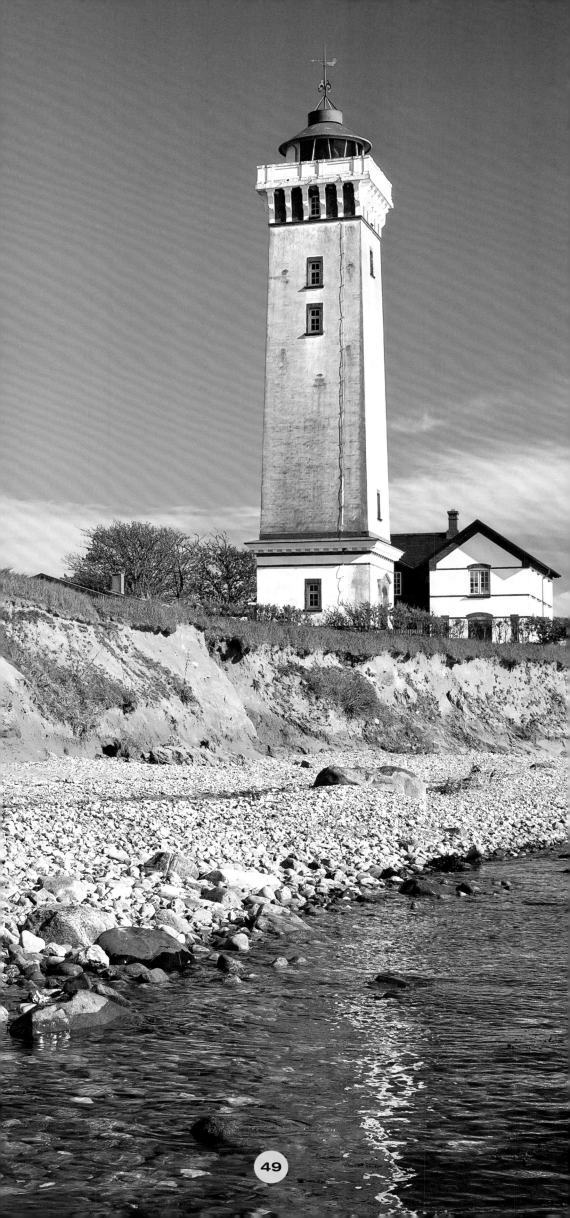

Sweden

Sweden is a parliamentary monarchy in northern Europe located on the eastern part of the Scandinavian peninsula together with the islands of Gotland and Öland. Sweden borders the Kattegat, the Gulf of Bothnia, Norway and Finland, and the Baltic Sea. In 1995 Sweden joined the European Union, but retains its currency as Swedish Krona (SEK). Sweden's climate is very mild considering its geographical location; it is dictated mostly by its proximity to the Atlantic and the warm Gulf Stream. A polar climate dominates in the northern highlands.

Since the opening of the Öresund Bridge connection on 1 July 2000 by Queen Margrethe II of Denmark and King Carl Gustaf XVI of Sweden, there exists a 16 km-long link between the Danish capital, Copenhagen and Malmö, capital of the south Swedish province, Scania.

Sweden is surrounded by approximately 221,800 islands, of which Gotland and Öland are easily the largest. As a land of forests, lakes and islets Sweden is, due to its many leisure and recreational opportunities, a much sought-after holiday destination where tourists can enjoy the variety of wildlife and scenery. The country is divided into 21 provinces of which Stockholm County, Västra Götaland and Scania have the most inhabitants and the largest population densities.

The province of Scania offers, without doubt, the most architecturally interesting lighthouses on the Swedish mainland. Gotland and Öland have a relatively high number of lighthouses worth seeing. On the east and west coasts there are also many lighthouses due to the large number of archipelagos, but they are mainly practically-built offshore lighthouses which warn against shallows, or undistinguished harbour lighthouses with just about discernible lights.

18. Malmö Inner Harbour Lighthouse
(Scania, Øresund strait)

The first lighthouse in the harbour of the Malmö metropolitan region was erected as early as 1822 and constructed from wood. The lanterns incorporated a silver-plated copper disc and a gas lamp. The harbour light was replaced in 1878 by a new iron lighthouse and has since stood in the inner harbour of Malmö. Before the white tower, with two red rings and a red-painted lantern housing, was converted to electricity in 1924 the beacon was equipped with an Auer burner fired by acetylene gas. The Auer burner had the advantage that it used less gas while at the same time yielding a higher intensity of light because, in contrast to the usual burner system, it was not the gas flame itself which provided illumination. Instead it brought a heat-resistant Auer gas mantle to a white glow. Through this a more intensive brightness was produced, thus optimising the range of the beacon. After the introduction of electric power the 500-millimetre drum lens that had been used up until then was replaced by a 1,000-millimetre optic lens in order to further increase the range so that the white light beam could be seen up to a distance of 14 nautical miles. The beacon has not been in operation since 1983 and now a small light with a simple lightbulb shines over the town.

55°36'45"N 012°59'45"E | Beacon deactivated in 1983

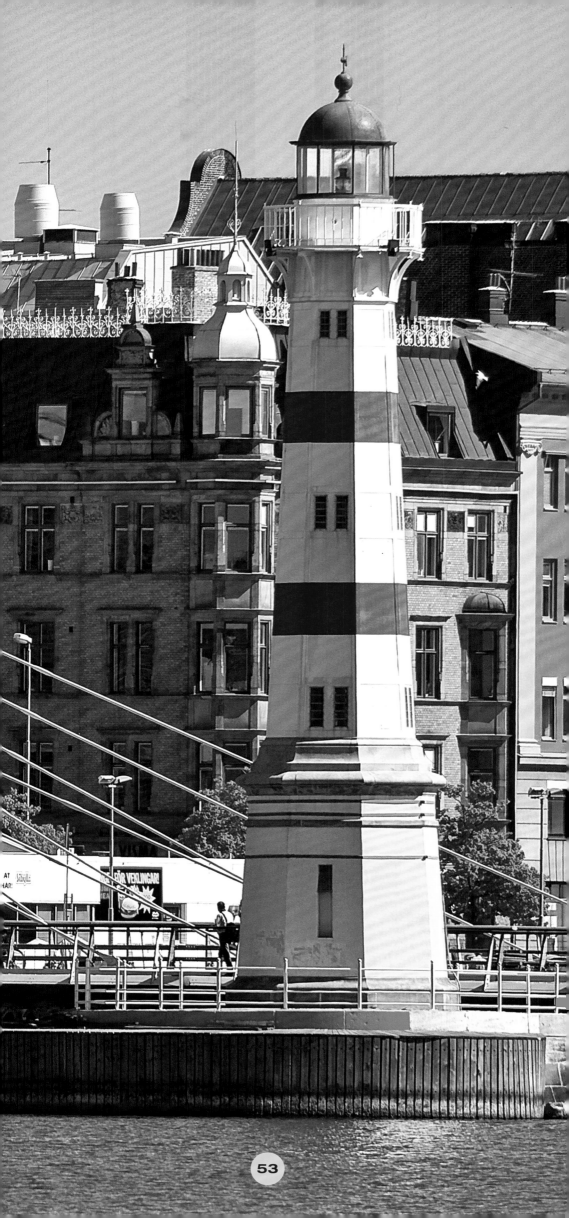

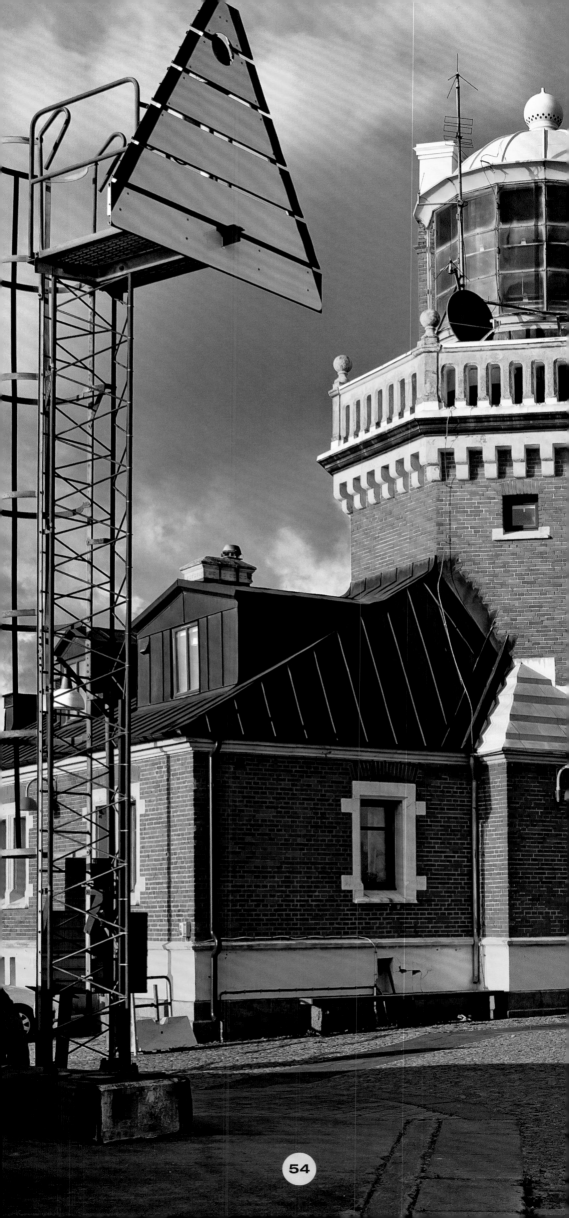

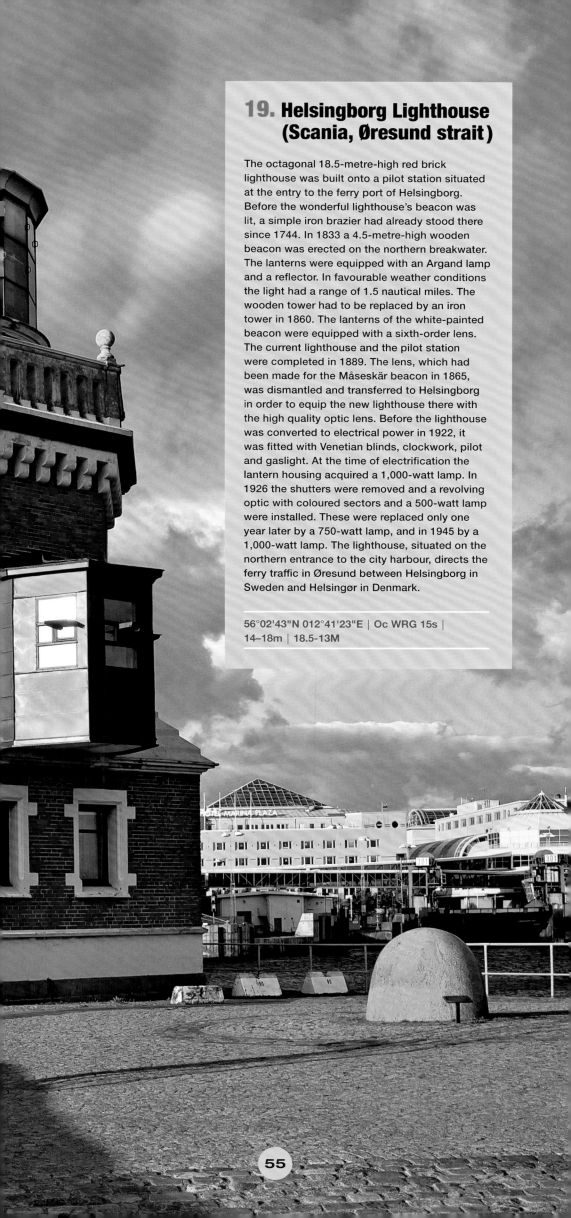

19. Helsingborg Lighthouse (Scania, Øresund strait)

The octagonal 18.5-metre-high red brick lighthouse was built onto a pilot station situated at the entry to the ferry port of Helsingborg. Before the wonderful lighthouse's beacon was lit, a simple iron brazier had already stood there since 1744. In 1833 a 4.5-metre-high wooden beacon was erected on the northern breakwater. The lanterns were equipped with an Argand lamp and a reflector. In favourable weather conditions the light had a range of 1.5 nautical miles. The wooden tower had to be replaced by an iron tower in 1860. The lanterns of the white-painted beacon were equipped with a sixth-order lens. The current lighthouse and the pilot station were completed in 1889. The lens, which had been made for the Måseskär beacon in 1865, was dismantled and transferred to Helsingborg in order to equip the new lighthouse there with the high quality optic lens. Before the lighthouse was converted to electrical power in 1922, it was fitted with Venetian blinds, clockwork, pilot and gaslight. At the time of electrification the lantern housing acquired a 1,000-watt lamp. In 1926 the shutters were removed and a revolving optic with coloured sectors and a 500-watt lamp were installed. These were replaced only one year later by a 750-watt lamp, and in 1945 by a 1,000-watt lamp. The lighthouse, situated on the northern entrance to the city harbour, directs the ferry traffic in Øresund between Helsingborg in Sweden and Helsingør in Denmark.

56°02'43"N 012°41'23"E | Oc WRG 15s | 14–18m | 18.5-13M

20. Kullens Lighthouse
 ## (Kullaberg, Scania, Øresund province)

On the northern estuary the Kullaberg nature reserve is much-loved by holidaymakers and hikers as a conservation area. On the northwest point of the headland, approximately three kilometres away from the picturesque harbour town of Mölle, stands the 67-metre-high Kullaberg on which the lighthouse, which serves as orientation beacon, is situated. The 18.5-metre-high building was completed under the direction of the Swedish architect, Magnus Dahlander, in 1900. Granite stones and brick were used as materials for the conical tower. The lantern housing incorporated three huge Fresnel lenses at a circumference of 2.55 metres each and a total weight of six tons; construction was completed by the French firm Barbier & Bénard. The lens track consists of a round container filled with 50 litres (approximately 677 kilograms) of mercury. The lens apparatus runs effectively in a circular cast-iron trough containing the mercury, producing virtually no friction and operating without wearing.

Apart from this, it makes sure that the lens system is expertly stabilised. The previously gas-run system was converted to electricity in 1907 and was equipped with two 1,000-watt light bulbs, so that the light intensity reached a value of 3.8 million candelas. The three Fresnel lenses rotate four times per minute and produce 12 flashes per minute. The lighthouse on the Kullaberg, with its range of 27.6 nautical miles (51 kilometres), is the strongest beacon in Scandinavia. The lighthouse has been radar-operated and monitored by the Swedish Marine Office in Norrköping, eastern Sweden, since 1979. In spite of this there is also a lighthouse keeper. In conditions of bad visibility a fog horn emits two blasts every 30 seconds. Every year the headland is visited by over 300,000 people. In the lighthouse there is a visitor and information centre with a beautiful view across the Øresund. Home baked cakes are also a speciality.

56°18'04"N 012°27'06"E | Fl 5s | 78.5m | 27.6M

THE NORTH SEA
Norway

Norway is situated on the Scandinavian peninsula bordering Sweden in the east and Finland and Russia in the north east. Over the North Sea from Norway lie Scotland in the west and Denmark in the south. Norway's Atlantic coast is approximately 25,000 km long and consists of many narrow and deep bays, the Fjords. If one were to calculate the length of the entire coast, it would be about 80,000 km. The largest towns in Norway are Bergen, Trondheim and Stavanger with more than 100,000 inhabitants, and the capital Oslo with more than 640,000 inhabitants. Norway has one of the largest surface areas in Europe and with 5.2 million inhabitants is very sparsely populated. Population density stands at only 13 inhabitants per square kilometre.

Norway's scenery is characterised by the Scandinavian mountains with ranges and barren highlands, the Fjells. The most recognisable landscape features are the

Fjords, which appeared during the Ice Age. The country is surrounded by around 150,000 islands. The best known island group is the Lofoten Islands situated north of the Arctic Circle; year after year it attracts tourists, photographers, nature lovers and artists. Next to the continental mainland, Spitzbergen Island, located in the North Atlantic, together with Bear Island and Jan Mayen Island, also belong to Norway.

The Scandinavian mountain range is responsible for the two different climate zones in Norway in that it separates the characteristically narrow humid coastal strip in the west from the continental zone (with cold winters and hot summers) in the east. Due to the different kinds of landscape and the great diversity of wildlife, Norway is a well loved and exciting travel destination. For a country with such a long coastline, 'lighthouse density' (with 154 active lighthouses) is very low. Most of the lighthouses have simple compulsory offshore lights and sector lights which warn against shallows and obstacles in areas with many small islets. However, the lighthouse on Cape Lindesnes is considered to be one of the most eyecatching.

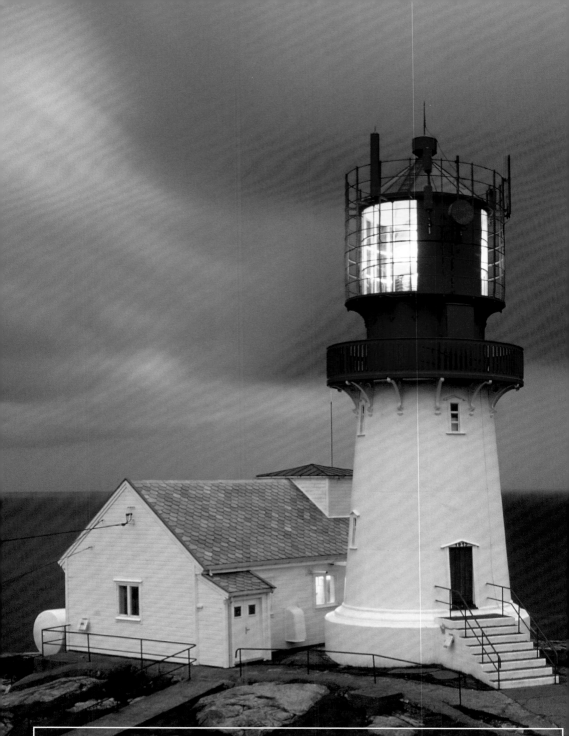

21. Cape Lindesnes Lighthouse (Vest-Agder Province)

About 80 kilometres west of Kristiansand, on a small mound of the South Cape, stands the new lighthouse of Lindesnes, located in the Norwegian province, Vest-Agder. The lighthouse, equipped with a Fresnel lens (operated with a white synchronised light) is an architectural highlight, even for hardened lighthouse enthusiasts and is situated on the southernmost mainland point of Norway. The tower lies 2,518 kilometres away from the famous North Cape and is one of the most important landmarks between the North and Baltic Seas. Most sailors who sail over the Skagerrak Strait willingly choose the south point as their destination because the coast there offers many possibilities for shelter in the form of natural harbours. This most important coastline meets the high sea at the south point of Norway. Below the lighthouse there are well-preserved bunkers which are easily accessible. Close by is a lighthouse museum built in to the cliffs, which is well worth seeing and open daily to visitors, with much interesting information about the history of the lighthouse and the 350-year nautical history of Norway. The first coal beacons were lit on 27 February 1656 on Cape Lindesnes. The current lighthouse is the most-visited attraction in south Norway and attracts approximately 70,000 people per year. No wonder. The view from the top of the lighthouse across the south coast of Norway is simply breathtaking. The strait in the east and the North Sea in the west meet at the south coast in front of Cape Lindesnes. In 2000 Lindesnes Lighthouse was chosen as the millennial site of the province of Vest-Agder and a visitors' centre was constructed where regular concerts and performances were staged. There is also a café, a souvenir shop and a restaurant.

57°59'00"N 007°02'48"E | F (Fixed)+Fl 20s | 49m | 17M

22. Obrestad Lighthouse (Rogaland Province)

Obrestad's first lighthouse was built in 1873 and a lighthouse keeper's station was added in 1905. In 1950 the tower was renovated, painted white and acquired a red lantern. A new building was added for the keepers. In 1969 the property was again extended in order to provide accommodation for staff family members. The lighthouse, which serves as a leading light, is situated on the south-western North Sea coast in the borough of Hå (Rogaland Province) between Egersund and Stavanger. Since the automation of the lighthouse in 1991, there has been no need for lighthouse keepers. In 1998 the beautifully-situated lighthouse was placed under protection. It functions as a museum with exhibitions showing the daily life of the lighthouse keeper, and wall paintings from the days of the war. In one of the rooms is a café in which tools and old oil containers which were left behind can be found; silent witnesses of the daily life of the lighthouse keeper of past times.

58°40'12"N 005°32'36"E | 38m | 18M

Denmark

(For general information regarding Denmark see page 38)

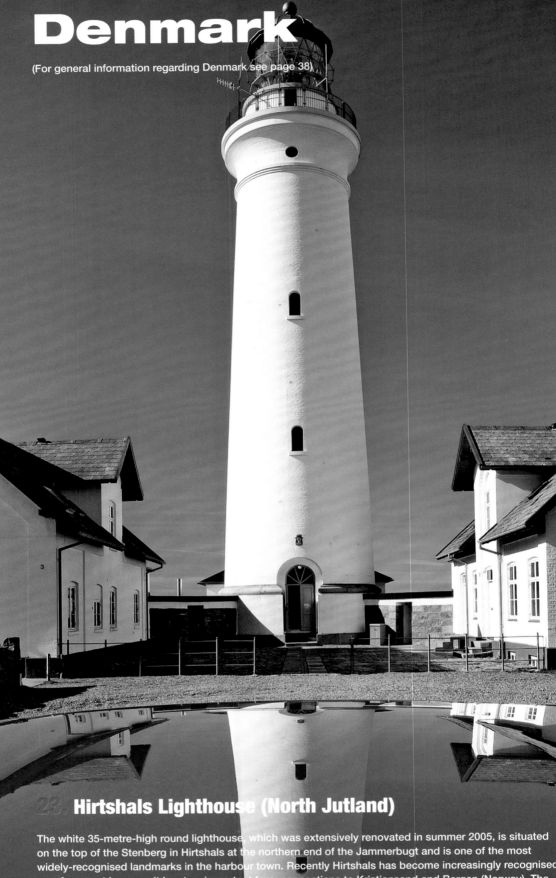

23. Hirtshals Lighthouse (North Jutland)

The white 35-metre-high round lighthouse, which was extensively renovated in summer 2005, is situated on the top of the Stenberg in Hirtshals at the northern end of the Jammerbugt and is one of the most widely-recognised landmarks in the harbour town. Recently Hirtshals has become increasingly recognised as a ferry port because it has two important ferry connections to Kristiansand and Bergen (Norway). The lighthouse was inaugurated in 1863 during the reign of King Frederick VII and his coat of arms decorates the entrance door. The challenging climb up the 144 steps to the observation tower is rewarded with a fantastic view over the harbour of Hirtshals and across the straits. The light of a 1,500-watt strong lamp is strengthened 100,000 times through the first lens, and the outer rotating lenses increase the light again by 1.25-million-fold so that the light is recognisable at a distance of 25 nautical miles in clear weather. As the lenses are hand polished a thorough cleaning is necessary at regular intervals – roughly every 6 hours. Should the lightbulb no longer function, an automatic replacement is on hand. The very first keeper of the Hirtshals lighthouse actually only lasted 19 days of service as he hanged himself from the top of the lighthouse. The inhabitants blamed the terrible Peter, a kind of human bird of prey, which lived on the Stenberg, for this macabre tragedy. Otherwise the wicked spirit lived off wild prey on the beach, much to the annoyance of the fishermen. The lighthouse is open to visitors year round.

57°35'8"N 009°56'51"E | F (Fixed)+Fl 30s | 57m | 18M

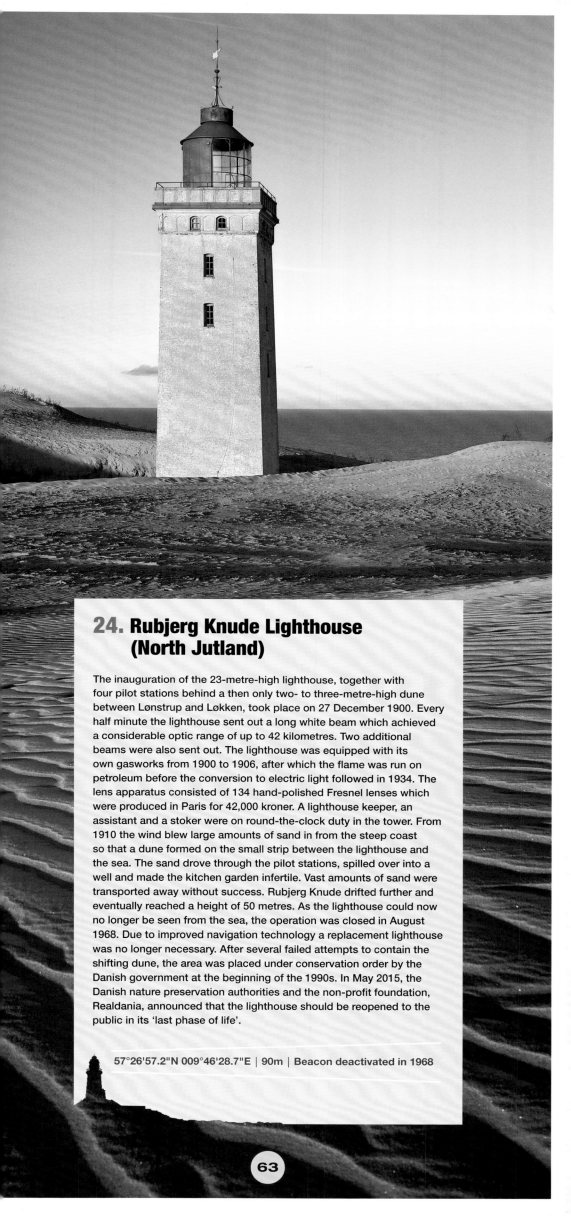

24. Rubjerg Knude Lighthouse (North Jutland)

The inauguration of the 23-metre-high lighthouse, together with four pilot stations behind a then only two- to three-metre-high dune between Lønstrup and Løkken, took place on 27 December 1900. Every half minute the lighthouse sent out a long white beam which achieved a considerable optic range of up to 42 kilometres. Two additional beams were also sent out. The lighthouse was equipped with its own gasworks from 1900 to 1906, after which the flame was run on petroleum before the conversion to electric light followed in 1934. The lens apparatus consisted of 134 hand-polished Fresnel lenses which were produced in Paris for 42,000 kroner. A lighthouse keeper, an assistant and a stoker were on round-the-clock duty in the tower. From 1910 the wind blew large amounts of sand in from the steep coast so that a dune formed on the small strip between the lighthouse and the sea. The sand drove through the pilot stations, spilled over into a well and made the kitchen garden infertile. Vast amounts of sand were transported away without success. Rubjerg Knude drifted further and eventually reached a height of 50 metres. As the lighthouse could now no longer be seen from the sea, the operation was closed in August 1968. Due to improved navigation technology a replacement lighthouse was no longer necessary. After several failed attempts to contain the shifting dune, the area was placed under conservation order by the Danish government at the beginning of the 1990s. In May 2015, the Danish nature preservation authorities and the non-profit foundation, Realdania, announced that the lighthouse should be reopened to the public in its 'last phase of life'.

57°26'57.2"N 009°46'28.7"E | 90m | Beacon deactivated in 1968

25. Lyngvig Lighthouse (Jutland)

The 38-metre-high round white Lyngvig Lighthouse stands on a 17-metre-high dune on the west coast of Jutland. The stranding of the steamboat *Avona*, in which 24 sailors died, led to the building of the lighthouse, which was completed three years after the shipwreck. The lighthouse was equipped with a Fresnel lens and an acetylene burner, whereby the revolving lens was moved by a weight sliding under the stairwell which was again pulled up with a spill. In 1920 the light was replaced with another acetylene burner, before the lighting and lens drive were converted to electrical power in 1955. Due to the automation of the lighthouse in 1965, the lighthouse keeper was pensioned-off. The upgrading with a 250-watt and 300,000 candela strong natrium-loaded lamp followed in the year 2000. Due to technical difficulties with the rotary operation, the light was replaced in November 2011 with an LED light. This led to a reduction in the range from 22 to 17 nautical miles. Shortly afterwards the Society for the Preservation of Lighthouses in Hvide Sande was established and was able to enforce the building of a new lighthouse with the old range and the proven rotating light.

56°2'59.1"N 008°6'13.2"E | Fl(3) 20s | 53m | 22M

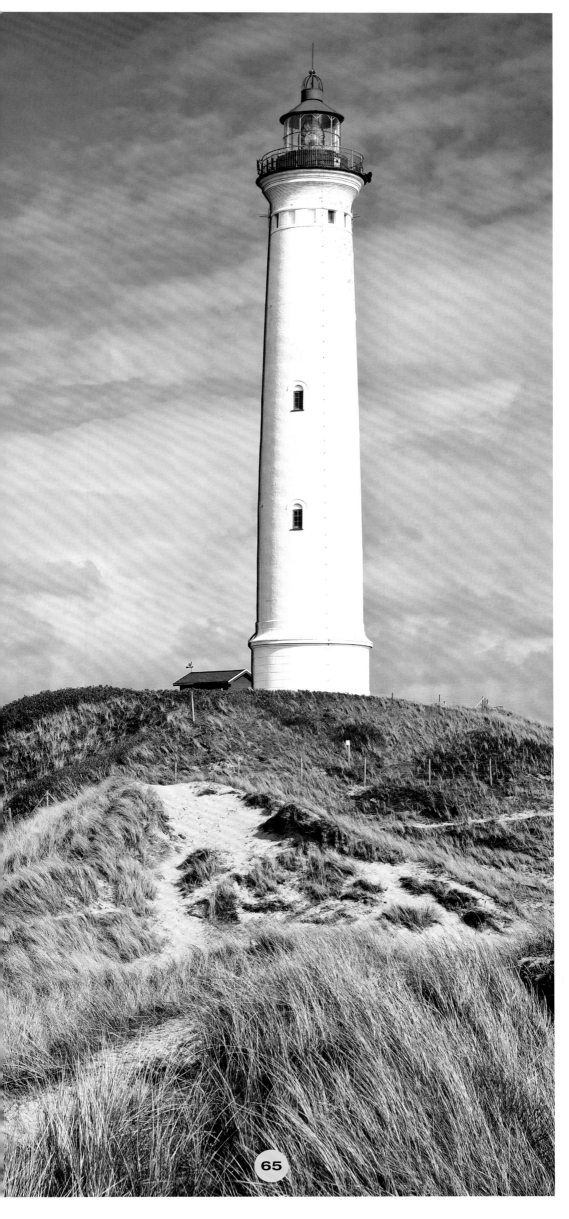

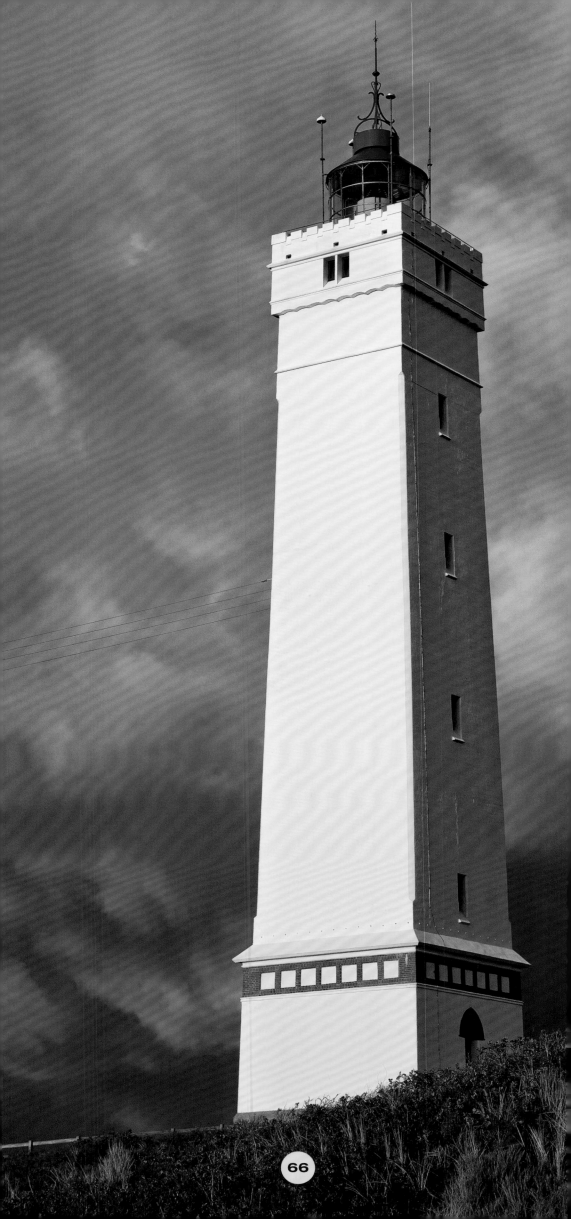

26. Blåvandshuk Lighthouse (Jutland)

The lighthouse on the promontory Blåvandshuk (at the western point of Jutland) is a very popular observation point in the high season from where, at a height of 39 metres, a fantastic view can be enjoyed up to Esbjerg in the south and Vejers Beach in the north. However, a stairway of 170 steps must first be climbed and in the summer season a queue forms. The holiday resort, Blåvand, possesses the finest sand beaches, 40 kilometres in length and protected by the large sandbanks of Horns Rev stretching up to 20 kilometres into the North Sea. To the north is the military and conservation area, Kallesmærsk Heide, which many migratory birds seek out as a resting point. Before the square white lighthouse, which is under a preservation order, was finished in 1900 sailors had already been using a small tower with a small angled light since 1888. Since 1948 the lighthouse has been connected to the electrical grid and it is equipped with a 1,000-watt lamp. Previously traditional light sources such as gas glow light were used and the revolving lens was powered by clockwork. There is now a tourist information office in the former lighthouse keepers' living quarters.

55°33'28"N 008°05'00"E | Fl(3) 20s | 55m | 22M

Germany

(For general information about Germany see page 12)

27. Ellenbogen-West & Ellenbogen-East Lighthouses (List, Sylt Island)

These 'lighthouse twins', situated 2,700 metres apart and different only in height and colour, which were completed in the year 1858, stand in the conservation area of Sylt, Lister Ellenbogen, on the northernmost peak of the North Sea island. The towers were built by the kingdom of Denmark and are the oldest lighthouses in Germany built from iron segments, and at the same time the oldest beacons which stand on the west coast of Schleswig-Holstein. The 11-metre-high lighthouse of Ellenbogen-West has a white coat of paint and a red lantern, while its counterpart on Ellenbogen-East is two metres higher and, due to its red and white paintwork, attracts attention from far away. Both lighthouses were automated in 1977 and are equipped with a 250-watt strong halogen metal vapour lamp and a polished drum lens. Identification is generated by a circulating belt. The Ellenbogen-West lighthouse serves as guiding and orientation beacon for the Lister Deep with a leading sector for the Rømø Deep, while the Ellenbogen-East lighthouse is responsible for the Hoyer Dyp. A toll is payable to travel through this much-loved holiday region because the property is privately owned. It is not possible to climb both towers. The Ellenbogen-East lighthouse was declared in 2003 to be unsafe due to the risk of erosion, but since 2007 coastal erosion has come to a standstill.

 I would hereby like to heartily thank the owners of Lister Ellenbogen for their kind permission to mention both lighthouses.

Ellenbogen-West Lighthouse | 55°3'10.6"N 008°24'5.1"E | Oc WRG 6s | 19m | 14-10M
Ellenbogen-East Lighthouse | 55°2'58"N 008°26'37.5"E | Iso WRG 6s | 22m | 14-10M

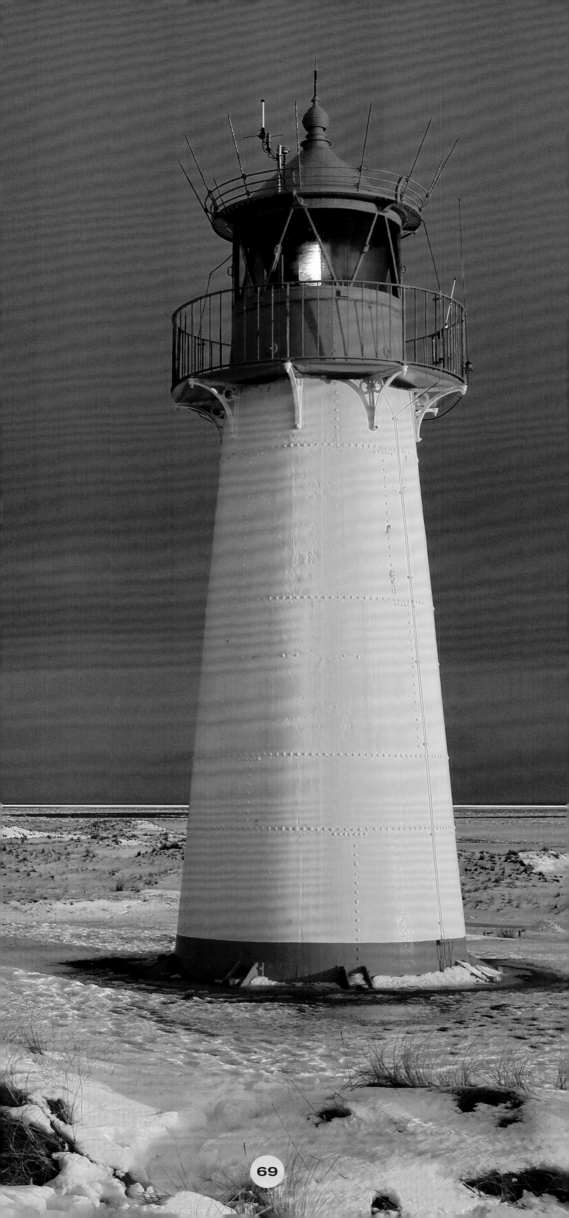

28. Kampen Lighthouse (Sylt Island)

When the island of Sylt still belonged to Denmark the Danish king, Frederick VII, issued the order to build a lighthouse on the highest point of the island. The tower, which serves as orientation beacon on the geest core of the island, the Red Cliff in Kampen, was constructed and finished in 1856. At first a lighting apparatus fuelled by petroleum was used, which was presented in 1855 at the World Trade Fair in Paris as a technical revolution. The building itself was built from yellow Bornholm bricks, and additional iron braces were laid around the tower in 1875. The lighthouse experienced the biggest change in 1929 as the beacon's covering was completely overhauled and the fuel converted from petroleum to electrical power. The drum lens acquired a metal vapour lamp with an output of 400 watts. In 1953 the yellow-grey building received its striking black and white daymark. The lighthouse keepers

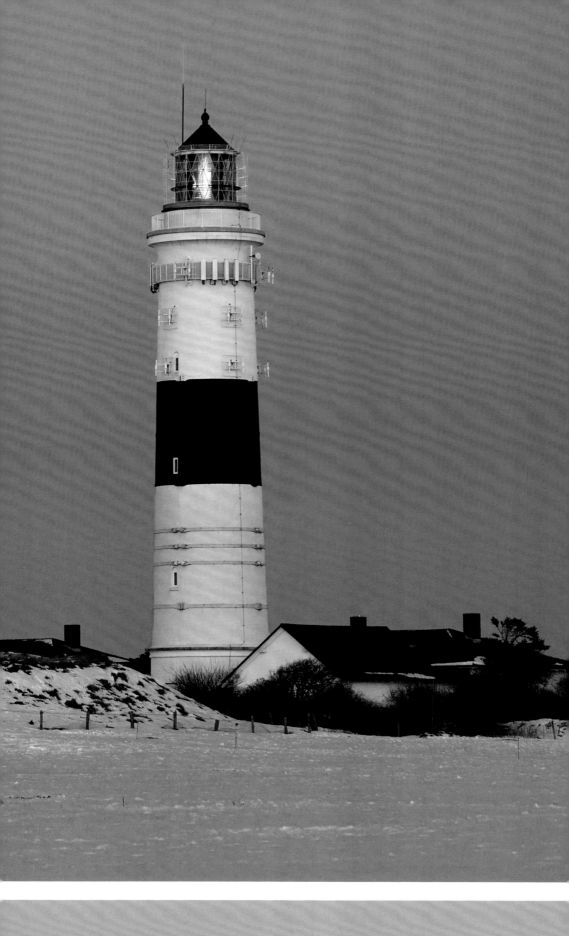

were no longer needed because the Kampen Lighthouse was automated (the remote control runs via a timer, like all lighthouses on Sylt). Time-consuming renovation work followed in the years 2004/05 resulting in the tower having to be completely covered in scaffolding for many months. On 4 June 2006, the 150th anniversary of the completion of the lighthouse was celebrated. On this occasion an exception was made and it was possible to climb the newly-renovated tower and enjoy the splendid panoramic views across the island landscape from a height of 40 metres. Due to its black and white colouring and its position, the Kampen Lighthouse is popular with artists and photographers.

54°56'46.4"N 008°20'26.4"E | LFl WR 10s | 62m | 20-16M

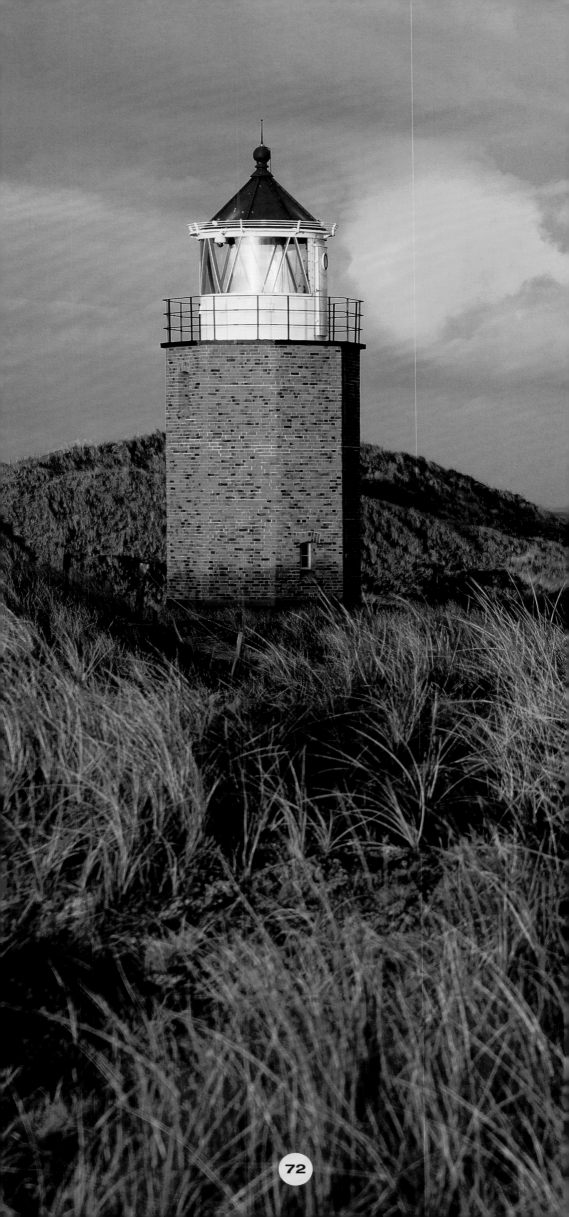

29. Red Cliff Lighthouse (Sylt Island)

The octagonal clinkered beacon was put into operation in 1913 and served as a light to warn of a sandbank at the entrance to the Lister Deep. The tower stands at the northern end of the Red Cliffs in the dunes northwest of Kampen on the island of Sylt. The 13-metre-high building, most recently renovated in 2012/13, is illuminated at night and provides, for this reason, a fascinating photo opportunity. The beacon, which was converted to electrical power in 1936, was deactivated in 1974. Its function as cross light was transferred to the Kampen Lighthouse, 2.5 kilometres away, which duly acquired an additional red sector. The small and decorative tower, which serves today as a landmark, was bought by the Borough of Kampen and thereby saved from demolition.

54°57'56.4"N 008°20'16.1"E | 23m | Lighthouse deactivated in 1974

30. Amrum Lighthouse (Amrum Island, North Sea)

In 1868 an article appeared in the *Hamburger Zeitung* reporting the loss of three ships near Amrum and Sylt. This account let loose an animated discussion among experts regarding the site for the building of a planned lighthouse. The island of Amrum was chosen in 1872 and the building was started one year later. About two kilometres away from the main village of Wittdün, placed in a picturesque dune landscape, today it is an unavoidable landmark on the island. The tower, the beacon of which was first lit shortly before sundown on New Year's Day 1875, is a cultural monument of the island community of Nebel, and is open to the public during the six months of summer. The climb up 197 steps to the observation deck is rewarded by a wonderful view over the island landscape. However, the building work, begun in 1873, had to be interrupted after five weeks because there was no granite stone available for the 172 steps of the winding staircase. When the necessary building materials arrived, some of the workers went on strike and flatly refused to set foot on the island which they described as 'bleak'. With the remaining labourers and replacement workers the completion of the brick building was achieved at the end of 1874 with the installation of the 16-lens optic with the accompanying Argand lamp (a lamp with a round wick which reaches a higher burning temperature through a larger supply of oxygen). The whole lens apparatus (height 2.7 metres, weight 2.9 tons) was presented as a technical highlight at the World Trade Fair in Paris. Its estimated worth is today around 5 million euros. Several of the parts enjoy an extremely long operating life. The ball bearings, which carry the complete lens, only needed to be replaced after 118 years. The fire was fed by petroleum before electrification followed in 1936. Up until 1952 the tower was dark red in colour. Only then was it painted in a light red with two white rings. Below the dunes there is a residential building which was inhabited by three lighthouse keepers but, after the automation of the lighthouse in 1984, they were no longer needed. Within three years the Arum Lighthouse was already printed on two special postage stamps.

54°37'52.2"N 008°21'16.5"E | Fl 7.5s | 63m | 23M

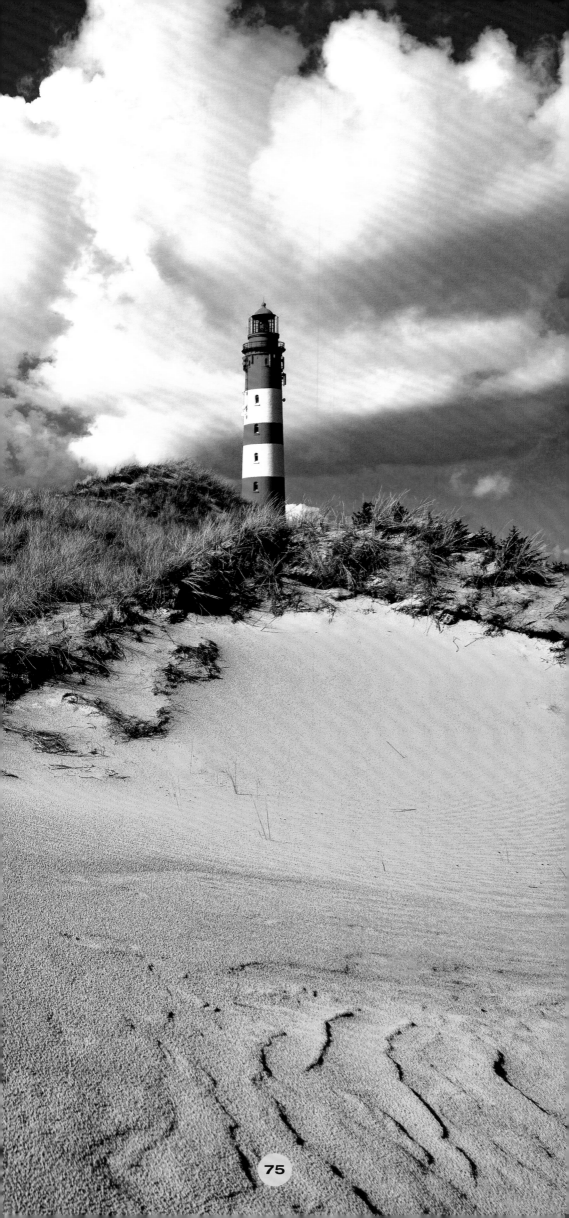

31. Westerheversand Lighthouse (Eiderstedt Peninsula)

In North Friesland (Schleswig-Holstein), in the small town of Westerhever, directly north of the coastal resort of St Peter-Ording, stands Germany's most famous lighthouse; a cross light and beacon. The 40-metre-high tower is situated 100 metres from the embankment on a four-metre-high raised wharf with steel base constructed from 127 thick oak stakes. In clear visibility, it can be seen by the naked eye from Heligoland. The drum lens in the lantern encircles the two vertically placed panels and was put into operation in 1908. The tower itself consists of 608 cast iron plates screwed together – altogether they weigh 130 tons. Until it was replaced in 1975 by a modern 2,000-watt xenon bulb (light intensity: 183,000 candela) a carbon arc lamp (combustion period: 9 hours, requiring changing afterwards) provided the source of light. The lighthouse keepers were accommodated in the two small houses next to the tower before they were let go in 1979 due to technical progress. Since then Westerheversand has been monitored from Tönning via radar. The former keeper's house now hosts a preservation centre for the nature reserve of Wattenmeer. It is possible to take a tour of the maritime building. In July 2007 the 100-year jubilee of the lighting of the lighthouse was celebrated, one year early. In the 1970s the lighthouse also appeared on a 55c special edition of the series of postage stamps. There is a wedding room on the fourth floor of the lighthouse, and one can also sail into the 'Harbour of Marriage'. This requires a 45-minute walk across the historical Stockenstieg bridge through the salt marshes where, in unfavourable weather conditions, the wearing of wellingtons is more advisable than high heels. The upper platform (up 160 steps) offers a fantastic view across the salt marsh landscape, the Eiderstedt Peninsula and the Wattenmeer. In stormy and icy conditions it is not possible to access the outer entrance at the top of the tower. For lighthouse enthusiasts, a trip to the red-and-white striped lighthouse with the black lantern is an absolute must.

54°22'24.1"N 008°38'23.7"E | Oc(3) WRG 15s | 41m | 21-16M

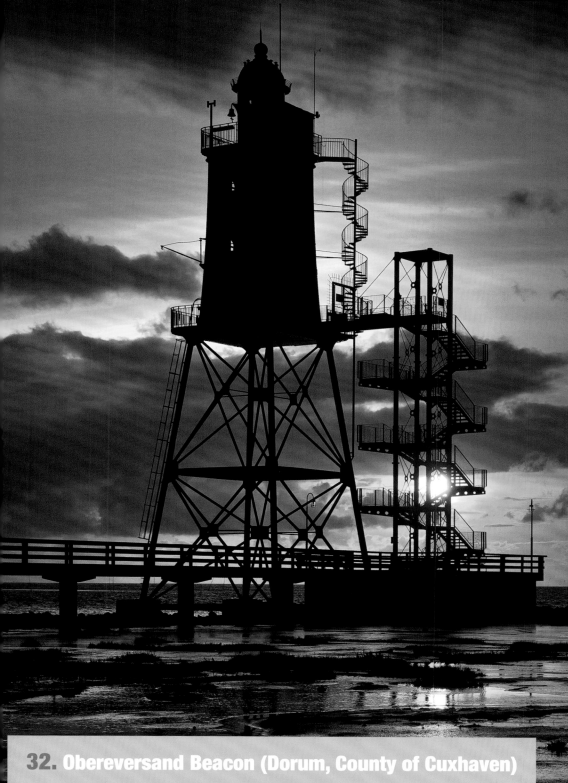

32. Obereversand Beacon (Dorum, County of Cuxhaven)

The rear light of Obereversand was commissioned by the Free Hanseatic city of Bremen and built by Weser plc in 1886/87. From 1887 to 1923 it guided the shipping of Eversand in the area of the Weser estuary through the Wurster branch of outer Weser with a white fixed fire together with the front light. Both lights closed a lighting gap from the sea to Bremerhaven. The main fairway had to be transferred in 1922 to the Fedderward Arm due to sand displacement in the Weser, so the towers became largely redundant. The Obereversand rear light afterwards served as a rescue beacon for shipwrecks and was kept in working order before strong ice drifts damaged the substructure of the inner light. Originally the tower was outfitted with a Fresnel continuous light and catadioptric reflector (reflective lens objective, i.e. the lenses as well as the mirror serve as optical elements). Initially the light was supplied by a petroleum lamp with three wicks, which nevertheless stretched further than 12 nautical miles, before a petroleum lightbulb with a stronger light was introduced in 1905. Today the lighthouse has a 5-watt energy-saving lamp which is controlled by a photocell. In March 2003 there followed the transfer of the rear light from Eversandwatt to Dorum-Neufeld, a small spa town in the county of Cuxhaven. The 37.4-metre-high beacon (in relation to the average low tide) now stands at the end of a pier and functions as harbour beacon for the romantic Dorum Harbour as well as a tourist attraction.

53°44'32.2"N 008°30'48.6"E

The Netherlands

The Netherlands is a parliamentary monarchy and together with Belgium and Luxembourg they form the Benelux countries. The capital of the Netherlands is Amsterdam but the government is based in The Hague. The three Caribbean islands of Bonaire, St Eustatius and Saba, which were occupied in colonial times, also belong to the Dutch territory. The Antilles Islands, Aruba, Curaçao and Sint Maarten have been autonomous countries since 10 October 2010, yet still belong to the Netherlands. The official languages include Dutch, West Friesen (in the province of Friesland), to Papiamentu (on Bonaire) and English (on St Eustatius and Saba).

Almost half of the Netherlands lies less than a metre above sea level and approximately a quarter of the country lies below sea level (including parts of Amsterdam). The dykes, which protect the flat levels from storm tides, are about

3,000 km long. Parts of the Netherlands were forcibly reclaimed by the sea. They are referred to as 'Polder'; on the German North Sea coast they are known as 'Koog'. About a fifth of the country's landmass is actually covered in water, of which the IJsselmeer bay makes up the largest area. The IJsselmeer originated from the previous North Sea Bay, Zuiderzee, which, due to violent storms in 1932, crashed through the 29-km-long end dyke.

On the North Sea coast and also on the banks of the inner seas are many interesting lighthouses. There is a huge variety in styles from small lattice towers to towers built with a cast iron segment and a more than 50-metre-high stone tower. Several architectural periods are represented from the Middle Ages up to the current century. Many lighthouses are surrounded by delightful scenery with abundant flora and fauna.

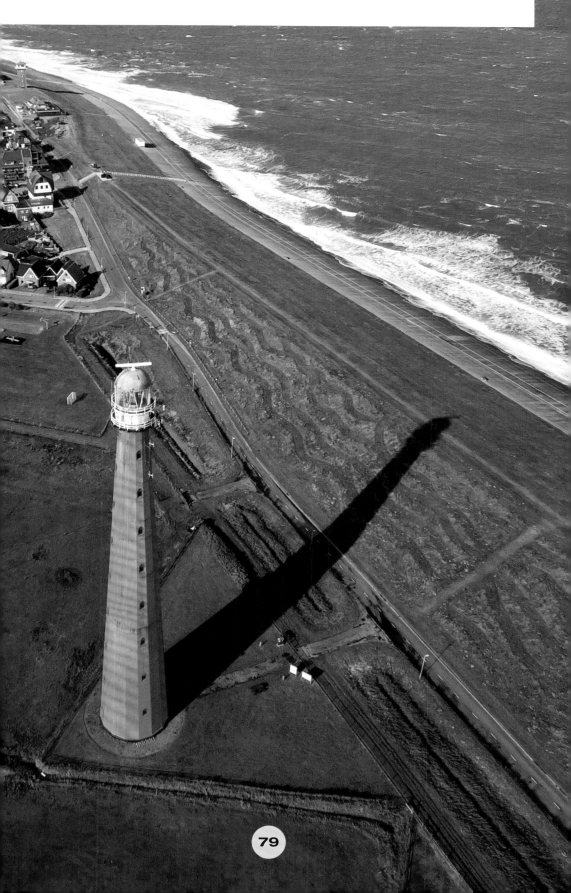

33. Nieuwe Sluis Lighthouse, Breskens

On the North Sea coast of South Holland stands a special attraction: the listed Nieuwe Sluis Lighthouse in the province of Zeeland which, with its white-red-green light, constantly ensured the safety of shipping on the Western Scheldt estuary from 19 January 1868 until the deactivation of the lighthouse on 3 October 2011. With its octagonal ground plan, height of 22.4 m and diameter of between 5–2.3 m, this lighthouse is the southernmost tower in the Netherlands and the only one on the southern side of the Western Scheldt. This tower is the oldest remaining cast iron lighthouse and is only 12 km away from the Belgian border. During its time of operation the Nieuwe Sluis Lighthouse was initially painted yellow, but eventually it received a red and white coat of paint, several times over. During the war the lighthouse was painted in a yellow-green camouflage before it was covered with its current colours (three black and two white rings). From 2014 to 2015 thorough renovation inside and out was undertaken by the Stichting Lighthouses Breskens Association and since then the lighthouse has been open to visitors. For safety reasons children under 4 are excluded because the climb up the snail-shaped staircase is too dangerous. Tourists who reach the top of the lighthouse can enjoy a fantastic view over the North Sea, Vlissingen, Breskens, Nieuwvliet and the Polder. On the lower landings of the lighthouse, interesting exhibits such as navigation light showpieces, compasses, miniature lighthouses and other maritime accessories can be seen. The well known Dutch lighthouse architect, Quirinus Harder, was responsible for the building and design of the lighthouse in 1866/67. The lighthouse is approximately 3 km southwest of Breskens, near the farming community of Nieuwe Sluis.

51°24'24.9"N 03°31'16.8"E | 28.4m | Deactivated in 2011

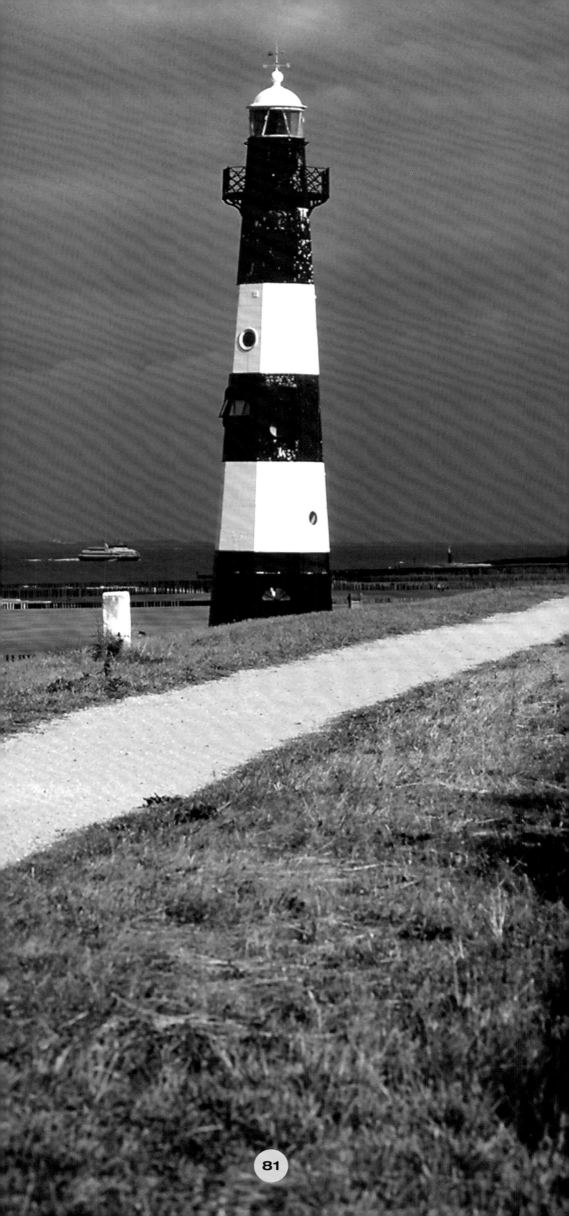

34. Noordwijk on Sea Lighthouse

The Dutch municipality of Noordwijk on Sea in the province of South Holland has been a popular seaside resort for 150 years. Due to its many tulip fields, Noordwijk is also internationally known as the Floral Seaside Resort. It is distinguished by a 13-km-long sand beach and a large area of dunes. Around 20 minutes away by car lies the Keukenhof, a world famous flower park where, especially in spring, visitors can delight in the purest blaze of colour from the different varieties of flowers. Noordwijk has, however, a further highlight to offer which tourists and, above all, lighthouse fans can delight in. This is the pure white lighthouse which was erected on Lighthouse Place on the Wilhelmina Boulevard in 1922. Since then it has been regarded, with its glass dome fitted lighthouse (unique in pharological terms), as a trademark of the seaside town of Noordwijk and was proclaimed a national monument in 1980. The tower has six floors and 108 steps and was built with brick and reinforced concrete. It is not possible to climb the sea beacon, but it is well worth the walk to the lighthouse. In addition, the lighthouse is a very popular photo subject.

52°14'55.0"N 04°26'02.3"E |
Oc(3) 20s | 33m | 18M

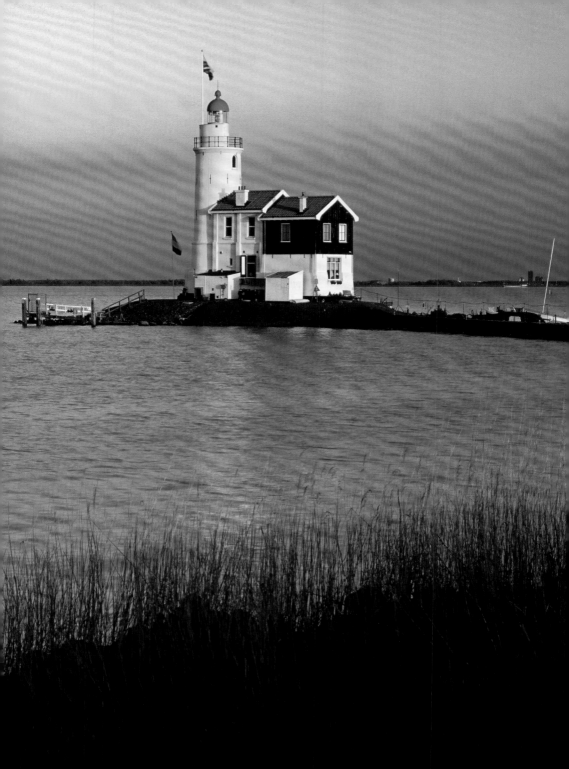

35. Marken Lighthouse (Markermeer, North Holland Province)

The foundation stone of today's round, white, 16-metre-high lighthouse on the promontory of Marken Island was laid in June 1839. Within only five months the new lighthouse was completed on its pillar foundation so that the beacon could be lit for the first time in November 1839. Firstly it used a white fixed fire, but with the purpose of providing a better distinction from the neighbouring fires, this was changed to a flashing light in 1890. After the current lantern housing was placed on the tower in 1901, the identification as uninterrupted light (5 seconds light, 5 seconds darkness) was retained. In December 1884 a fog bell was installed, to be replaced in 1919 by a fog horn. In order to produce the necessary pressurised air for the fog horn, a machine house had to be added for the compressor. Some time later the building was extended with an extra living accommodation for the lighthouse keeper. Through the addition of this low extension a silhouette was created which led to the nickname 'The Horse Of Marken'. Two years later followed the conversion to gaslight, which initially caused children's diseases, and the lighthouse was classified as unreliable. However, the problems were solved with the result that the lighthouse is still in operation today. In 1986 the tower was shifted several centimetres by ice masses forcing their way under the foundations. A similar situation had also occurred in winter 1971. It is not possible to view the lighthouse internally because it is inhabited.

52°27'36"N 05°08'20"E | Oc 8s | 16m | 9M

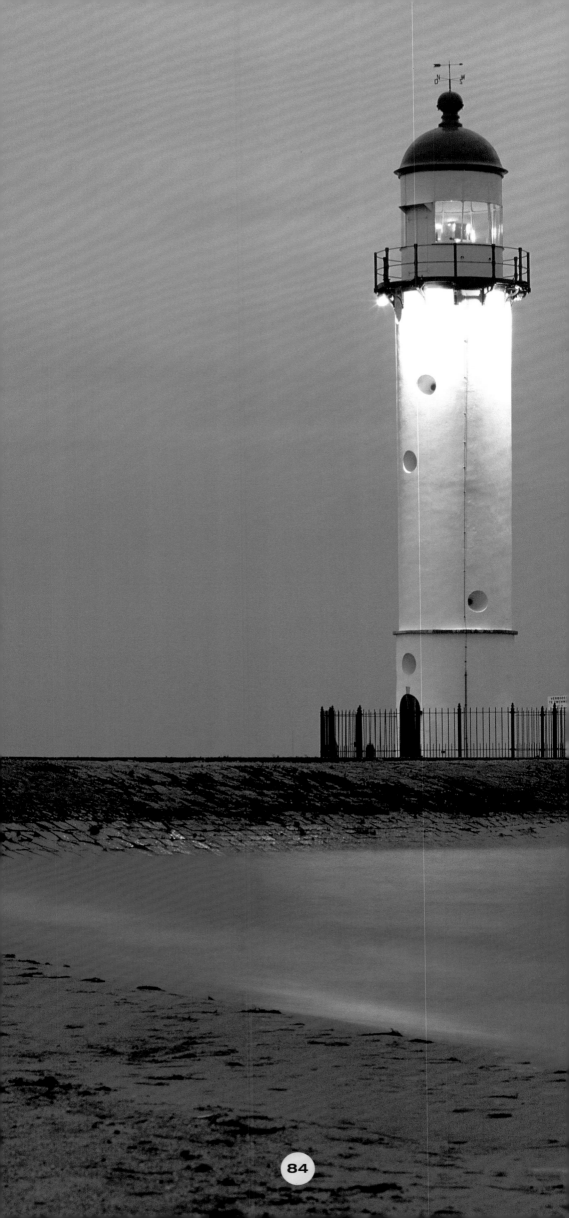

36. Hellevoetsluis Lighthouse (Haringvliet, South Holland Province)

The 18-metre-high round lighthouse, standing out in a brilliant white, stands at the western entrance to the canal across Voorne Island. The tower, which has been in operation since the year 1822, secures the way for incoming sailors to the narrow yacht harbour of Hellevoetsluis. The tower, built of brick and tiles, was originally equipped with a lantern in which two Argand lamps with parabol reflectors burned. Thirty-three years later the technology in the lantern was brought up to date when a fourth order lens was installed. In order to minimise the increased risk for the seafarer caused by sandbanks in Haringvliet, an extra red sector light was added. During a general overhaul of the tower, the beacon was deactivated from October 1901 for four months. The lantern acquired a modern third order lens and the building itself a coat of green paint. Previously it was white with a black stripe under the light. After electrification in 1933 the identification of fixed fire changed to synchronised mode and was completed with a green sector light. After the beacon was deactivated during the Second World War it was re-commissioned in 1953. The decorative lighthouse, which is well worth seeing, is also lit up by spotlights and is a highlight among lighthouses. On the other side of the canal estuary lies the light vessel *Noord Hinder*, which today operates as a museum ship.

51°49'11"N 004°07'42"E | Iso WRG 10s | 17m | 11-7M

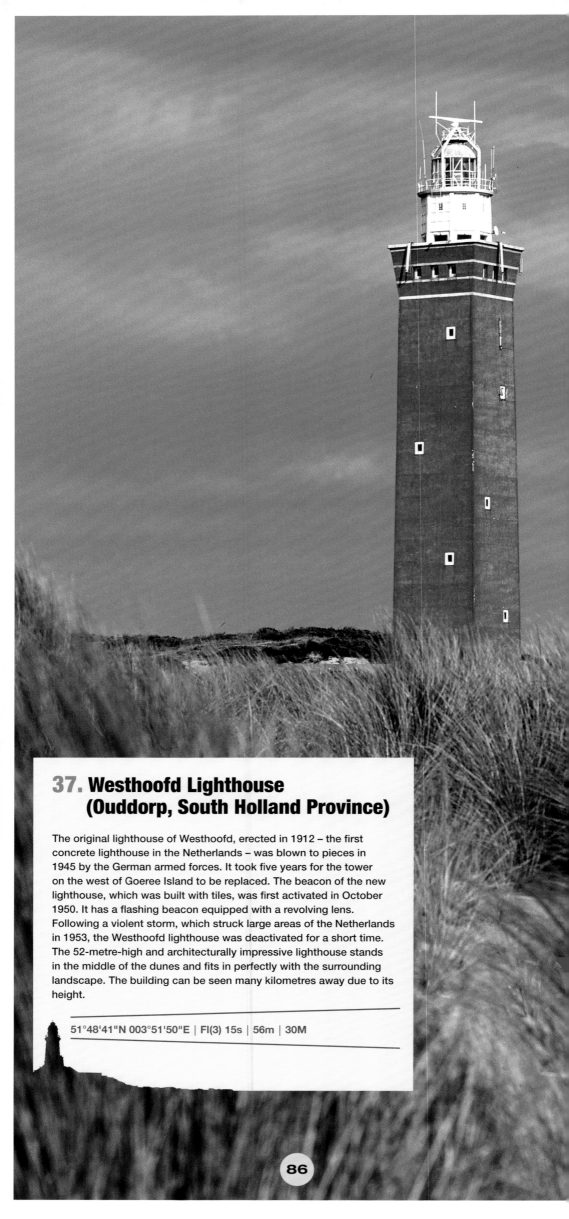

37. Westhoofd Lighthouse (Ouddorp, South Holland Province)

The original lighthouse of Westhoofd, erected in 1912 – the first concrete lighthouse in the Netherlands – was blown to pieces in 1945 by the German armed forces. It took five years for the tower on the west of Goeree Island to be replaced. The beacon of the new lighthouse, which was built with tiles, was first activated in October 1950. It has a flashing beacon equipped with a revolving lens. Following a violent storm, which struck large areas of the Netherlands in 1953, the Westhoofd lighthouse was deactivated for a short time. The 52-metre-high and architecturally impressive lighthouse stands in the middle of the dunes and fits in perfectly with the surrounding landscape. The building can be seen many kilometres away due to its height.

51°48'41"N 003°51'50"E | Fl(3) 15s | 56m | 30M

38. Westerlichttoren Lighthouse (Westerschouwen, Zeeland)

Due to its striking red and white paint this 50-metre-high lighthouse looks like a huge, colourful lollipop. The beacon, completed in 1840, is situated about six kilometres away from Haamstede, a health resort on the island of Schouwen-Duiveland. The beacon was originally equipped with an Argand lamp which was fuelled by burning oil. The first order lens, outfitted with 8 x 2 lens panels, was at that time the strongest light in the Netherlands. As a result of the light-and-dark phases lasting too long the lens was exchanged in 1882 so that the revolution time of the lens was reduced from twelve to three minutes. Before the light was converted to electricity in 1934, it was equipped with an incandescent light burner in order to strengthen the light source. Through electrification the return time was reduced to 15 seconds and the light strengthened so much that the navigational support of the Schouwen Bank light vessels was no longer necessary for maritime navigation. The Westerlichttoren lighthouse received its current identification with a new lens in 1953. Due to the progress of modern technology a complete overhaul of the lantern house was necessary in 1979. A radar antenna was installed on the new lantern house, and the old one was placed at the disposal of the harbour master of Burghsluis as an administration office. As well as this architectural treat, a beautiful dune and beach landscape also awaits visitors to the West Beach of Westerschouwen.

51°42'31"N 03°41'31"E | Fl(2+1) 15s | 58m | 30M

Belgium

Belgium, with its population of around 11.3 million (as of 2016), is a federal state in western Europe bordered by the North Sea and neighbouring the Netherlands, Germany, Luxembourg and France. Brussels is the capital and at the same time the seat of the Belgian royal family. In the north of the country (the Dutch-speaking region) are the Flemish population, while the Walloons live in south Belgium, the French-speaking region. In east Belgium there is also a German-speaking region where Standard and West German dialects are prevalent. With around 370 inhabitants per square kilometre, Belgium counts among the most densely populated countries in Europe.

Belgium is a founder member of the European Union, which has its headquarters in Brussels. Furthermore, Belgium is in the economic union of Benelux with the

Netherlands and Luxembourg. The Flemish-Walloon conflict, which has lasted since the nineteenth century, characterises the opposing interests in Belgian politics. The Flemish region comprises Antwerp, Limburg, East Flanders, Flemish Brabant and West Flanders, while the Walloon region consists of Hainaut, Liège, Luxembourg, Namur and Walloon Brabant.

The 70-kilometre-long North Sea coast is situated in the province of West Flanders. There, next to several beacons and directional lights, stand four lighthouses at Knokke-Heist, Blankenberge, Ostend and Nieuwpoort. What makes the Belgian North Sea coast special is that a 68-km-long tram connection (the Kusttram) runs along the coast from the Dutch border near Knokke in the north down to the French border near La Panne in the south. Both lighthouses in Ostend and in Nieuwpoort are beautiful towers worth a journey for lighthouse enthusiasts.

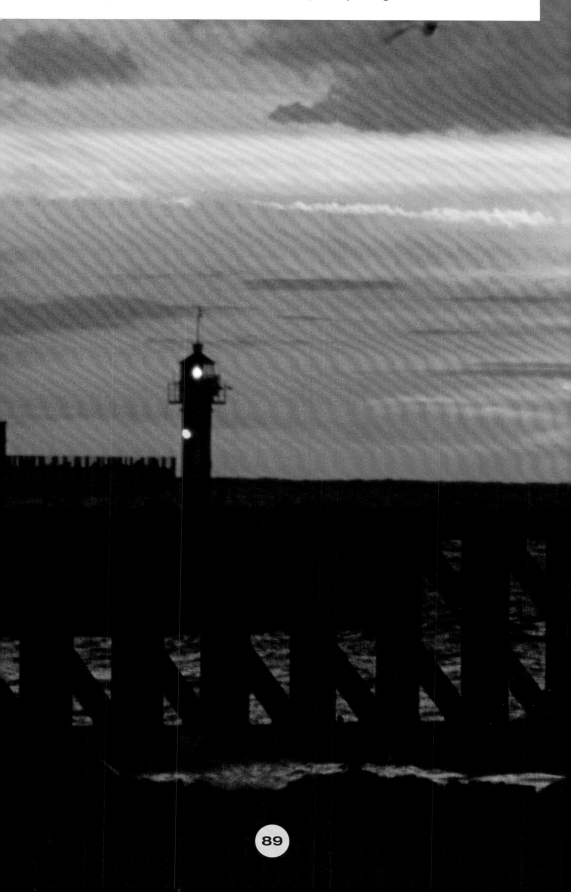

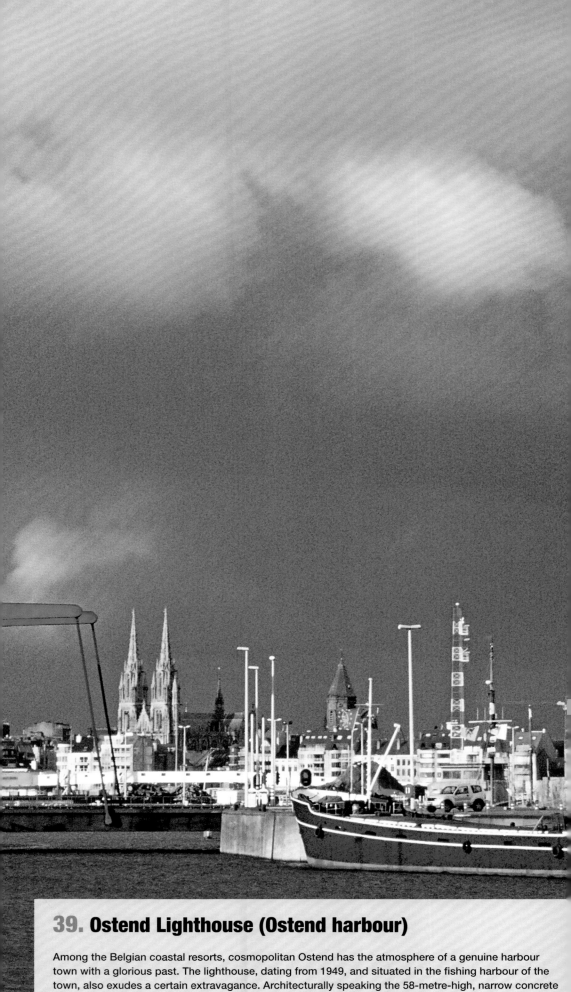

39. Ostend Lighthouse (Ostend harbour)

Among the Belgian coastal resorts, cosmopolitan Ostend has the atmosphere of a genuine harbour town with a glorious past. The lighthouse, dating from 1949, and situated in the fishing harbour of the town, also exudes a certain extravagance. Architecturally speaking the 58-metre-high, narrow concrete tower is often compared to a Doric column. After having been left as bare grey concrete for 45 years it acquired a new, unusual but just as fitting coat of paint in 1994. With the wave-like design and colour combination of white, blue and yellow the lighthouse, equipped with a revolving optic lens, is described

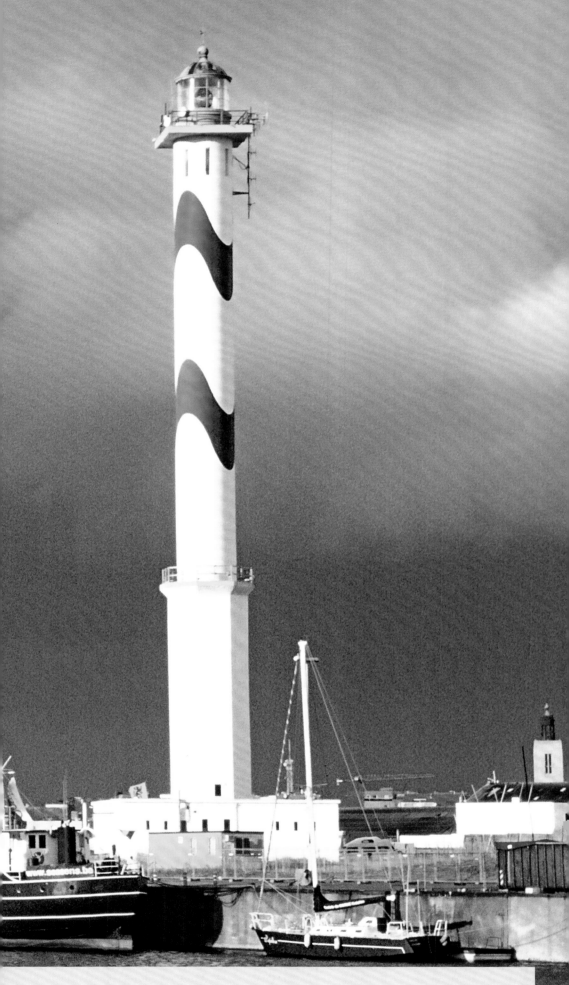

by many lighthouse experts as a rarity. The Morse Code identification the light sends out is the letter O (three flashes) for Ostend. The lighthouse is recognisable from a great distance and indicates the location of the ferry port and the fishing harbour. It was immortalised on a series of stamps which came into circulation in 2006. Apart from the 'Lange Nelle', as the unique tower is lovingly named, Ostend also has a pier beacon light built on stilts, which affords ships safe entry into the harbour. The Kusttram (coastal tram) halts at several stops in Ostend.

51°14'10.2"N 002°55'49.4"E | Fl(3) 10s | 65m | 27M

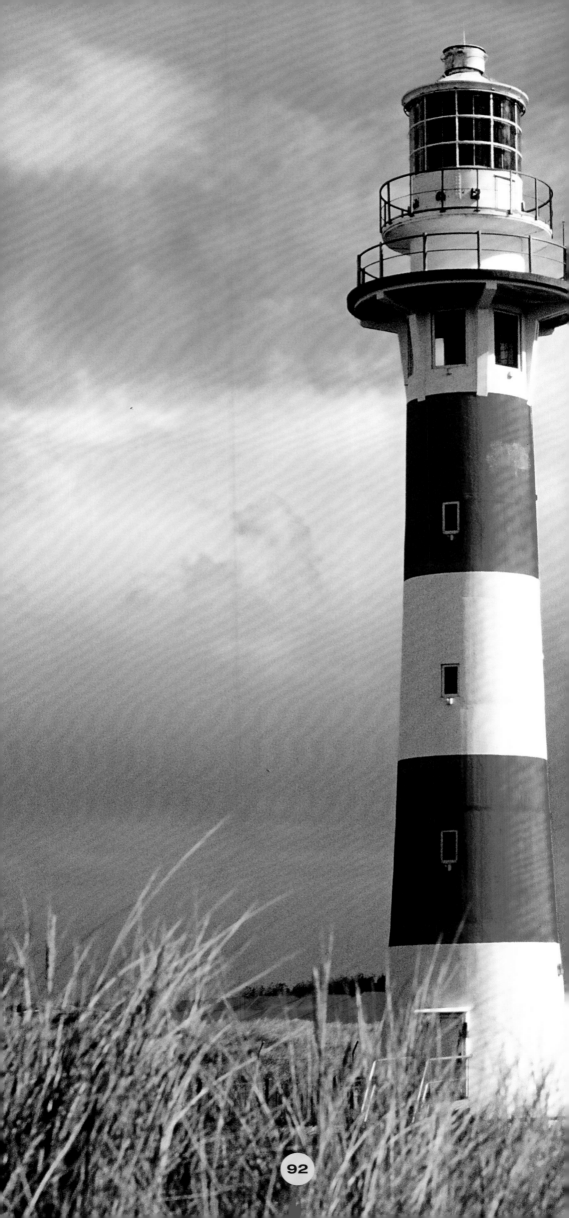

40. Nieuwpoort Lighthouse (IJzer estuary, North Sea)

Nieuwpoort Lighthouse, built in 1949 and Belgium's most southerly lighthouse, is situated on the eastern side of the IJzer estuary, approximately 16 kilometres from the French border. The red and white tower is the only lighthouse in Belgium which stands in a natural landscape and which has a red light. It received the maritime coat of paint in 1953. To visit the lighthouse a two-kilometre-long trip by foot or bike is necessary. Next to the classically-ringed lighthouse, which was immortalised on a stamp in 2006, are two further breakwater beacons (built on stilts). The eastern breakwater beacon can only be reached on foot or by bicycle.

51°09'17.0"N 002°43'47.2"E | Fl(2) R 14s | 28m | 6M

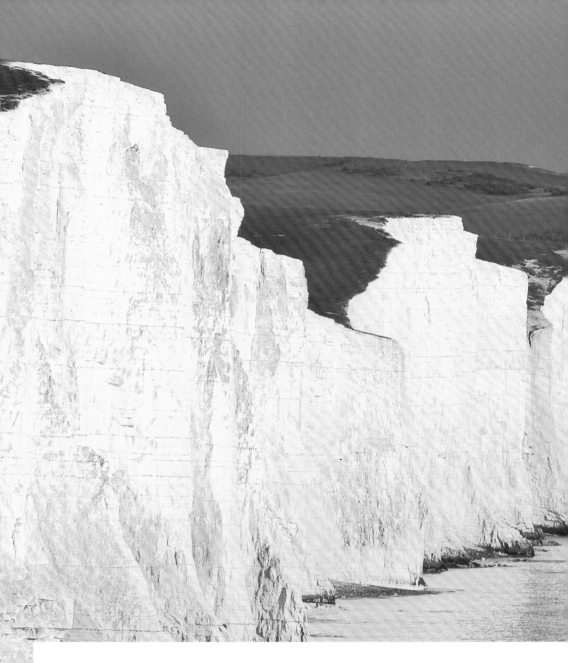

England & Scotland

England is situated in north-west Europe and covers the largest part of southern Great Britain. In the north the country borders Scotland and in the west Wales and the Irish Sea. In the east, England borders on the North Sea, in the south the English Channel and in the southwest the Atlantic Ocean. The landscape consists of extensive coastline as well as lowlands and pleasing valleys which are threaded through mountain ranges. The English coastal landscapes provide breathtaking scenery, such as Seven Sisters on the English Channel coast, the rocky coasts of Land's End on the Atlantic, and Holy Island and Farne Islands on the North Sea coast. From an architectural perspective the English coast has a number of very

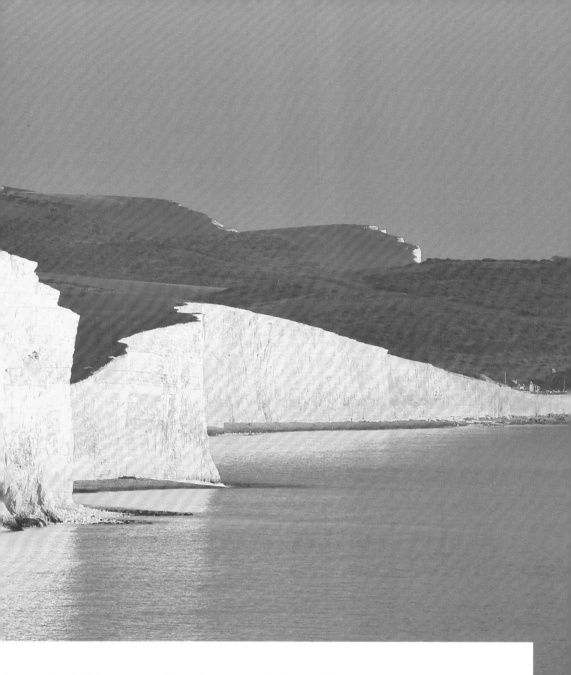

interesting lighthouses such as the very well-situated lighthouse at Beachy Head on the chalk cliffs of the South Coast near the South Downs in Sussex. England lies in a moderate climate zone that has, due to the Gulf Stream, a rather damp but mild climate. Because both warm tropical air and cold polar air simultaneously blow through the country, changeable weather predominates – providing great variety for photographers.

With over 53 million inhabitants England is by far the most populated part of the United Kingdom. London, the capital and centre of finance, has over 8.7 million inhabitants, with the metropolitan region of Greater London home to 13.8 million. The country consists of 39 counties which have existed since the Middle Ages. Since the middle of the twentieth century, the administration districts have been altered many times, but the historical counties continue to dominate. The larger towns operate independently as boroughs.

41. Lizard Lighthouse (The Atlantic, Cornwall)

The Lizard Lighthouse is situated in Cornwall and stands on Lizard Point, the southernmost part of England, on a steep coast facing the Atlantic. As well as nightly guidance for ships which come and go through the English Channel, it serves as a land marker during the day. The Trinity House Lighthouse Service is responsible for the operation and maintenance of the 19-metre-high lighthouse. The Maritime and Coastguard Agency is commissioned with the maintenance of lighthouses and other shipping beacons in the UK. The first tower on this point was erected thanks to the private initiative of Sir John Killygrew in 1619. The financing of this lighthouse, which operated with open light, was supposed to be paid by duties from passing ships. However, this plan did not come to fruition as the shipowners did not want to pay. So, the lighthouse was deactivated a short time later with the patent issued by Trinity House being withdrawn because Sir John Killigrew was unable to cover the costs of maintenance by himself. Today's lighthouse was built according to the plans of the British businessman and politician, Thomas Fonnereau, in 1752. The lighthouse installation consists of two octagonal towers and a building in between, on which today two large fog horns are placed. The optic is comprised of a metal halogen lamp with a four-surfaced first order spotlight. The lantern was placed on the east tower, while the light on the west tower was deactivated in 1904. Administration of the lighthouse was taken over by the Trinity House Lighthouse Service in 1771, and in 1903 the east tower was converted to electrical power. Both constant lights were changed for a flashing light. Automation followed in 1998. In 2009 a visitors' centre was opened, in which lighthouse fans can admire machinery from earlier periods and visitors can discover the fascinating history of this beautiful lighthouse installation. The lighthouse can be reached by car from Lizard village, or by hikers along the South West Coast Path directly along the cliff.

49°57'36.7"N 005°12'8"E | Fl 3s | 70m | 26M

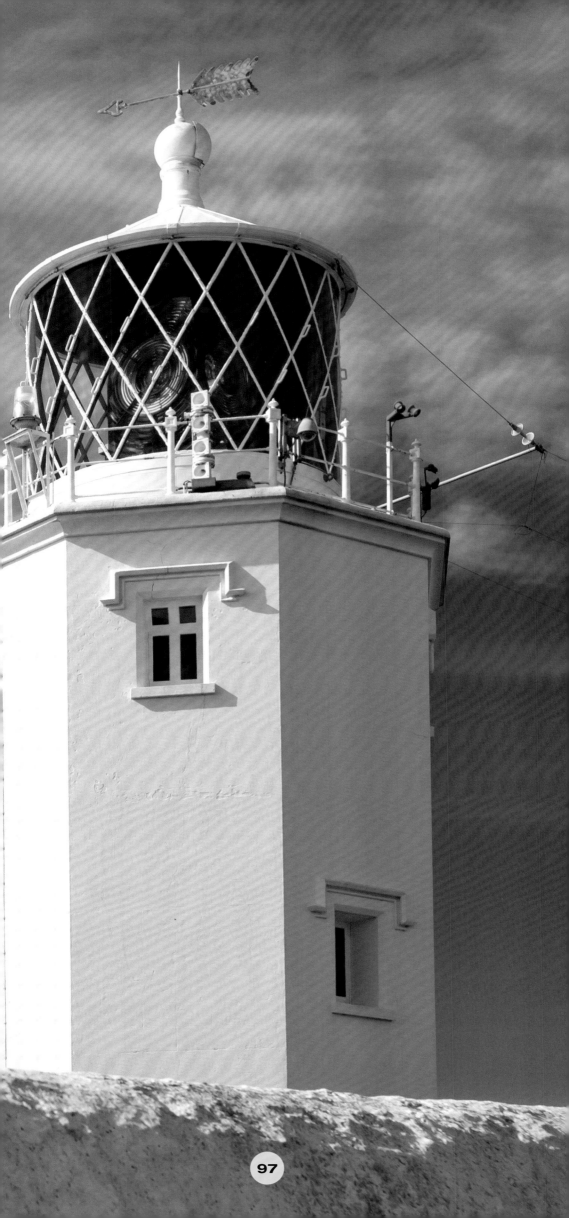

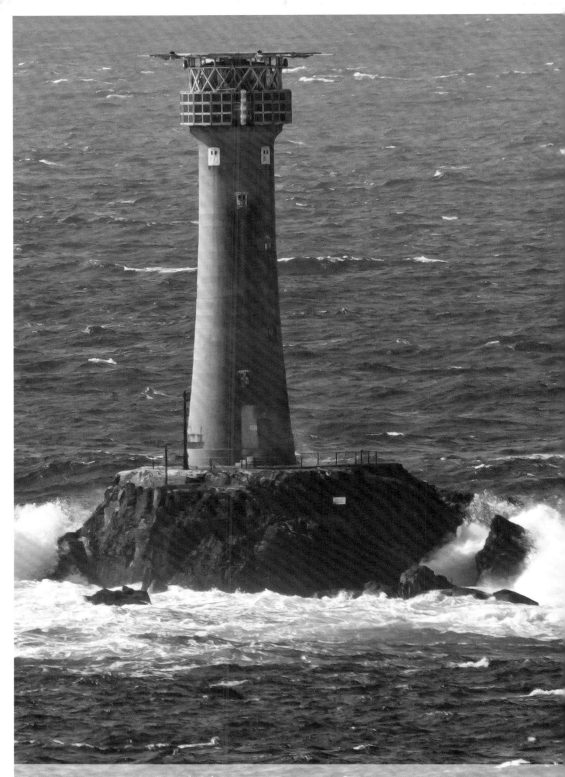

42. Longships Lighthouse (off Land's End, The Atlantic)

Longships Lighthouse is an offshore lighthouse, which stands approximately two kilometres off the coast of Land's End in Cornwall. It was built in its current style in 1875. The original tower, Wolf Rock Lighthouse, was built according to the plans of the architect Samuel Wyatt, a staff member of Trinity House. At that time the lighthouse stood 24 m above sea level. In very high seas this turned out to be too low and the light needed for shipping navigation was obscured. The building of a higher offshore lighthouse began in 1869. The light of today's lighthouse has a height of 35 m and stands on Carn Bras, one of the Longship Islands. The small island protrudes 12 m above sea level. The offshore lighthouse was automated in 1988 and has been unmanned since then. It has a conical, cylindrical granite tower with a lantern from which the light source gives out a comfortable range of 11 nm (approximately 20 km). On the upper side of the unpainted tower is a helicopter landing pad. The architect James Nicholas Douglass was responsible for the building of the new lighthouse. In 1898, in spite of the technical improvements of the new offshore lighthouse, the SS *Blue Jacket* sank having run into a rocky subsurface nearby, in spite of it being a clear night. The lighthouse itself only very narrowly escaped damage from the shipwreck. The colours of the lights are steered by the sectors. The red sector lights warn skippers of shallows on Cape Cornwall directly north, and at Gwennap Head to the south-east. In the instance of incoming fog, the fog horns emit a signal every 10 seconds.

50°04'0.69"N 005°44'48.39"W | Iso WR 10s | 35m | 11M

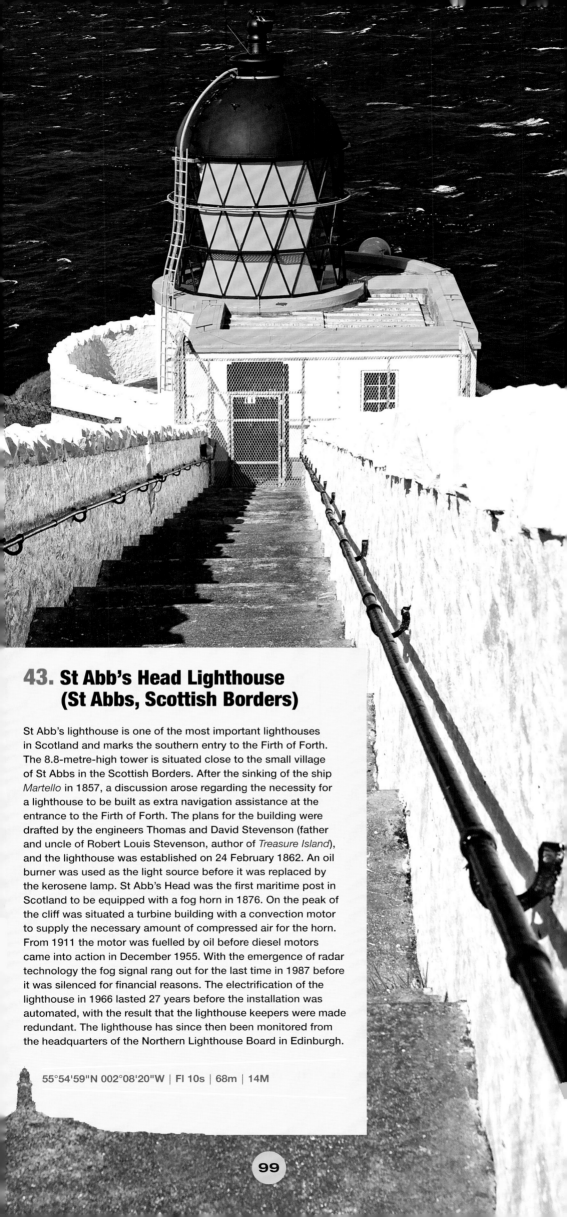

43. St Abb's Head Lighthouse (St Abbs, Scottish Borders)

St Abb's lighthouse is one of the most important lighthouses in Scotland and marks the southern entry to the Firth of Forth. The 8.8-metre-high tower is situated close to the small village of St Abbs in the Scottish Borders. After the sinking of the ship *Martello* in 1857, a discussion arose regarding the necessity for a lighthouse to be built as extra navigation assistance at the entrance to the Firth of Forth. The plans for the building were drafted by the engineers Thomas and David Stevenson (father and uncle of Robert Louis Stevenson, author of *Treasure Island*), and the lighthouse was established on 24 February 1862. An oil burner was used as the light source before it was replaced by the kerosene lamp. St Abb's Head was the first maritime post in Scotland to be equipped with a fog horn in 1876. On the peak of the cliff was situated a turbine building with a convection motor to supply the necessary amount of compressed air for the horn. From 1911 the motor was fuelled by oil before diesel motors came into action in December 1955. With the emergence of radar technology the fog signal rang out for the last time in 1987 before it was silenced for financial reasons. The electrification of the lighthouse in 1966 lasted 27 years before the installation was automated, with the result that the lighthouse keepers were made redundant. The lighthouse has since then been monitored from the headquarters of the Northern Lighthouse Board in Edinburgh.

55°54'59"N 002°08'20"W | Fl 10s | 68m | 14M

44. South Foreland Lighthouse (Dover, English Channel)

The Victorian lighthouse at South Foreland stands on the White Cliffs of Dover and was the first electrically-powered lighthouse and the site of the first radio signal transmission. It was commissioned in 1899 by the Italian radio pioneer and company founder of the Wireless Telegraph & Signal Company, Guglielmo Marconi. The exact location of the lighthouse is the western edge of St Margaret's Bay. The white lighthouse was built in 1843 in order to securely guide shipping traffic through the Straits of Dover. The town of Dover in Kent has arguably the most important harbour in England and lies on the narrowest part of the English Channel between Great Britain and France. The lighthouse has been out of action since 1988 and is now a museum. At the foot of the lighthouse are two former lighthouse keeper's houses. Today they house, among other things, a tea shop where it is possible to fortify oneself with delicious English cream teas. The café has a quaint 1950s ambience with its patterned wallpaper and old china teacups on the shelves. Inside the lighthouse it is possible to discover more about the life and daily routine of the former lighthouse keepers. The lighthouse, from an architectural perspective well worth seeing, can be reached from the White Cliffs of Dover visitors' centre three kilometres away, across the North Downs Way. This approach is the most rewarding. The lighthouse is open to visitors from mid-March to October for a small entry fee. The effort of climbing the 76 steps up to the top of the lighthouse is rewarded by a breathtaking view over the English Channel towards France.

51°14'04.0"N 001°37'11.0"E | 21m | Signal deactivated in 1988

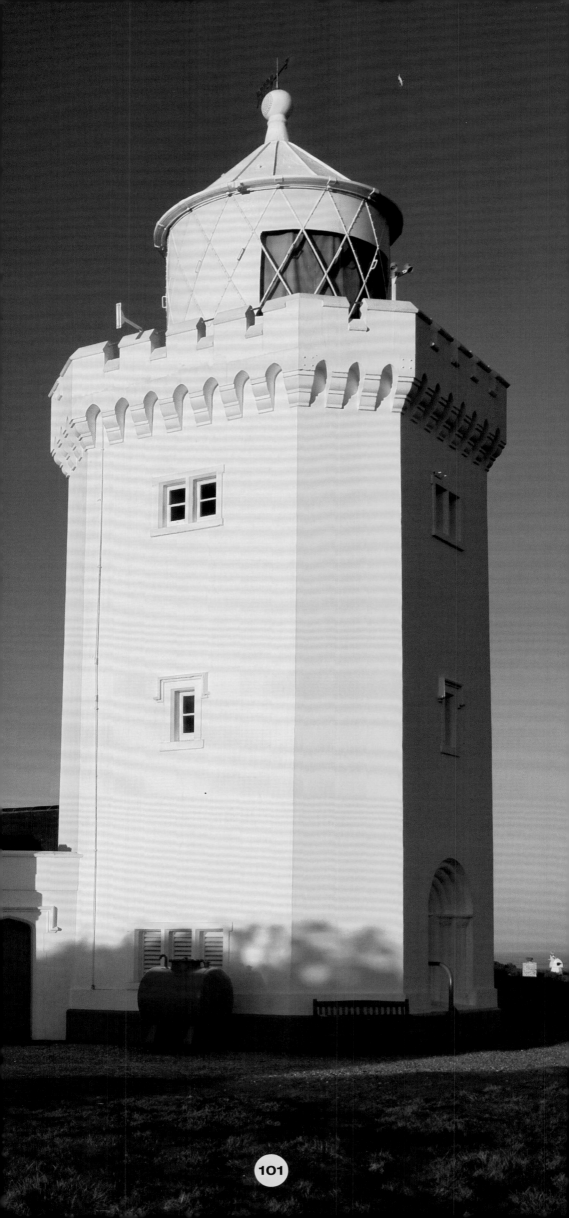

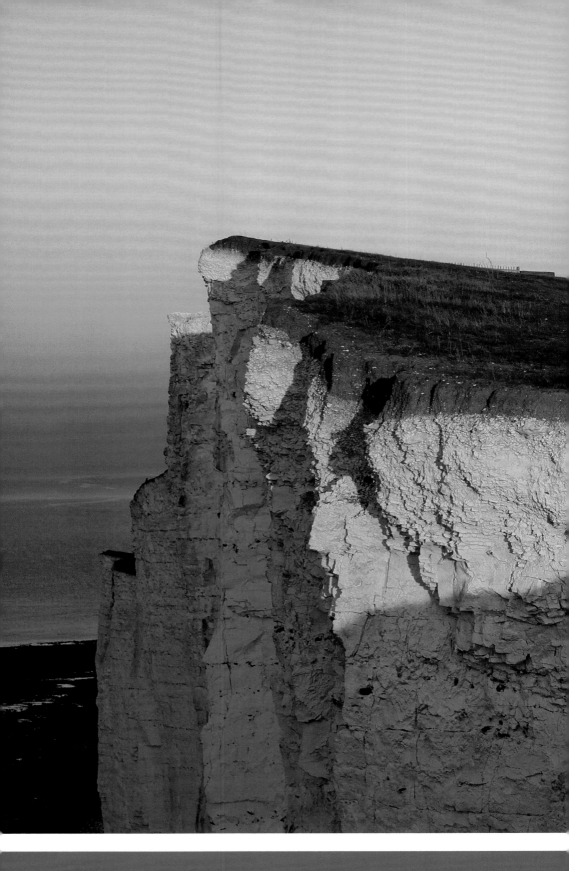

Beachy Head & Belle Tout Lighthouses
(Eastbourne, English Channel)

The chalk cliff landscape at Beachy Head, near the harbour town of Eastbourne in Sussex, with its 162-metre-high cliffs, boasts breathtaking and mystical scenery. The chalk cliff is part of the South Downs and, with its imposing height, the highest cliff in Great Britain. It is connected to a further seven chalk cliffs known as the Seven Sisters. The name Beachy Head derives from the French word 'beauchef', or rather 'beauchief', which translated into English means beautiful cape – and not as one might guess from the English 'beach'. Beachy Head has been so named since 1724. Thanks to its prominence and colour in good visibility, this wonderful chalk coast is a very important landmark for ships on the English Channel. In poor conditions, however, the off-lying reefs present a danger for shipping, so the building of the Belle Tout Lighthouse, on the headland, was begun in 1831. The lighthouse was completed in 1834, but was closed 68 years later in 1902 because the beacon was barely visible in mist or fog.

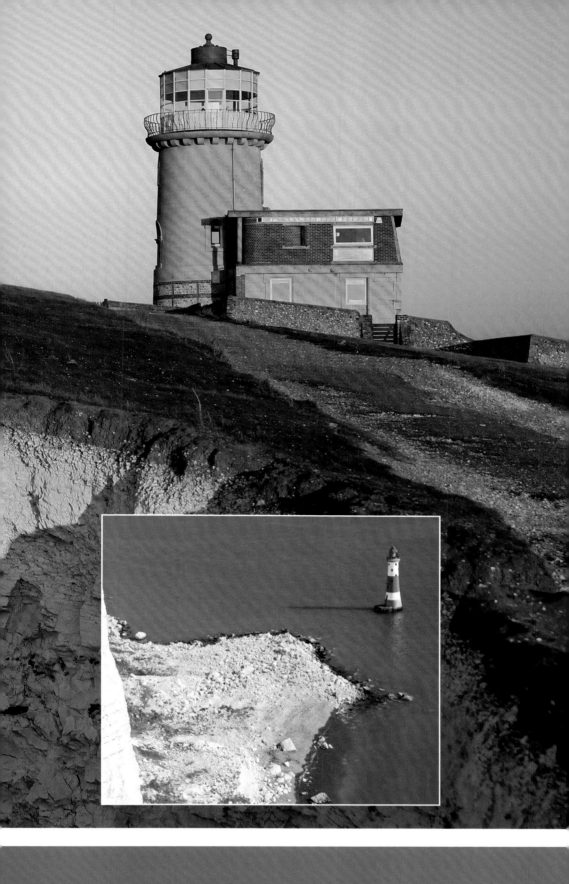

As a result a new lighthouse – Beachy Head – was built, completed in the same year, 1902. It was positioned in the sea directly next to the cliffs at Beachy Head. For the building of the red and white striped, 43-metre-high lighthouse, a cable car to transport building materials and the workers to the iron platform next to the lighthouse was required. Since its deactivation, the Belle Tout Lighthouse, situated two kilometres away from the new lighthouse, has been privately owned. Due to the continuing erosion of the cliffs in 1999 the old lighthouse was moved 17 metres inland as an emergency measure. Both lighthouses and the magnificent coastal landscape are a popular tourist attraction, especially in summer.

50°44'15"N 000°14'52"E | Fl(2) 20s | 31m | 26M (Beachy Head Lighthouse)

46. Barns Ness Lighthouse (Dunbar, East Lothian)

The white round tower of the Barns Ness Lighthouse is situated approximately five kilometres from the town of Dunbar in East Lothian. The 37-metre-high lighthouse is, like most of the towers in Scotland, characterised by the building style of the Stevenson family of architects which, across several generations, were responsible for the planning and building of maritime beacons. Because the lighthouses were deployed on remote sections of the coast, the Stevensons made huge efforts to place the navigational aids for seafarers in strategic locations. The design engineer David A Stevenson was in charge of the building of the Barns Ness lighthouse 1899–1901 with the lighthouse activated in October 1901. During the Second World War the building material (white chalk sandstone from Craigie near Cramond, Edinburgh) proved to be very robust: in spite of intensive bombardment in the vicinity the tower received absolutely no damage. Up until its electrification in 1966 the building was occupied by two lighthouse keepers. Until its complete automation in 1986 the tower was still only occupied by one caretaker because the light had been converted to half-automatic operation. In October 2005, the light was deactivated permanently.

55°59'14"N 002°26'4"W | 36m | Signal deactivated in 2005

47. Anstruther Harbour Lighthouse (Fife, Firth of Forth)

The romantic harbour of Anstruther in the county of Fife has two lighthouses. The old, octagonally-built and largely white-painted lighthouse is 9 metres high and stands on the peak of the harbour pier. It was built in 1880, has a black-painted lantern housing with a white point and had the task of guiding sailors from the entrance to the Firth of Forth safely into the harbour of Anstruther. The building of this lighthouse was dedicated to the writer and founder of the Free Church of Scotland, Dr Thomas Chalmers (1780–1847). The flare of the prominent breakwater beacon was deactivated and replaced by a 6-metre-high improvised beacon (signal height: 7 metres). The small, unprepossessing and corroded steel beacon stands on top of the opposite east beacon at the entry to the harbour of Anstruther. The new tower captivates with its very simple and sensible construction. Neither the reasons for nor the time of the deactivation of the architecturally-interesting old lighthouse are known. Today a small, decorative but nautically insignificant light glows from the lantern. During the summer season, along with the fishing craft and excursion boats, holidaymakers and motor and sailing yachts head for the Isle of May.

56°13'18"N 002°41'30"W | 9m | Beacon deactivated

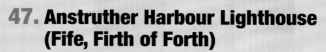

48. Scurdie Ness Lighthouse (Montrose, Angus)

Scurdie Ness is a headland on the southern side of the estuary of the South Esk river near Montrose in Angus. There stands the white lighthouse of the same name with its black-painted lantern gallery. The lighthouse is also commonly referred to as Montroseness Lighthouse. After authorisation the two well-known lighthouse engineers Thomas and David Stevenson took over the supervision of the building of the lighthouse, which was activated in 1870. The 38-metre-high tower can be comfortably reached from the small village of Ferryden on the south side of the South Esk river along an approximately two-kilometre-long footpath.

56°42'06"N 002°26'14"W | Fl(3) 20s | 39m | 23M

49. Kyleakin Lighthouse (Eilean Bán, Loch Alsh)

The lighthouse engineers Thomas and David Stevenson were also given the assignment to build the Kyleakin Lighthouse on the small island of Eilean Bán in Loch Alsh and supervised its construction up to the activation of the beacon in the year 1857. Loch Alsh is an inlet in the Hebrides which separates the Isle of Skye from the Scottish mainland. The lighthouse had the task of protecting the traffic between the Isle of Skye and the village of Kyle of Lochalsh. In 1995 the Skye Road Bridge was opened, which connected the Kyle of Lochalsh to the Scottish mainland and Kyleakin, where the ferry once left for the Isle of Skye. The opening of this connection hit Kyleakin particularly hard – the most important ferry port on the island changed into a sleepy nest. Due to the building of the bridge and the cessation of the ferry traffic, the Kyleakin Lighthouse beacon was deactivated in 1993. The island of Eilean Bán is now under a conservation order.

57°16'40"N 005°44'33"W | Lighthouse deactivated in 1993

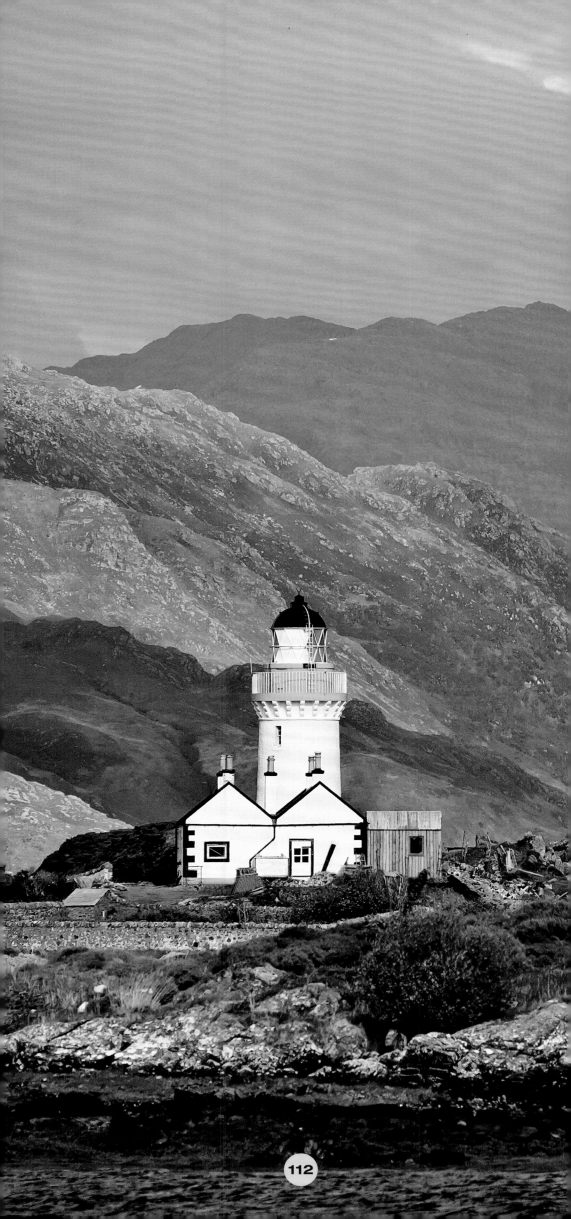

50. Ornsay Lighthouse (Eilean Sionnach, Sound of Sleat)

The small island of Ornsay lies in the Sound of Sleat in front of the large Hebridean island of Skye. On Eilean Sionnach, an upstream island off Ornsay Island, stands the 19-metre-high lighthouse which was erected in 1857 under the leadership of lighthouse architects, Thomas and David Stevenson. Automation followed in 1962. The tower's lantern is equipped with an acrylic lens. A 250-watt Wolfram bulb provides the necessary light in order to achieve the required range. However, in case of breakdown of the main light, an emergency light (60-watt bulb) installed in the lantern provides for a range of at least another ten nautical miles. The main light only functions when a mains power supply is available. Otherwise the emergency lighting, which is powered by a large battery, switches on (it has capacity for 14 days). Holidaymakers taking the journey northwards on the Isle of Skye get to see the Ornsay lighthouse on the right hand side after about 15 kilometres. The small lighthouse can – as long as one has a telephoto lens – be photographed, together with the Glenmore Mountain in the background, from a by-road.

57°08'36"N 005°46'24"W | Oc 8s | 18m | 15M

51. Lismore Island Lighthouse (Eilean Musdile, Sound of Mull)

The small and uninhabited island of Eilean Musdile is situated on the south-west point of the island of Lismore at the eastern end of the Sound of Mull. The brilliant white 26-metre-high lighthouse, with an ochre-coloured ring around the gallery, was erected in 1833 in order to secure shipping on a difficult and demanding route at the southeastern entrance to the Sound of Mull, the southwestern entry of Loch Linnhe and at the northern entry to the Firth of Lorn. In order to make the building of the lighthouse possible, Eilean Musdile was bought in January 1830 from its previous owner, Charles Campbell, for the price of £500. The Scottish architect, Robert Stevenson, was commissioned to plan the construction of the lighthouse, while the building contractor, James Smith from Inverness, was responsible for the building work. The total building costs ran to £4,260 after completion. The

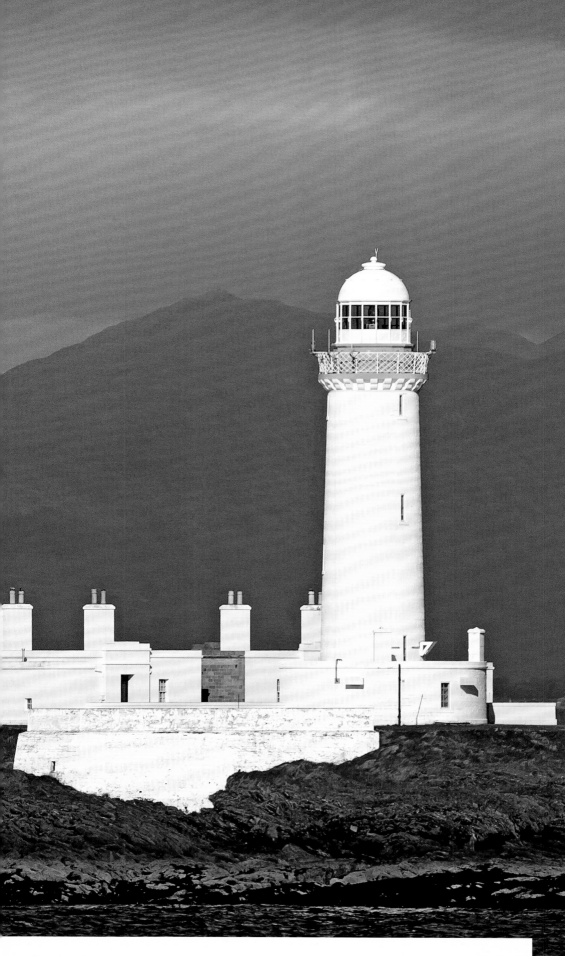

operation of the lighthouse was carried out by a workforce of four lighthouse keepers who executed their duties every six weeks in rotation. Food supplies for the lighthouse keepers were delivered by boat. The Lismore Lighthouse was modernised and automated in 1965 for around £10,000 so the job of lighthouse keeper became a casualty of cost-saving. Both empty one storey homes of the previous lighthouse keepers are still standing. The lighthouse was listed by the Scottish government and classified A, the highest category. The building, which is well worth a visit, can easily be spotted from the ferry between Scottish harbour town Oban and the Hebridean island of Mull. With a telephoto lens (focal distance of approximately 300 mm) very beautiful full-frame photographs of the lighthouse with the Scottish Highlands in the background can be taken from the water.

56°27'20"N 005°36'27"W | Fl 20s | 31m | 19M

52. Hartland Point (Devon, Bristol Channel)

Hartland Point is the northwestern-most point in the county of Devon and marks the spot where Bideford Bay meets the Atlantic. For the seafarer, the 40-metre-high church tower at St Nectan originally served as an important orientation point. In 1874 the lighthouse was completed and subsequently officially opened by the Bishop of Exeter. As the revolving light was operated by clockwork and had to be wound every two-and-a-half hours, four lighthouse keepers were employed to operate the beacon manually. They lived together with their families in the lighthouse until the automation of the tower in 1984. Today the maintenance and supervision of this building is carried out through the Trinity House Lighthouse Service. The light of the tower has, thanks to its signal height of 37 metres in spite of a merely 18 metre building height, an enormous range of 25 nautical miles. In foggy weather the fog horn emits a 5-second-long blast every 60 seconds, which can be heard from a distance of over two nautical miles. The lighthouse warns the sailor about the headland and at the same time provides a marker for ships on their way through the Bristol Channel. Due to the demolition of the original road which led to the lighthouse, the tower is now only accessible by helicopter or off-road vehicle. The architecturally special lighthouse is, due to the infrastructure, sadly no longer open to visitors. On New Year's Day 1982 the ship *Johanna*, registered in Panama, was stranded on the cliffs in front of Hartland Point only 100 metres away from the lighthouse. The ship was on her way from Holland to Barry Island and loaded with wheat. The four crewmen and three officers were saved. Today there are only a few rusty remnants as a reminder of the disaster.

51°01'03"N 004°31'04"W | GpFl(6) 15s | 37m | 25M (8M from 2012)

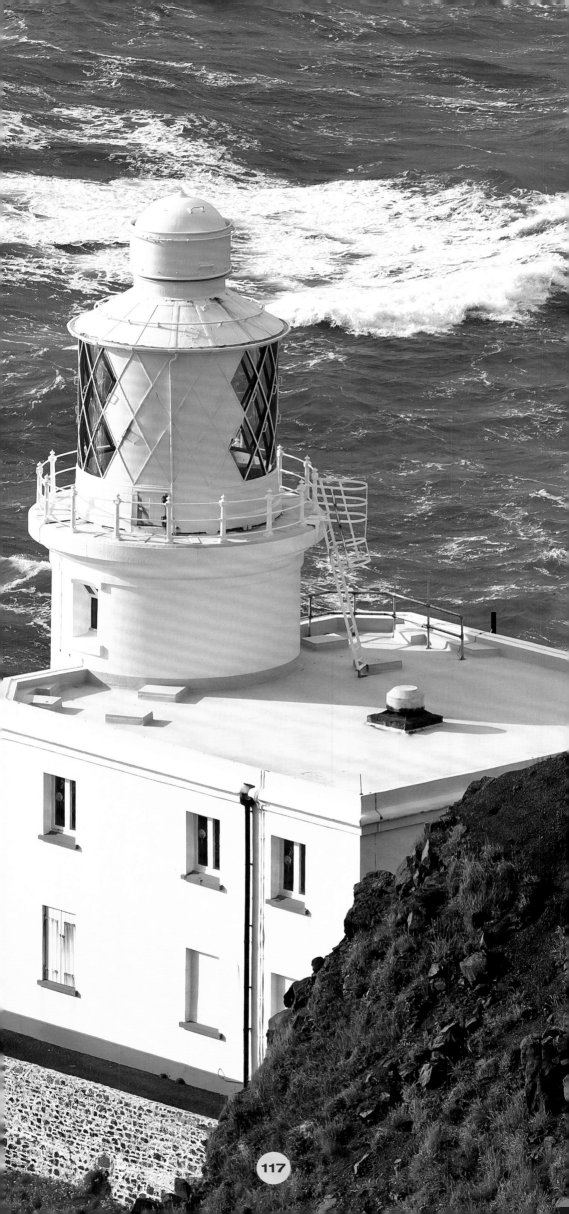

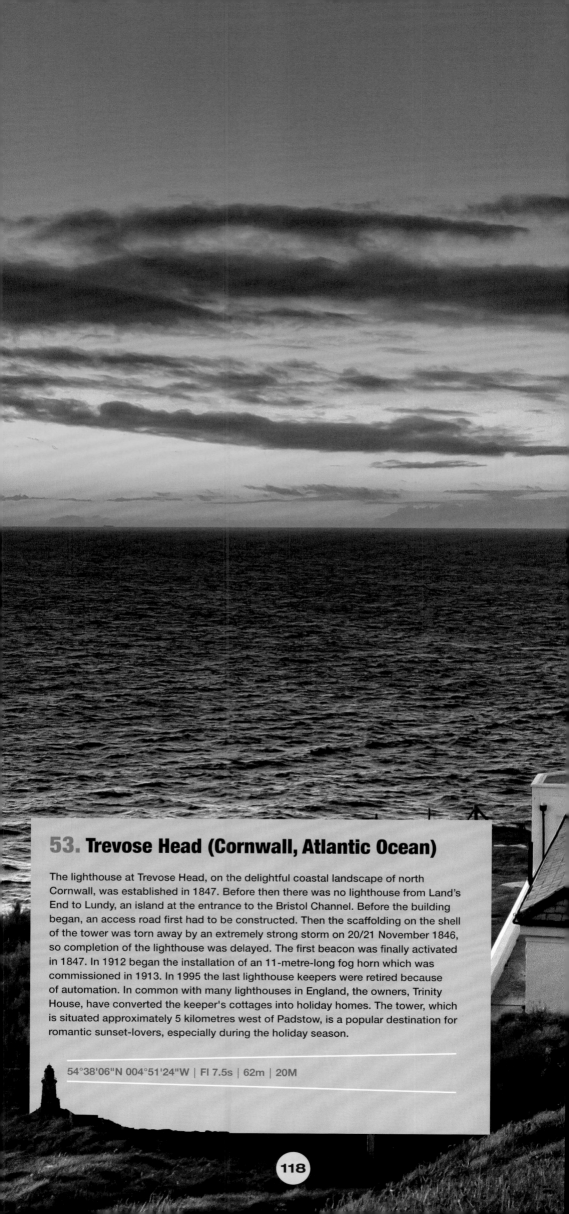

53. Trevose Head (Cornwall, Atlantic Ocean)

The lighthouse at Trevose Head, on the delightful coastal landscape of north Cornwall, was established in 1847. Before then there was no lighthouse from Land's End to Lundy, an island at the entrance to the Bristol Channel. Before the building began, an access road first had to be constructed. Then the scaffolding on the shell of the tower was torn away by an extremely strong storm on 20/21 November 1846, so completion of the lighthouse was delayed. The first beacon was finally activated in 1847. In 1912 began the installation of an 11-metre-long fog horn which was commissioned in 1913. In 1995 the last lighthouse keepers were retired because of automation. In common with many lighthouses in England, the owners, Trinity House, have converted the keeper's cottages into holiday homes. The tower, which is situated approximately 5 kilometres west of Padstow, is a popular destination for romantic sunset-lovers, especially during the holiday season.

54°38'06"N 004°51'24"W | Fl 7.5s | 62m | 20M

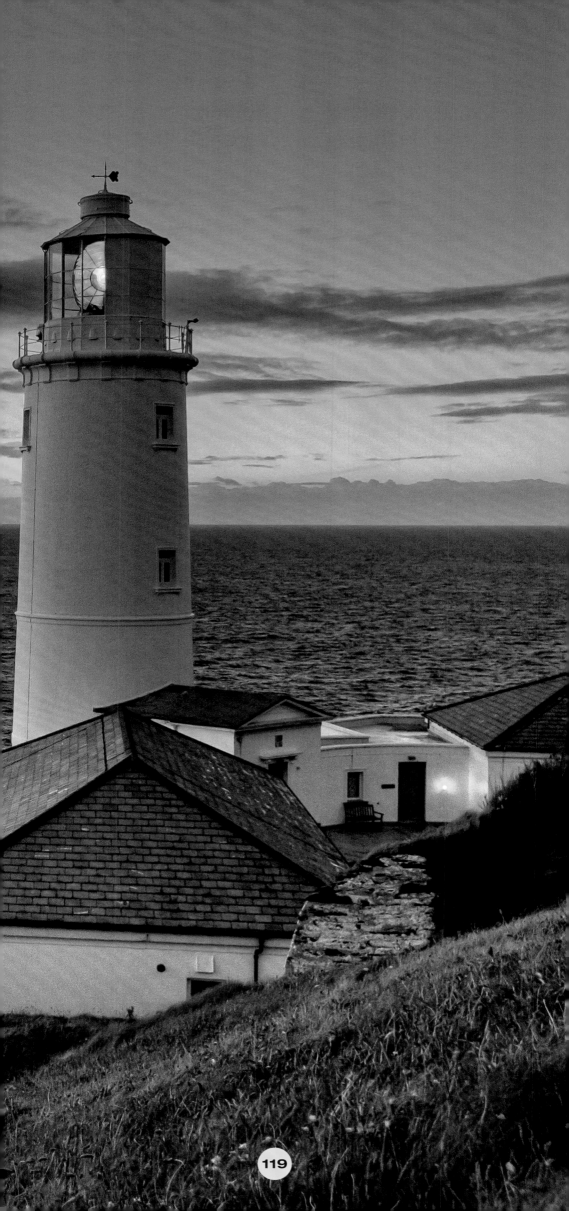

Ireland

Ireland is part of the British Isles and is divided into the Republic of Ireland (around five-sixths of the island, the capital of which is Dublin) and Great British province of Northern Ireland (approximately one-sixth of the island, the capital of which is Belfast). The whole island is divided into four historical provinces (Connacht, Leinster, Munster and Ulster) which are divided into 32 counties. The republic and the province are separately administered.

The Republic of Ireland has been independent from the United Kingdom since 1921 and withdrew from the Commonwealth in 1949. Ireland is the only nation of the British Isles to be a member of the European Monetary Union. In Northern Ireland the British Pound is still in use. In 2005 the Anglo-American, or imperial, measurement system was changed to the metric system and now speed and distance are measured in kilometres. In Northern Ireland, mph and miles continue to be used on the roads.

Both Northern Ireland and the Republic of Ireland drive on the left. The official languages are the Celtic language Irish (Gaelic) and English.

Due to its abundance of natural greenery and farmland, the island is known as 'the Emerald Isle'. It has changeable weather and a moderate climate, so has year-round visitors. Historical places of interest in eastern Ireland offer plenty of culture from Celtic times to the classical architecture of magnificent Georgian mansions. In the southwest of Ireland the Ring of Kerry, a 179-km-long panoramic coastal road in County Kerry, offers views over exquisite coastal landscapes of the often wild Atlantic.

The many craggy and rocky coasts of Ireland mean that navigation in this area is not easy – the operation of lighthouses for the safety of shipping was and still is vital. All Irish lighthouses are, in spite of the division of the island into the Republic of Ireland and British Northern Ireland, looked after by the same authority, the Commissioners of Irish Lights in Dublin.

54. Baily Lighthouse (Howth Head, Irish Sea)

The 13-metre-high Baily Lighthouse stands at the south-eastern point of the peninsula Howth Head, to the north of Dublin. Howth was originally an island, but is today joined to the mainland by a narrow strip of land. The building material for the tower, which was built in 1814, consists of granite and was completed according to the designs of the famous lighthouse architect, George Halpin Senior. The area around Howth was the scene of many shipwrecks. On 3 August 1846, a paddle steamer of the City of Dublin Steam Packet Company was stranded on the rocky cliff near the coast around 2.5 km north of Baily, due to dense fog. As a result of this shipwreck an installation of fog bells at the lighthouse was planned. The necessary work for this was postponed due to costs for other building projects. The most notable accident in this area occurred on 15 February 1853 when disaster struck the PS *Queen Victoria*, and 80 people lost their lives. In 1871 an air pressure-driven fog horn was installed which was replaced by a siren in 1879. In June 1972, the lighthouse was converted to electricity and equipped with a 1,500-watt strong light bulb within the rotating lens system. The fog signal was finally discontinued before the automation of the lighthouse followed. The last lighthouse keepers left their workplace on 24 March 1997 so Baily was the last Irish lighthouse to fall victim to automation. Since then the Commissioners of Irish Lights have been responsible for the necessary maintenance work. In the year 2000 they set up a small museum exhibiting objects from the lighthouse's past.

53°21'41.6"N 006°03'08.8"W | Fl 15s | 41m | 26M

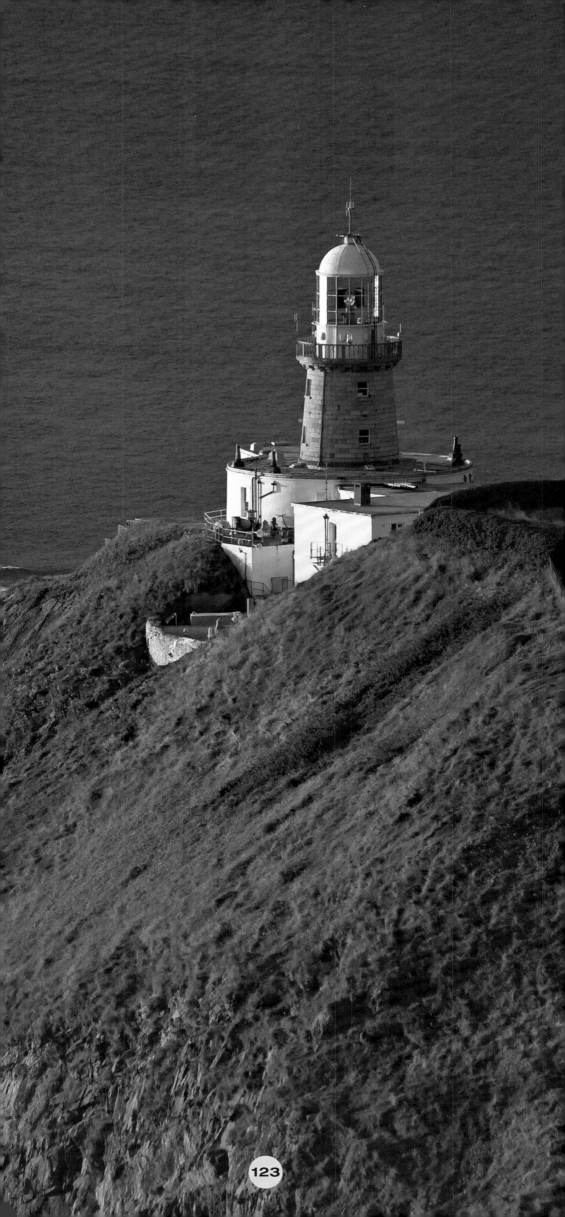

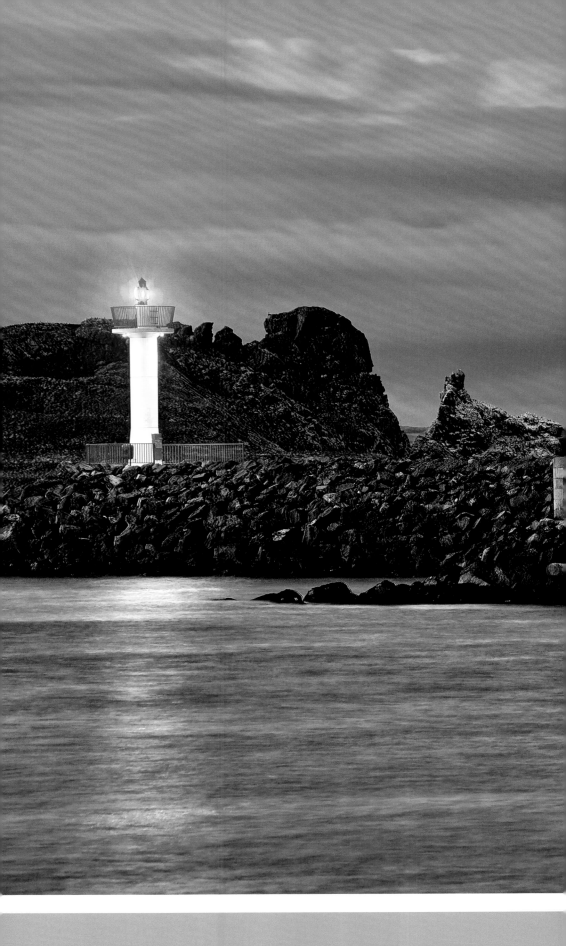

55. Howth Lighthouse (County Fingal, Irish Sea)

Howth Head is a peninsula up the coast from Dublin, which is connected to the mainland solely by a narrow strip of land. The former fishing village of Howth is a popular destination for daytrippers from Dublin. At the end of the East Pier of Howth Harbour there is a very good view of the round lighthouse which was built from grey brick in 1818 and which stands out because of its white lantern and red gallery. Before the accommodation building was constructed in 1821, the three lighthouse keepers had to make do with extremely narrow living quarters. The lantern was equipped with 12 Argand lamps with red glass and catopric silver-plated copper reflectors before the

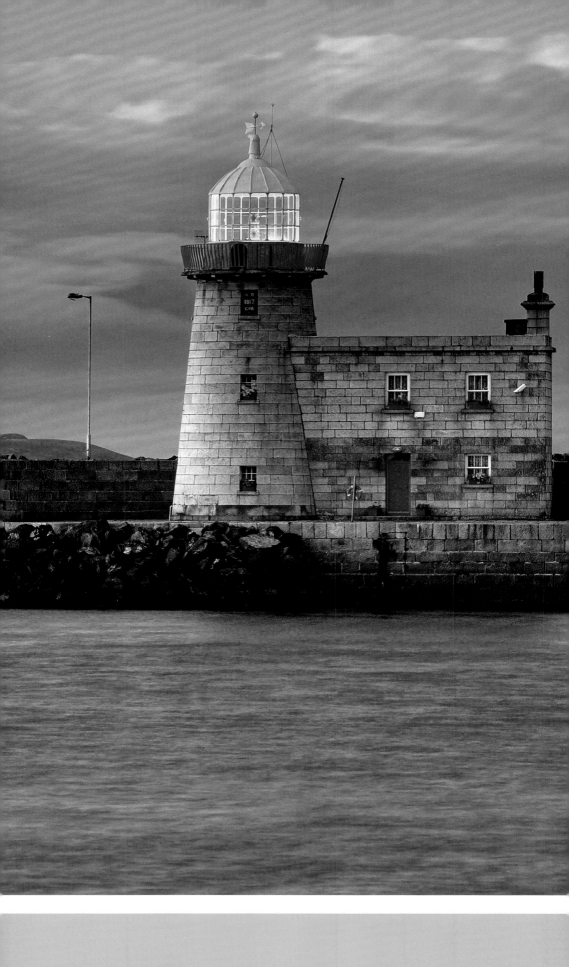

lighthouse was converted to electricity in 1955. In May 1982 the beacon was deactivated for good; in its place a 10-metre-higher and more modest concrete tower on the extended east pier took over the lighting of the harbour. For tourists, a faint flame continues to burn but it is insignificant for navigation.

53°23'39"N 006°04'01"W | 13m | Beacon deactivated in 1982

Hook Head Lighthouse (County Wexford, Irish Sea)

The headland of Hook Head is situated on the eastern side of the entrance to Waterford Harbour. On the southern point of the Hook peninsula stands the tower, constructed in Norman style, which initially operated as a defence tower and later as a lighthouse indicating the harbour entry from Waterford. At first an open fire on the top of the tower guided the sailors in the right direction. From 1671 a coal-fired lantern came into operation before, in 1791, a whale-oil lantern with 12 lamps was used to light the tower. From 1911 paraffin was used as fuel, added to which a clockwork mechanism controlled the precise timing of the beacon. Today the lantern is equipped with a third order Fresnel lens (light strength: 480,000 candela, with electrification in 1972) and has been remote controlled since 1996 from Dún Laoghaire by the Commissioners of Irish Lights. Until this point the lighthouse keepers climbed daily, over a period of 800 years, up the 115 steps to the top of the tower in order to fulfil their duties. Until the lighthouse was automated, the keepers lived in the eighteenth century houses at this oldest lighthouse of the British Isles. Today there is a visitors' centre with a café. Since 2001 Hook Head Lighthouse has been open to visitors. From the observation platform it is possible in clear weather to look out onto the fishing village of Dunmore East on the opposite side of Waterford Harbour. The Hook peninsula is also a popular excursion destination because of its many beaches.

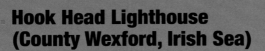 52°07'18"N 006°55'42"W | Fl 3s | 46m | 23M

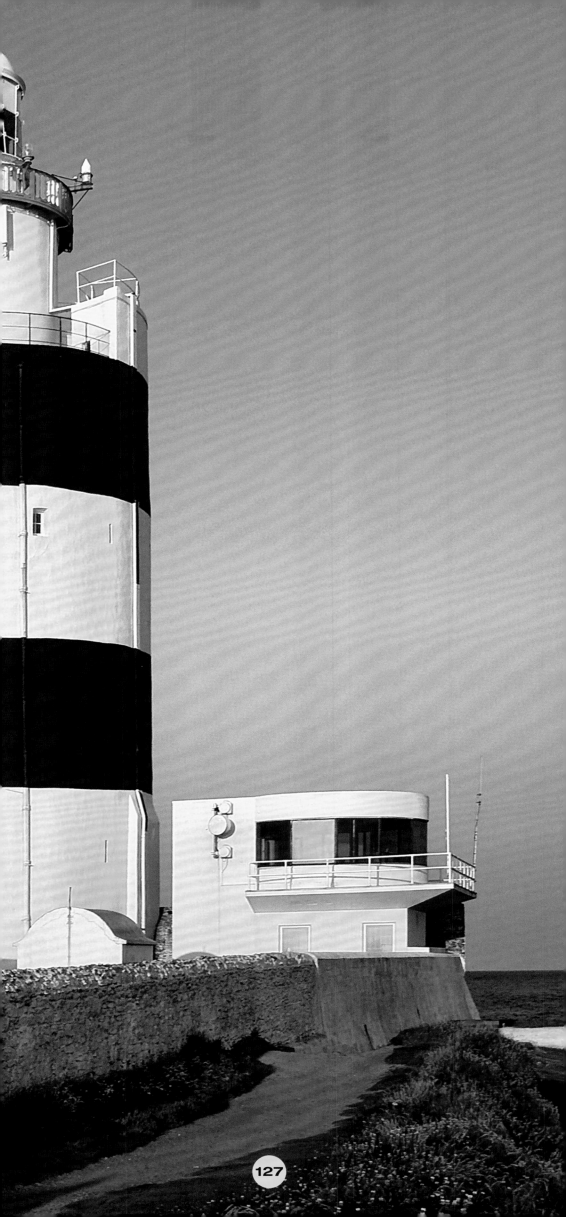

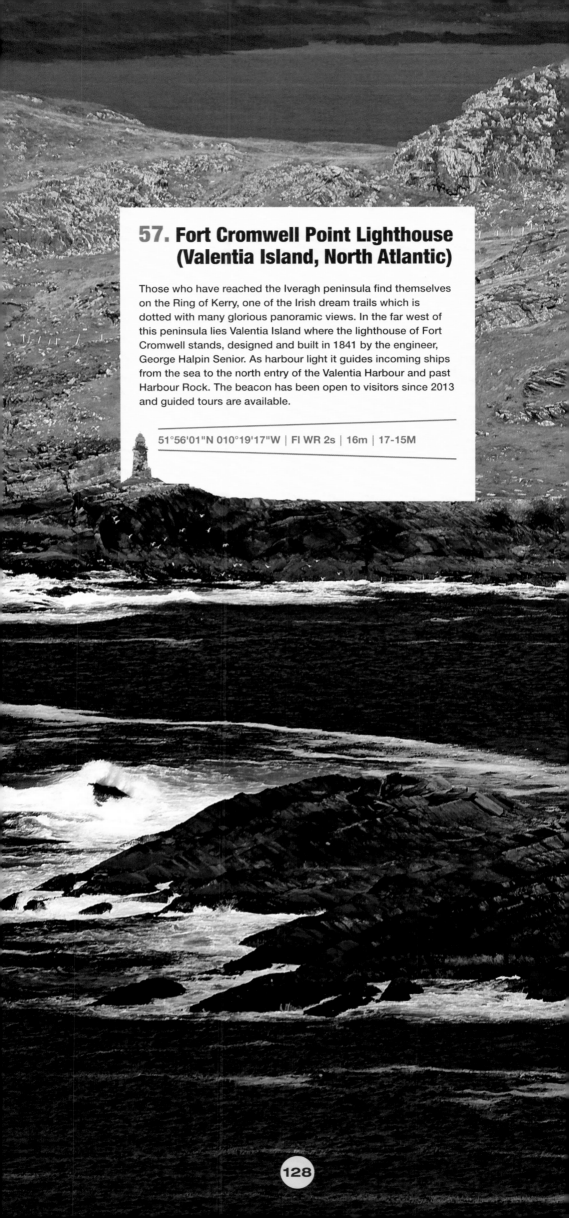

57. Fort Cromwell Point Lighthouse (Valentia Island, North Atlantic)

Those who have reached the Iveragh peninsula find themselves on the Ring of Kerry, one of the Irish dream trails which is dotted with many glorious panoramic views. In the far west of this peninsula lies Valentia Island where the lighthouse of Fort Cromwell stands, designed and built in 1841 by the engineer, George Halpin Senior. As harbour light it guides incoming ships from the sea to the north entry of the Valentia Harbour and past Harbour Rock. The beacon has been open to visitors since 2013 and guided tours are available.

51°56'01"N 010°19'17"W | Fl WR 2s | 16m | 17-15M

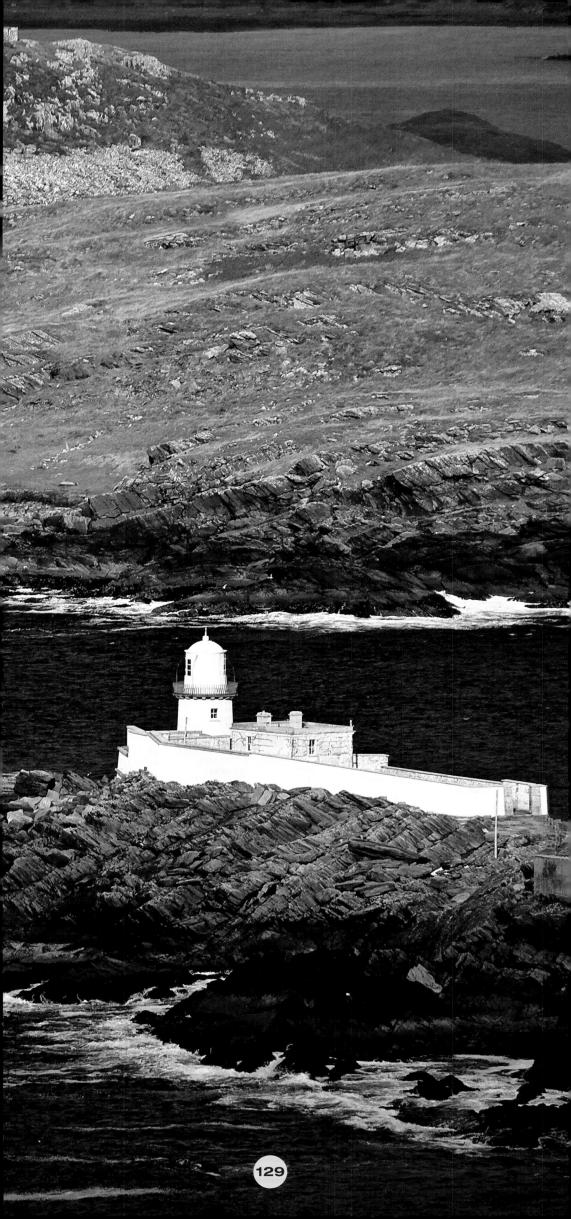

Iceland

Iceland is, by land area, the second-largest island nation in Europe after the United Kingdom and the largest volcanic island in the world. The island is situated just south of the Arctic Circle. Iceland is a member of the European Free Trade Association (EFTA) and politically subdivided into eight regions: Capital region, Southern peninsula, Western region, Westfjords, Northwestern region, Northeastern region, Eastern region and Southern region. The island state lies to the southeast of Greenland and northwest of the Faroe Islands. Between Greenland and Iceland lies the Denmark Strait. To the north of Iceland lies the Greenland Sea, to the east the Norwegian Sea, with both adjoining the Arctic Ocean. To the south lies the North Atlantic. In spite of its membership of EFTA, Iceland also signed the Schengen Agreement.

The scenery is characterised by volcanic activity and an abundance of water. Iceland is rich in active volcanoes, rivers, lakes, waterfalls, geysers and glaciers. The 4,970-km-long coastline is strongly furrowed and sprinkled with small islands

in the area of the Icelandic fjords. In order to guarantee the safety of shipping, the lighthouses on the coast and on the islands are an enormously important element in smooth and disaster-free navigation. The majority of the Icelandic lighthouses are noticeable due to their orange-coloured paint, a compact size and using concrete as the main building material.

Because of the warming Gulf Stream of 5°C on the south coast, the climate of Iceland is considerably milder than in other regions on the northern Arctic Circle. The Gulf Stream meets the East Greenland Stream just offshore and this makes Icelandic waters especially rich in fish due to the low pollution; around 270 varieties of fish live there. Iceland was almost free of glaciers after a warm period around 1,000 years ago, but now 11 per cent of the upper part of the country is covered with glaciers. The Vatnajökull is Europe's largest glacier with a 1,000-metre-thick ice cap in places. The winters are relatively mild and the summers rather cool so the capital, Reykjavik, experiences similar temperatures to Hamburg in the winter. In the highlands and the north of the island winter is more notable for biting cold, storms and snowfall.

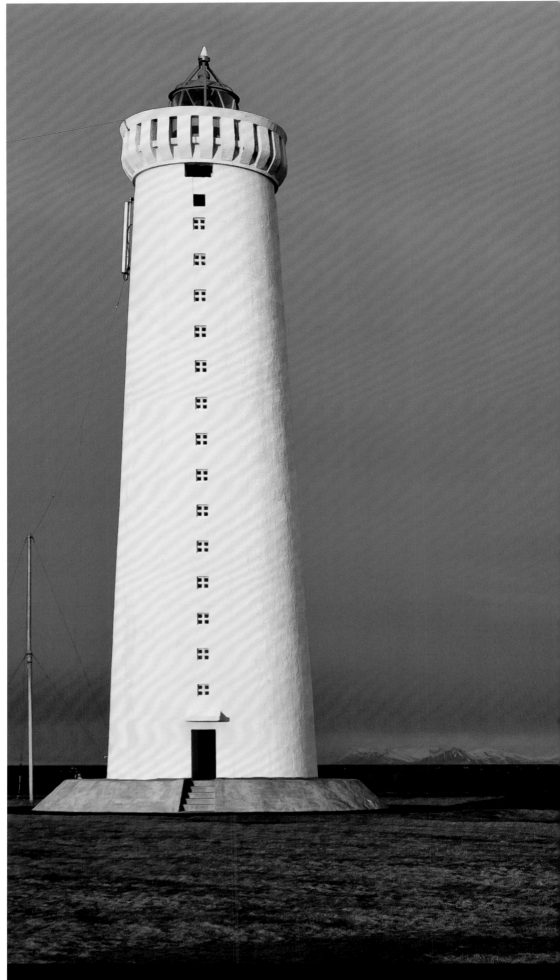

58. Garðskaga Lighthouse
(Garður, Reykjanes, North Atlantic)

With a height of 28.6 metres, the Garðskaga Lighthouse is one of the tallest beacons in Iceland and stands on a headland in the outer northwest of the Reykjanes peninsula two kilometres to the west of Garður. Gar[lies around 10 kilometres north of Kevlavík and 30 kilometres to the west of the capital, Reykjavík. This interesting round grey tower was built because the sea had moved closer and closer to the old lighthouse

and brought it into acute danger. The lens of the old lighthouse was transferred to the new building, completed in 1944. The entire energy source was changed from gas power to an electrical power supply. Nature has defied the old lighthouse – it now operates as a bird observatory and is as equally loved by ornithologists as by the locals. A museum and café have been opened next to the new lighthouse.

64°04'55"N 022°41'24"W | F (Fixed) WRG | 29m | 10M

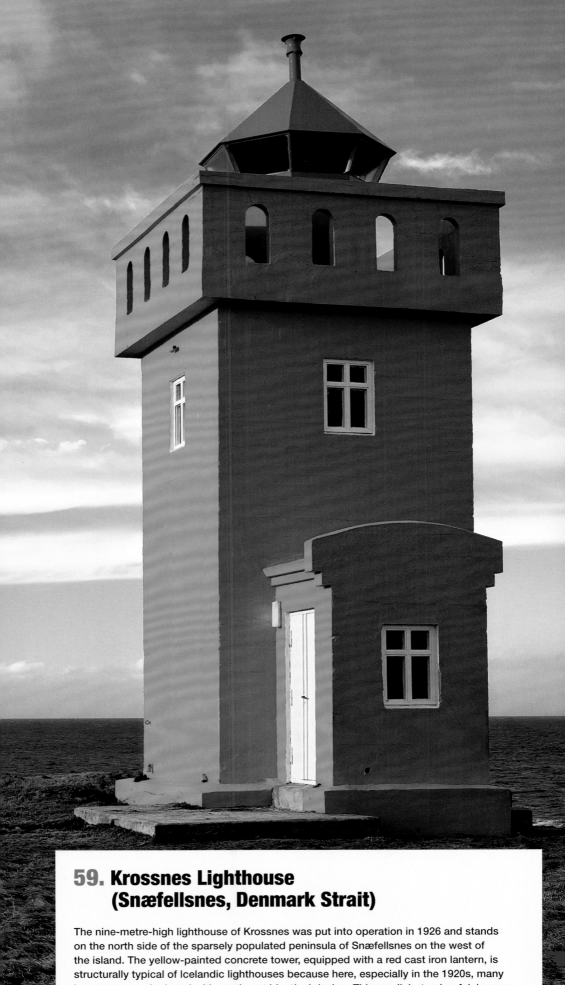

59. Krossnes Lighthouse (Snæfellsnes, Denmark Strait)

The nine-metre-high lighthouse of Krossnes was put into operation in 1926 and stands on the north side of the sparsely populated peninsula of Snæfellsnes on the west of the island. The yellow-painted concrete tower, equipped with a red cast iron lantern, is structurally typical of Icelandic lighthouses because here, especially in the 1920s, many beacons were deployed with an almost identical design. This small, but colourful, beacon is positioned on the headland of Krossnes, northwest from the harbour town Grundarfjörour and guides shipping in the bay and harbour of the same name. Reaching the lighthouse at Grundarfjörour requires a drive in a car and a walk through an enchanting natural landscape. The Snæfellsnes peninsula is considered to be an island in miniature because it reproduces in a small area all the features of a large island. It is not without reason that daytrippers and nature photographers stream here in droves, especially in summer.

64°58'18"N 023°21'24"W | FI(4) WRG 20s | 21m | 13-11M

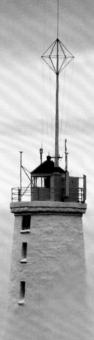

60. Reykjanes Lighthouse
(Reykjanes Peninsula, North Atlantic)

The original Reykjanes Lighthouse was the oldest lighthouse in Iceland and stood at the far
south-west of the Reykjanesskagi peninsula. The tower was established in the year 1878 and was
destroyed by an earthquake only eight years later. The ruined tower wasn't demolished until April
1908. Twenty years later, in 1929, a new round white concrete tower with a red lantern and gallery
was constructed. As the 31-metre-high beacon stands on a raised volcanic cone, it is already
visible from afar. The tower is not only interesting from an architectural point of view, but its position
in the bizarre lava landscape is appealing for nature-lovers. Only a few hundred metres away from
the west side of the tower is an imposing steep coast with rocks inhabited by many birds. About
two kilometres away from the beacon lies a field of sulphur in which minor volcanic activity can be
felt. When visiting the lighthouse on days when the east wind is blowing the penetrating smell of
sulphur is apparent, but that's normal on this largely untamed island.

63°48'56"N 022°42'16"W | Fl(2) 30s | 73m | 22M

61. Dyrhólaey Lighthouse
(Cape Dyrhólaey, South Iceland, North Atlantic)

Despite being merely 13 metres high, Dyrhólaey Lighthouse on Türlochinsel Island reaches, due to the height of the cliffs, a record-setting signal height of 123 metres and has the enormous range of 27 nautical miles (equal to a distance of 50 kilometres). The lighthouse, and the area around Türlochinsel Island, is the southernmost point of Iceland and along with the rocky coast, the rock formations and the black lava beach present a unique landscape. Together with the terns, colonies of colourful puffins nest on the rock walls during the summertime (and to protect them, access is forbidden from the beginning of May until the end of June). The cape itself was created around 80,000 years ago from an underwater volcanic eruption. Even today there is a mild but noticeable sulphur odour. The lighthouse was established in 1927 and converted to electrical power in 1964.

63°23'59"N 019°07'35"W | Fl 10s | 123m | 27M

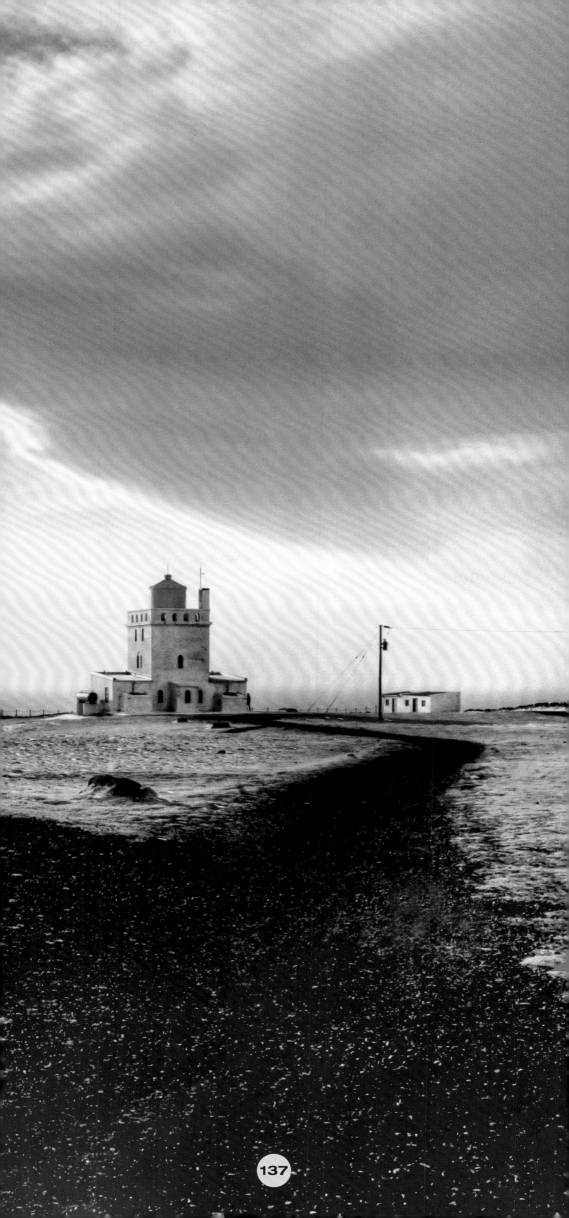

France

France is a centralised state in Western Europe with overseas islands and
territories (such as French Guiana and Réunion) spread over several continents.
France itself has sea coasts on the Mediterranean (to the south), on the Atlantic
(to the west), and the English Channel and the North Sea (in the north). In the
south France borders Spain, the mountains of the Pyrenees and the principality
of Andorra (ruled equally by the French president and the Bishop of Urgell, Spain,
referred to as co-rulers). From north to south, along the eastern side of France, the
country has borders with Belgium, Luxembourg, Germany, Switzerland and Italy.
In terms of land area France is the largest country in the European Union and, after
Russia and the Ukraine, the third-largest country on the European Continent. Paris
(with 2.2 million inhabitants) is the capital and forms the largest metropolitan area
in France. Due to the six-cornered shape of the mainland, France is also referred
to as 'the Hexagon'. Since the adoption of a new constitution on 5 October
1958, France's current system of government is spoken of as the fifth Republic.
Compared to the previous constitutions the role of the executive and that of the
president is stronger.

The coastal landscapes in Brittany and Normandy are particularly diverse –
rough and breathtaking. There are also, among other things, a lot of lighthouses
there which magically draw many tourists, photographers and artists. The most
photographed lighthouse stands in Ploumanac'h on the Breton north coast, the
so-named Cotê de Granit Rose. The granite-built lighthouse is at its best shortly
before sunset.

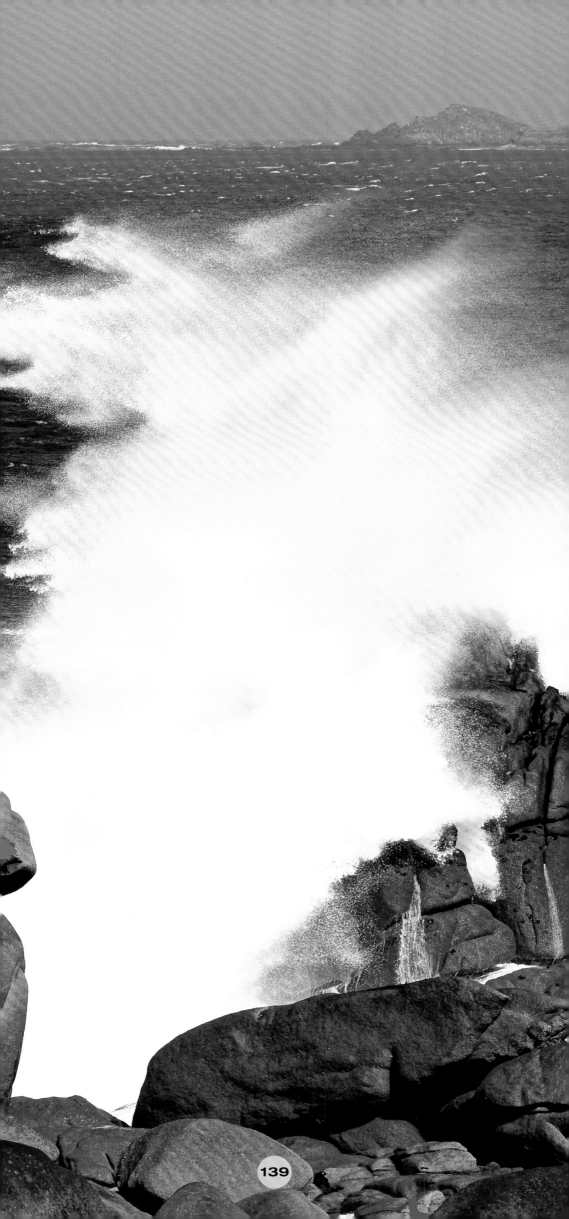

62. Beacon Lighthouse (Port Vendres)

The white Beacon Lighthouse, which is equipped with a red lantern, stands on a boat dock in a bay of Port Vendres in the Départemente Pyrénées-Orientales. This harbour community lies on the Mediterranean close to the Spanish border. Port Vendres is the only natural harbour in this region and serves year-round as a lively leisure, fishing and working harbour. Due to the crimson red cliffs the coast also bears the name 'the Crimson Coast'. While the lighthouse on Cape Béar watches over the coastal harbour, the highly-regarded Beacon Lighthouse operates as an extra land marker and navigational aid for the sport boats within, as well as outside, the bay of Port Vendres. In previous eras famous painters such as Picasso, Matisse, Braque and Dufy, who were influential in the nearby painters' colony of Collioure, brought the community of Port Vendres fame beyond limits. The artists believed that due to the individual style of the Beacon Lighthouse, it had been created by Salvador Dali (who lived in neighbouring Cadaqués on the Costa Brava) in a fevered frenzy. In Céret, located inland, stands the Museum of Modern Art where the work of these artists is documented.

42°31'N 003°6'E

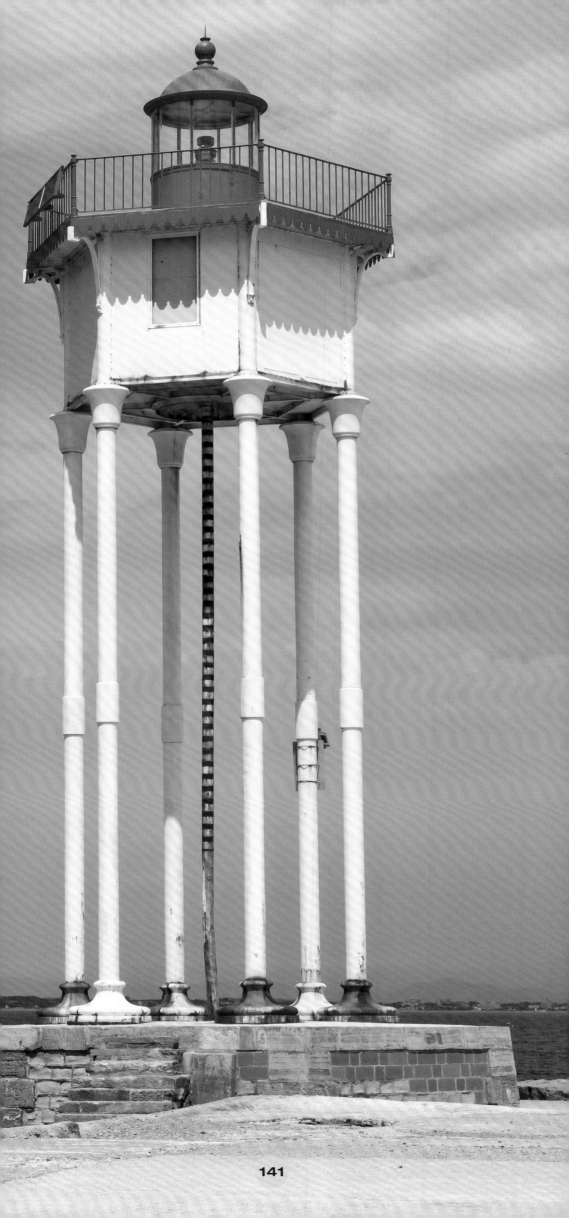

63. Ploumanac'h Lighthouse (Perros-Guirec, Brittany, Channel coast)

The 15-metre-high granite lighthouse marks the entry to the harbour of Ploumanac'h, in the region of Perros-Guirec and the Départmente Côtes-d'Armor. Rebuilt in 1945 after its destruction during the Second World War, the current tower replaced the original which was established in 1860. The official name of the navigational beacon is *Phare de Mean Ruz* which, translated from the Breton, means something like 'the red stone'. This description fits because the section of coast, Côte de Granit Rose, on which the unique lighthouse is situated is studded with huge pink blocks of granite. The contrasts of the colours are seen to their best advantage in the evening and morning light next to the blues of the water and sky. From the lighthouse it is possible to enjoy a wonderful view over the Atlantic Ocean and to Les Sept Îles and the island of Rouzic. Apart from this, the visitor is also granted a view of the Castle of Costaérès on the island of the same name. The castle, constructed between 1892 and 1896 in the neo-Renaissance style, has been the second home of the German actor, Dieter Hallervorden, since 1988. The lighthouse can be reached on foot from Ploumanac'h along a narrow path across the cliffs (sturdy footwear required). The alternative, and much more interesting, route is approximately six kilometres along a former toll path, which leads from Perros-Guirec along the sea to Ploumanac'h. The white light sector of the beacon can be seen as far as Rouzic Island. For photographers and artists this small but considerable beacon in its magical surroundings provides, especially in the evening light, a fantastic subject.

48°50'15"N 003°29'0"W | Fl WR 4s | 26m | 12-9M

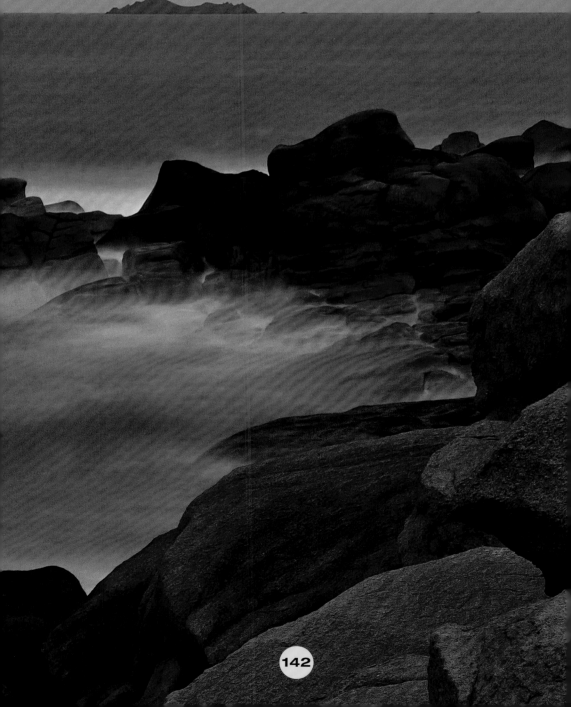

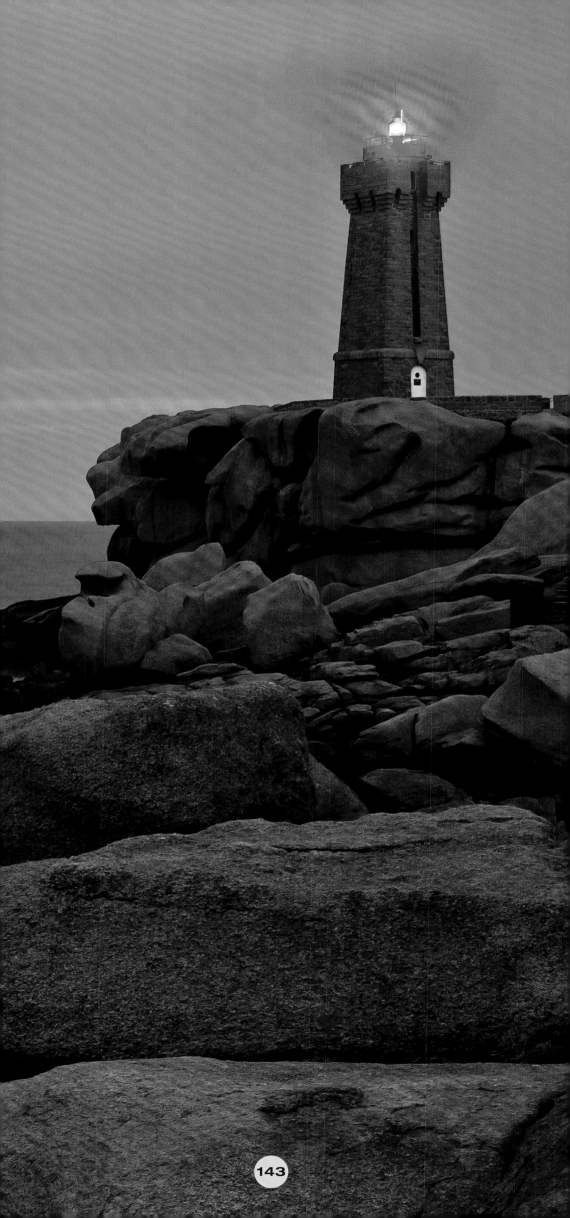

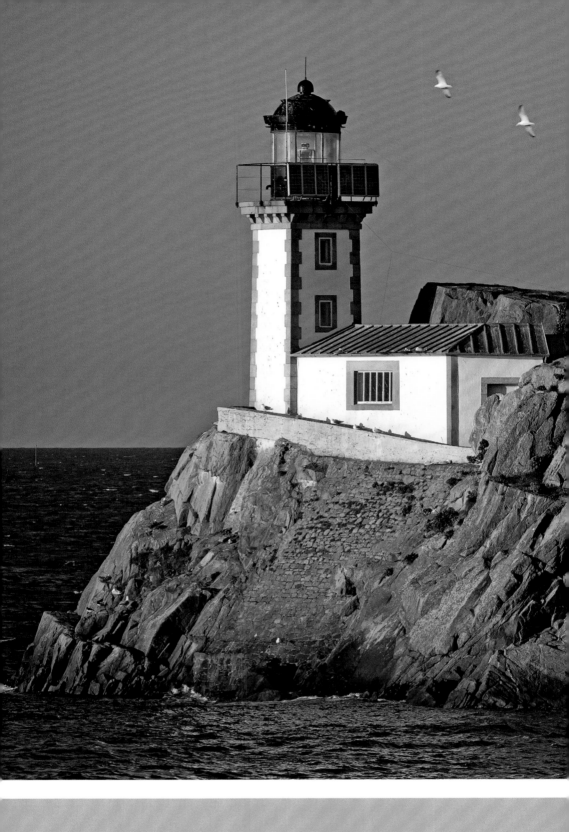

64. Île Louet Lighthouse
(Carantec, Baie de Morlaix, Channel Coast)

This interesting 12-metre-high lighthouse enjoys a scenic standpoint on the picturesque island of Île Louet. This small island is situated at the north-west end of the cove, Baie de Morlaix, in the Département Finistère. The lighthouse and its small caretaker's house, which was established in 1860, is seen to its best advantage from the Pointe de Pen al Lann. This observation point is in Carantec, a popular coastal resort, which lies on a peninsula with a diverse cliff coast featuring many beautiful lookout points. From Pointe de Pen al Lann you can also clearly see the Château de Taureau built on a reef in the sixteenth century and the lighthouse on the Île Noire.

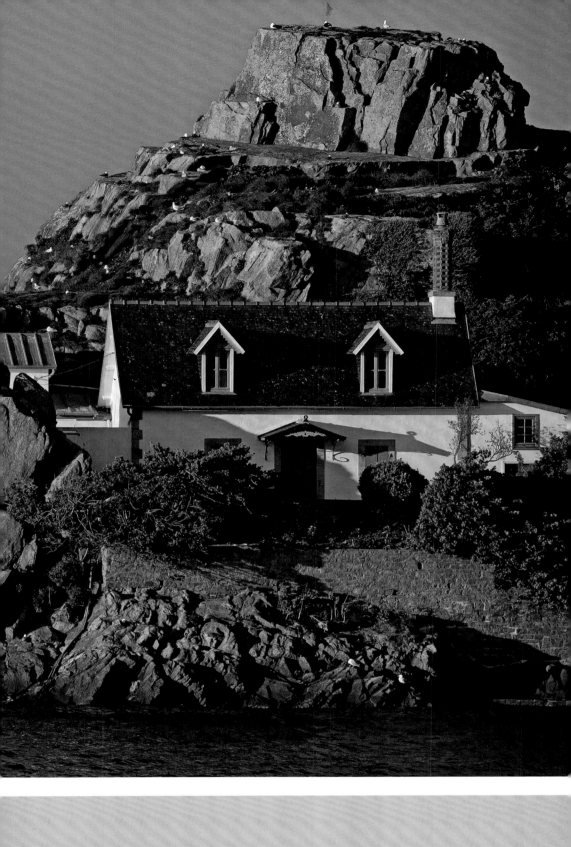

48°40'25"N 003°53'20"W | Oc(3) WG 12s | 17m | 15-10M

65. Roscoff Lighthouse (Brittany, Channel coast)

In order to guard the approach to the Breton harbour of Roscoff, a lighthouse was built on the northern side in 1880, and a white light was deployed. Four years later a red light was added on the opposite side of the breakwater. Due to the narrow range, however, the building of a new and better-equipped lighthouse 430 metres inland was immediately planned. The construction of the 24-metre-high granite, square and pyramid-like tower began in 1914 but was not completed until 1934 due to the First World War. Automation followed in 2002. The lighthouse, which is situated directly on the approach road from Roscoff to the harbour, can be visited in the summer months. From the top, up 95 steps, a beautiful view over Roscoff Harbour, the rough coastal landscape and the Île de Batz, around 3.5 kilometres away, can be appreciated.

48°43'21"N 003°58'50"W | Oc(2+1) 12s | 26m | 15M

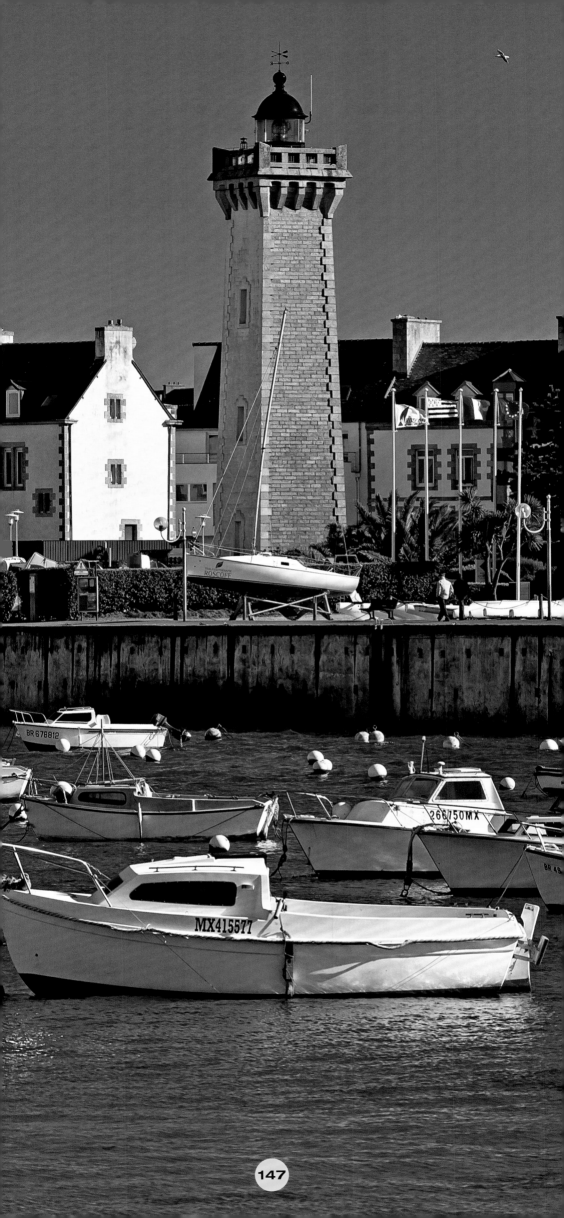

66. Pontusval Lighthouse
(Brignogan, Brittany, Channel coast)

The Pontusval Lighthouse, which came into operation in September 1869, is situated near Brignogan beach. An efficient light in spite of its relatively low height of 16 metres with a range of 10 nautical miles, it is considered to be a safe main beacon between the Île Vierge and the Île de Batz. It fits in wonderfully with the rough and rocky landscape. The area around Brignogan was long notorious to seafarers and fishermen for its shipwrecks. In the eighteenth century the lighthouses on Île Vierge and Île de Batz were often not visible due to thick sea fog. Thus the demand for a new lighthouse became more pressing and in 1867 construction was begun on the Pontusval lighthouse using local materials. Because several lighthouses in Brittany were built in this style, the tower is known as a standard lighthouse.

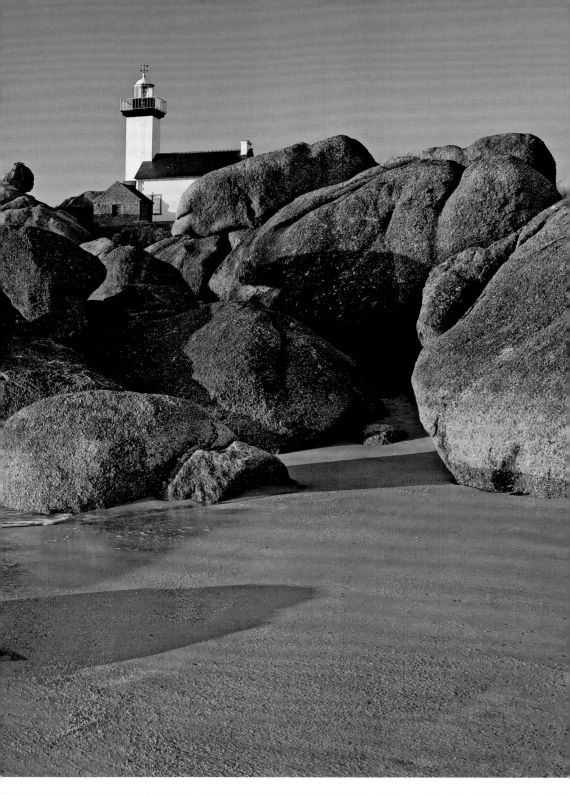

48°40'42"N 004°20'48"W | Oc(3) WR 12s | 16m | 10-7M

THE ATLANTIC OCEAN

Portugal

Portugal is situated to the west of the Iberian peninsula and is the westernmost nation of continental Europe. In the east and north the country has a 1,214-km-long border with Spain, while south and west Portugal border the Atlantic Ocean. The islands of the Azores and Madeira, and Porto Santo are Portuguese territories. For more than forty years the country was under the dictatorship of António de Oliveira Salazar. The regime was brought down by the Carnation Revolution on 25 April 1974 and the way was paved to the democratic Third Republic.

Today Portugal is one of the most visited countries in the world with over 17 million tourists each year, and it has changed from a country of emigration to one of immigration. The largest migrant groups come from Brazil, Cape Verde and Ukraine. More than 10 per cent of the Portuguese population live in the towns Lisbon and Porto. The most popular travel destinations in Portugal are the Algarve and the capital, Lisbon (known for its melancholic form of music, *Fado,* and the well-known football club, SL Benfica). At weekends and during holidays Costa do Estoril is a very popular attraction for the inhabitants of the metropolitan region of Lisbon. The Algarve occupies the whole south coast of Portugal and has, with its pretty towns and villages, cliffs and sandy beaches, become a popular holiday resort. On the North Atlantic coast and in the Tegus Estuary can be found beautiful and rough coastal scenery and many interesting lighthouses of different building styles. The Algarve and the Costa do Estoril provide holidaymakers, artists and photographers with wonderful coastal landscapes and maritime views.

67. Santa Marta Lighthouse
(Cascais, Costa do Estoril, North Atlantic)

The Santa Marta Lighthouse stands about two kilometres west of the former fishing village Cascais and was completed in 1868. Until 1936 the tower was only 12 metres tall before it was raised by eight metres for operational reasons. The former fortification was restored in 2006 by the architects Francisco and Manuel Aires Mateus and radiates, together with the lighthouse built on a square foundation, a new brilliance. This unique project has been open to the public for free since 2007. The lighthouse is equipped with a light reflector with a range of up to 18 nautical miles. The classical white and blue tiles on the walls, *azulejos*, give the building a typical Portuguese look. A museum was installed in the former keepers' house, the Santa Marta Lighthouse museum, in which equipment from lighthouses and the Portuguese navy are exhibited. As well as this, films are shown which bring visitors closer to the daily life of the lighthouse keeper.

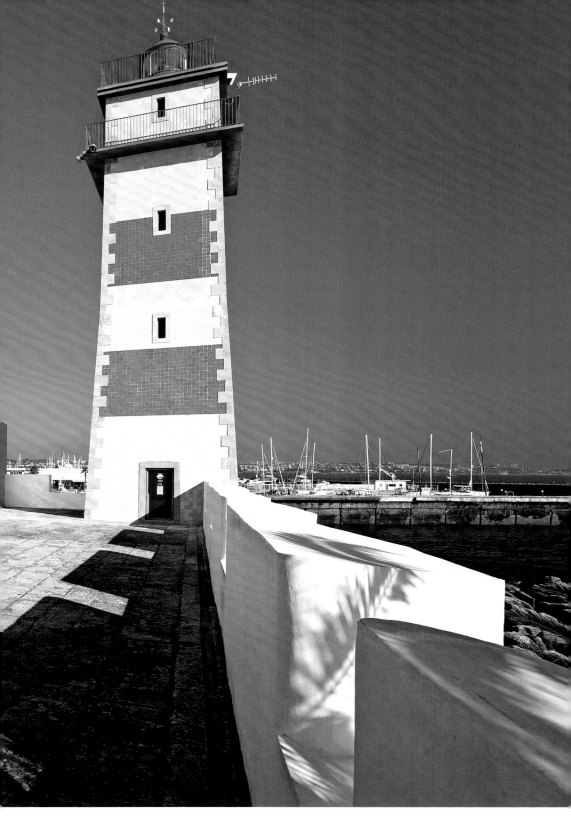

38°41'25"N 009°25'15"W | Oc WR 6s | 25m | 18-14M

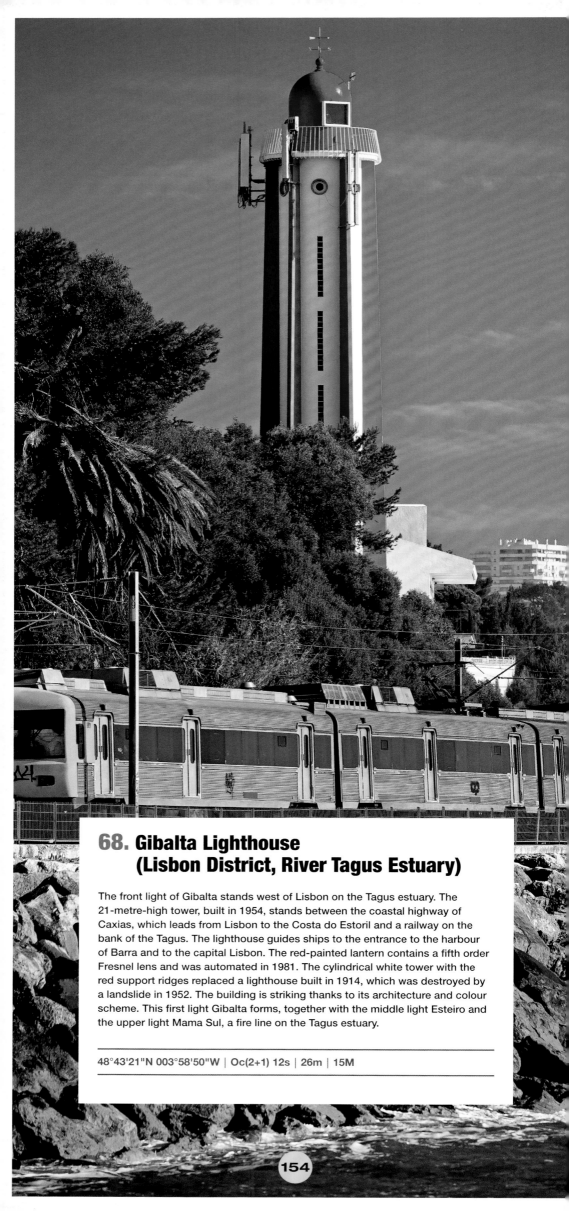

68. Gibalta Lighthouse
(Lisbon District, River Tagus Estuary)

The front light of Gibalta stands west of Lisbon on the Tagus estuary. The 21-metre-high tower, built in 1954, stands between the coastal highway of Caxias, which leads from Lisbon to the Costa do Estoril and a railway on the bank of the Tagus. The lighthouse guides ships to the entrance to the harbour of Barra and to the capital Lisbon. The red-painted lantern contains a fifth order Fresnel lens and was automated in 1981. The cylindrical white tower with the red support ridges replaced a lighthouse built in 1914, which was destroyed by a landslide in 1952. The building is striking thanks to its architecture and colour scheme. This first light Gibalta forms, together with the middle light Esteiro and the upper light Mama Sul, a fire line on the Tagus estuary.

48°43'21"N 003°58'50"W | Oc(2+1) 12s | 26m | 15M

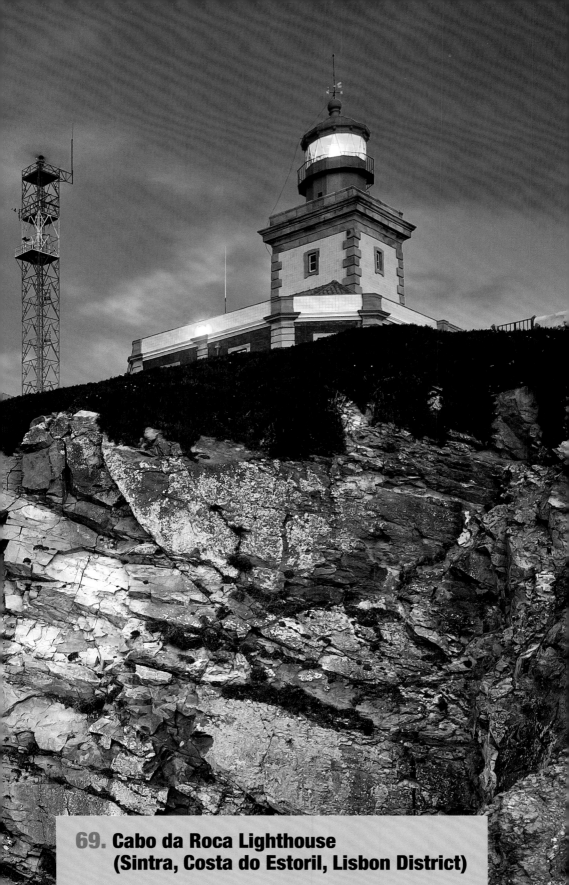

69. Cabo da Roca Lighthouse
(Sintra, Costa do Estoril, Lisbon District)

The 22-metre-high lighthouse on Cabo da Roca is an orientation light, which lies on the westernmost point of continental Europe. (The true western point of Europe is found on the Azores islet of Monchique.) The Cabo da Roca Lighthouse, completed in 1896, stands at the top of the 100-metre-high cliffs in the middle of the rough and breathtaking landscape of the Costa do Estoril. Near the lighthouse there is a monument on the cliffs on the plinth of which is engraved a quote by the poet, Luis de Camões: 'Where the land ends, the sea begins...' The lighthouse is not open to the public, but in the nearby tourist office there is information available about the lighthouse and the nature reserve of Sintra-Cascais.

38°46'55"N 009°29'50"W | Fl(4) 17s | 165m | 26M

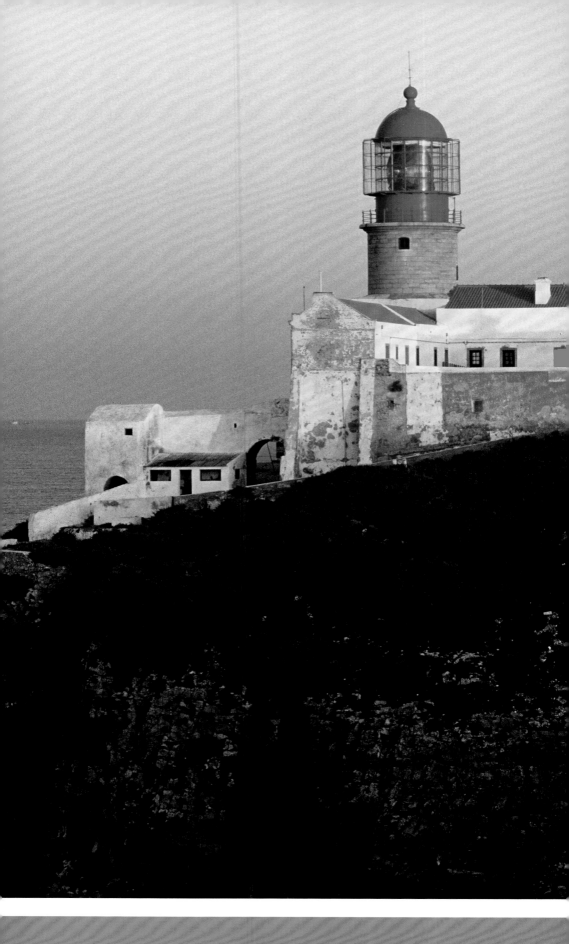

70. Cape St Vincent Lighthouse
(Sagres, Faro District, Algarve)

The lighthouse on Cape Saint Vincent is situated on a stretch of cliffs on the Algarve coast near Sagres, on the southwestern point of Europe. This coastal point was named after the patron saint of seafarers, the Saint Vincent of Saragossa. The 28-metre-high tower was erected in the year 1846 and is the oldest lighthouse in Portugal. In 1908 the lighthouse was raised by 5.8 metres and at the same time acquired a Fresnel lens with a diameter of four metres. This was the largest optic lens in the world at the time, producing a beam of light shining 32 nautical miles (almost 60 kilometres) across the Atlantic. During the day the lantern room had to be covered with white cloths, otherwise the sunlight would produce a dangerous burning lens effect, which could cause considerable

damage to the inside of the lantern. Thanks to this Fresnel lens the lighthouse at Cape Vincent has the strongest light intensity in Europe. The building additionally acquired a fog horn to warn seafarers from coming dangerously close to the cliff in foggy weather. At night the white flashing light (recurrence: 5 seconds) makes sure that the ships on the most-travelled sea routes worldwide maintain a safe distance from the cape. The best time to get a good shot of the lighthouse and to capture the grandeur of this location is early in the morning.

37°01'22"N 008°59'47"W | Fl 5s | 86m | 32M

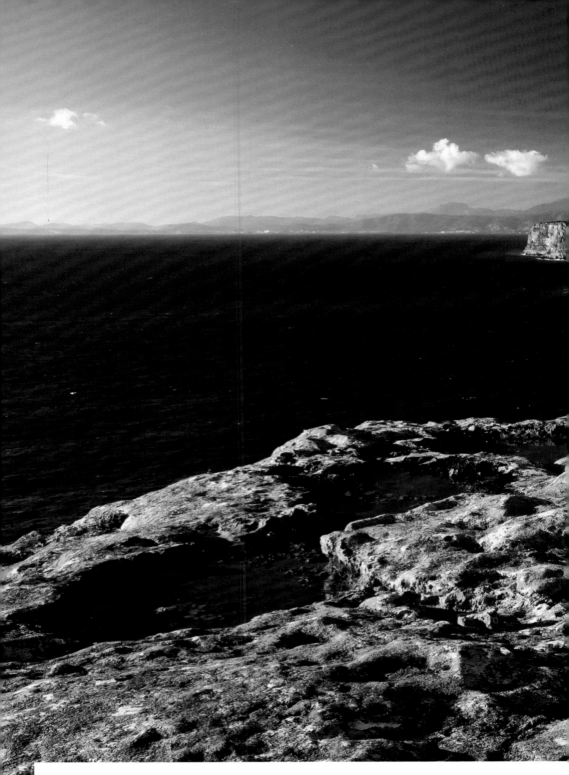

THE MEDITERRANEAN

Spain & Mallorca

Spain is a constitutional monarchy of about 47 million people, bordering France
in the northeast along the Pyrenees mountain range and Portugal in the west.
Beyond the mainland, the Kingdom of Spain also includes the Balearic Islands in the
Mediterranean, the Canary Islands in the Atlantic, as well as the enclaves of Ceuta
and Melilla on the North African coast, making Spain the only European country that
has a border with Africa.

The island of Mallorca is the largest and arguably the best-known island in the
Balearics. The island, which belongs to Spain, lies 170 km off the Spanish mainland

in the western Mediterranean. Mallorca is an immensely popular holiday destination, with more to offer both scenically and culturally than just being 'the party island'. As far as scenery goes the wide variety encompasses everything from the Serra de Tramuntana mountains to the wide beaches of Playa de Palma in the southwest and the big city atmosphere in the capital, Palma de Mallorca. In Port d'Andratx, Port de Sóller and Port d'Alcudia there are wonderful harbours, while inland culture lovers are kept satisfied with the many basilicas, churches, markets and romantic villages to be discovered.

The highest mountain in Mallorca is the 1,445-metre-high Puig Major in the Serra de Tramuntana. Only a few kilometres away lies Sóller in a picturesque harbour bay, which has two beautiful lighthouses to offer. As far as lighthouses are concerned, in almost every coastal region a lighthouse is present and they are of the most varied styles of architecture. For an island only 98 kilometres wide and 78 kilometres long the density of lighthouses is very high.

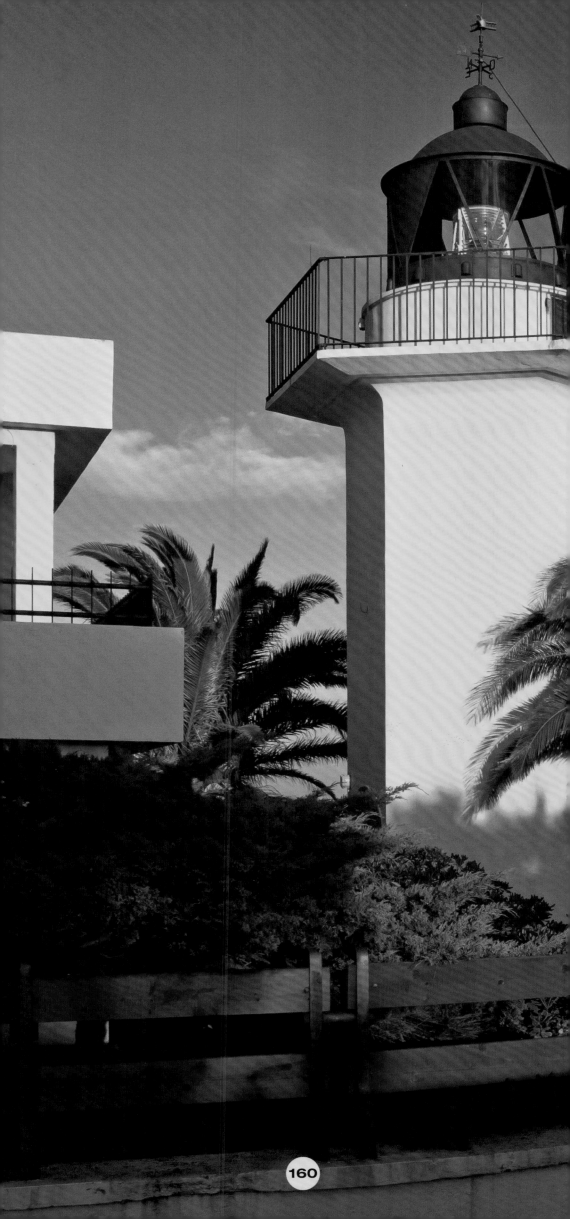

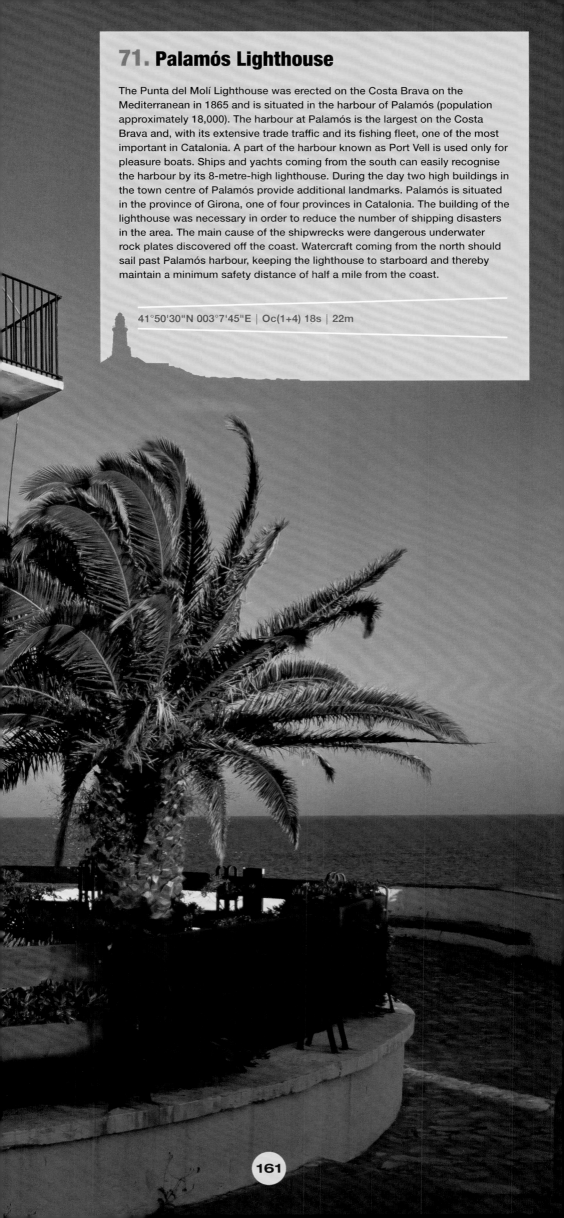

71. Palamós Lighthouse

The Punta del Molí Lighthouse was erected on the Costa Brava on the Mediterranean in 1865 and is situated in the harbour of Palamós (population approximately 18,000). The harbour at Palamós is the largest on the Costa Brava and, with its extensive trade traffic and its fishing fleet, one of the most important in Catalonia. A part of the harbour known as Port Vell is used only for pleasure boats. Ships and yachts coming from the south can easily recognise the harbour by its 8-metre-high lighthouse. During the day two high buildings in the town centre of Palamós provide additional landmarks. Palamós is situated in the province of Girona, one of four provinces in Catalonia. The building of the lighthouse was necessary in order to reduce the number of shipping disasters in the area. The main cause of the shipwrecks were dangerous underwater rock plates discovered off the coast. Watercraft coming from the north should sail past Palamós harbour, keeping the lighthouse to starboard and thereby maintain a minimum safety distance of half a mile from the coast.

41°50'30"N 003°7'45"E | Oc(1+4) 18s | 22m

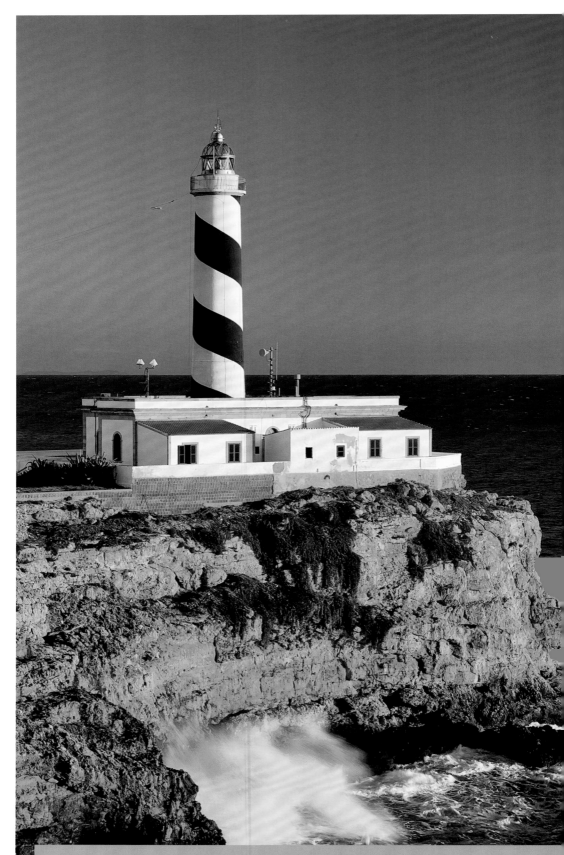

72. Cala Figuera Lighthouse (Mallorca, Balearic Islands)

The lighthouse of Cala Figuera is situated in the bay of Palma near the village of Son Ferrer. The 24-metre-high tower stands on the peak of a cliff in a former military area. The lighthouse was established in 1860. In 1962, extensive maintenance work was carried out and the lighthouse was converted to electrical power. The old dilapidated lanterns were exchanged for a new salt-air-resistant lantern and the light acquired a new fourth order lens with a 1,500-watt lamp. The white tower was given an unmistakable spiral-shaped coat of paint. Many holidaymakers and skippers affectionately describe the lighthouse as candy cane. The Cala Figuera Lighthouse is situated four kilometres away from Cala Figuera itself, and is only accessible on foot or by bicycle.

39°27'27"N 002°31'21"E | Fl(4) 20s | 45m | 15M

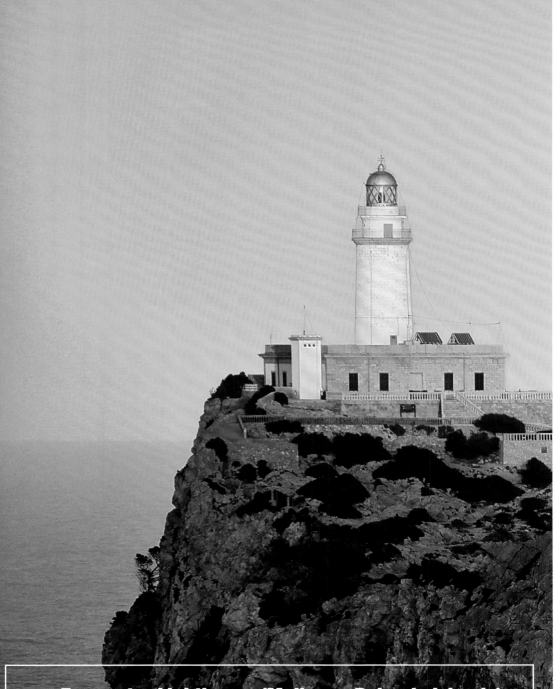

Formentor Lighthouse (Mallorca, Balearic Islands)

The Formentor Lighthouse stands on the headland at the eastern end of the peninsula of Formentor and on the northernmost point of the island of Mallorca. It's known among locals as the Meeting of the Winds. The best-known observation point is the lookout known as Mirador es Colomer after the small island of the same name, Colomer Island, which can be seen from here. The highest point of the Formentor peninsula is the Fumart with a height of 384 metres. The lighthouse and its scenic surroundings is a tourist highlight of the peninsula. The lighthouse was built on this inaccessible headland by 200 workers under very difficult conditions. It took almost three years for the tower to be completed in 1863. The area was first opened up in 1857 by the Italian road construction engineer, Antonio Paretti, who was responsible for the building of the legendary serpentine road in the bay of Sa Calobra on the Majorcan north coast. The building material for the lighthouse was obtained from the quarry at La Puebla on the Spanish mainland, and transported to the building site by ships from Alcúdia. Eventually the material was heaved up to a height of over 160 metres by a rope winch. It took 40 workers to manage this feat of strength. The building costs ran to a total sum of over 1.3 million real. The lighthouse was finally established on 30 April 1863. In 1962 the tower was converted to electricity but, due to being struck by lightning several times, the installation was closed down. As a result it was decided to continue the operation using two generators. Today the lighthouse is run by self-powered solar energy and monitored by radar, and a restaurant and visitors' centre has also been opened. From the lighthouse gallery it is possible to enjoy breathtaking views over the Formentor peninsula including, in clear weather, the neighbouring island of Menorca about 40 kilometres away.

39°57'41"N 003°12'45"E | QFI(4) 20s | 210m | 21M

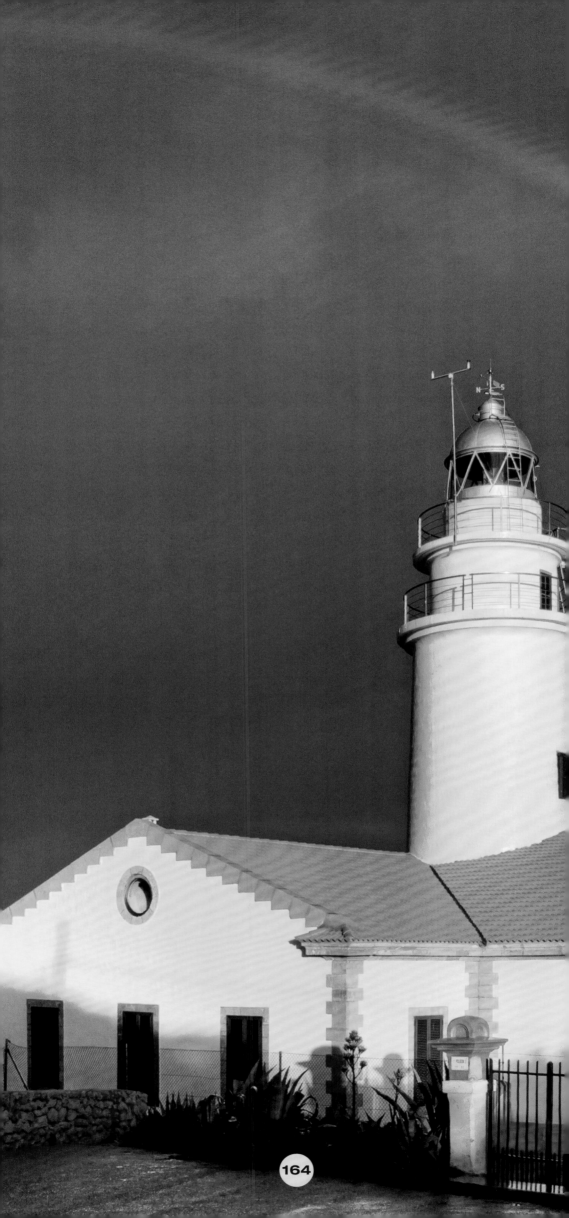

74. Capdepera Lighthouse (Punta de Capdepera, Mallorca, Balearic Islands)

The 21-metre-high Capdepera Lighthouse stands on the north coast of the Spanish island of Mallorca. The tower was built under the supervision of the engineer Emili Pou y Bonet in 1861 and has its exact position near the eastern point of Mallorca on a 55-metre-high hill above the coast. The lighthouse can be reached from Cala Ratjada on a narrow winding road either on foot or by car. The walk through the forest to the lighthouse is rewarded with beautiful views across the sea and onto the bay of Cala Ratjada. In good visibility it is even possible to see the neighbouring island of Menorca, around 30 kilometres away. The scenery surrounding the lighthouse is diverse and beautiful due to the rock formations and the rugged coastal landscape.

39°42'56"N 003°28'39"E | Fl(2+3) 20s | 76m | 21M

Far de Capdepera

Sicily

The Mediterranean island of Sicily is situated directly off the tip of the boot of the Italian mainland and is roughly triangle-shaped. The capital of Sicily is Palermo (known worldwide for its catacombs and the Cosa Nostra, the Sicilian Mafia, which controlled the local communities and attained notoriety). Off the north coast of Sicily lies the Tyrrhenian Sea, to the east lies the Ionian Sea, and between the south-west coast and the African continent runs the Strait of Sicily. The roughly three-kilometre-wide estuary at Messina separates Sicily from the Italian mainland.

Mount Etna is, with a height of 3,345 metres, the highest mountain on the approximately 25,000 km² island and the largest and most active volcano in Europe. Off Sicily's 1,100-kilometre-long coast are two groups of islands: the Aeolian islands, of which Stromboli is the best known due to the active volcano; and the Aegadian

islands, of which Favignana Island is the largest in this group. The islands of Favignana, Levanzo and Marettimo are each equipped with one lighthouse and can be easily reached by ferry from the harbour and provincial capital Trápani.

Sicily has a Mediterranean climate with hot and dry weather conditions in summer and cool and damp weather in winter. In the south of the island temperatures of over 40°C can be reached due to the Sirocco which blows in from the Sahara. In Catenanuova the highest temperature ever measured in Europe was registered at 48.5°C on 10 August 1999.

Sicily's central position in the Mediterranean means shipping and trade is very important to the larger towns. In order to achieve safe trade shipping, as well as for sport boats and sailing yachts, lighthouses were built on Sicily and the surrounding islands. They warn the sailor of shallows and lead them safely into the harbours in the dark.

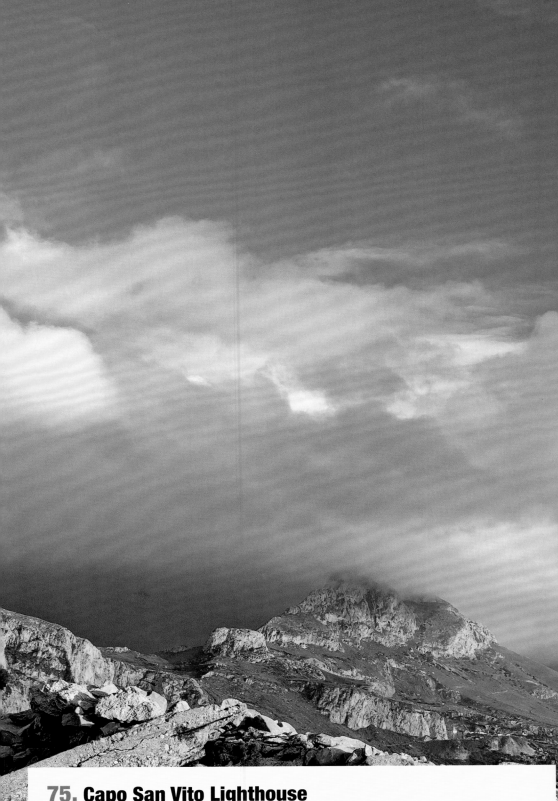

75. Capo San Vito Lighthouse
(Capo San Vito, Tyrrhenian Sea)

Due to the increase in shipwrecks in the middle of the nineteenth century, the government decided to build a lighthouse on the northwest coast of Sicily. The headland of Capo San Vito, near the seaside resort San Vito Lo Capo (40 kilometres away from Trápani) was chosen as the location. After taking five years to build, the lighthouse was finished in August 1859. The height of the round white stone tower, with a grey lantern, built on a one-storey keeper's house, is 40 metres. Next to the main beacon with the white light there is also a secondary light in the tower, of which the red light is recognisable at a distance of four nautical miles. Originally vegetable oil was used to fuel the lamp but that was replaced in 1887 by a kerosene lamp. Further modernisation ensued in 1919 and 1936 as, among other things, the old mechanisms were replaced. Electrification followed in 1938 before the technical equipment was completed with the installation of a 1,000-watt halogen lamp in 1964. The old kerosene lamp was kept on as an emergency and secondary light.

38°10'52"N 012°44'03"E | Fl 5s Iso R 4s | 45m | 25-4M

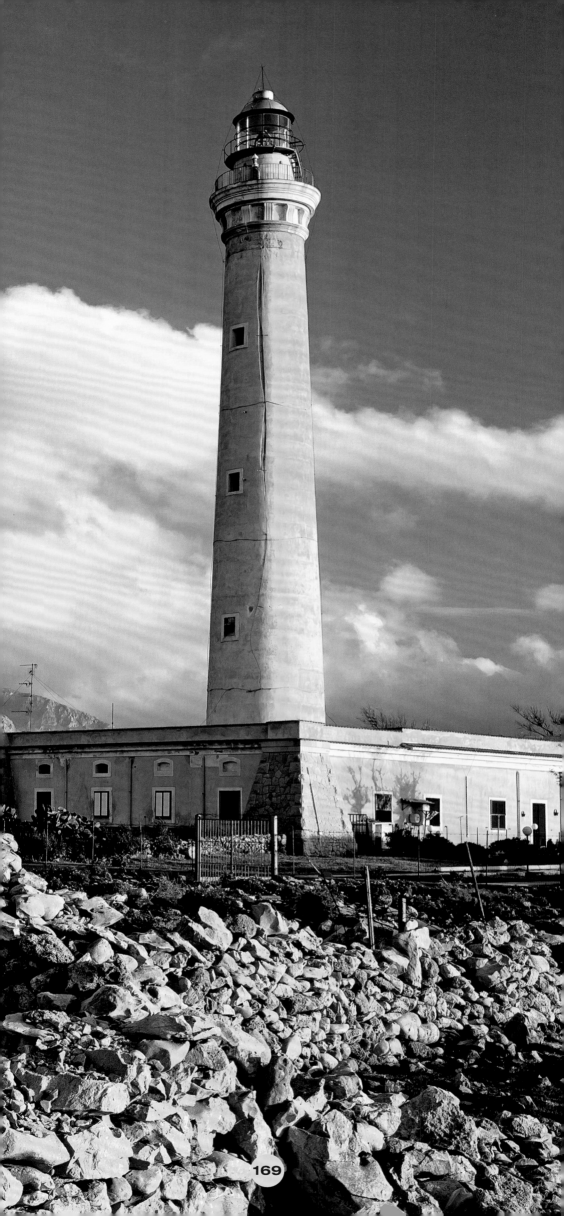

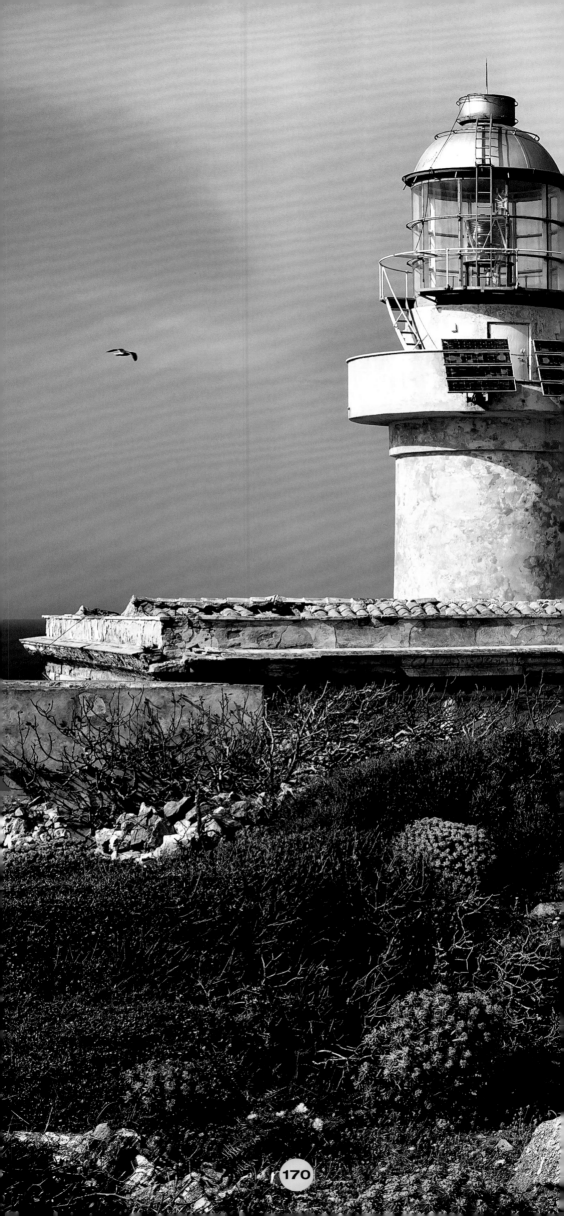

76. Isola di Lévanzo Lighthouse (Aeolian Islands, Strait of Sicily)

The island of Levanzo (population: 200) is the northernmost of the Aeolian Islands and with a surface area of 5.8 square kilometres also the smallest. Politically the island is part of the municipality of Favignana in the county of Trápani. The only village on the island, with its white houses, lies on the south coast at Cala Dogana, where the ferries also dock. The lighthouse is situated at the other end of the island on Capo Grosso, the north point. It takes about 45 minutes to reach the lighthouse on foot. On closer observation the lighthouse reveals some signs of decay, but the lantern is in good condition. The highest elevation of Lévanzo is the Pizzo Monaco at 278 metres. Next to the lighthouse at the north cape is the Grotta del Genovese, with paintings from 10,000 BC, the most popular attraction on Lévanzo island. The island was unpopulated for many years and was primarily used as grazing land for cattle.

38°00'12"N 012°20'02"E

Malta

Malta is a southern European island country in the Mediterranean and comprises an archipelago, with the main island of Malta, the inhabited islands Gozo and Comino, as well as the unpopulated smallest islands, Cominotto, Filfla, St Paul's Island and Fungus Rock. Malta was a British colony and gained independence on 24 September 1964. Malta became a member of the European Union on 1 May 2004 and introduced the Euro four years later. The official languages are English and Maltese. The archipelago of Malta has a land area of 316 square kilometres, and lies 81 kilometres to the south of Sicily. The main island of Malta (the capital of which is Valletta) is 28 kilometres long and up to 13 kilometres wide in places. In Malta they drive on the left.

There are many different coastal landscapes such as deep coves and wide beaches in the northeast and east, and grotto-like caverns in the southwest and north of the island where the land rises very ruggedly out of the sea and there are long stretches of steep cliff faces like the Dingli Cliffs. On the Maltese islands there are seven lighthouses. In the north of the island of Gozo stands the Giordan Lighthouse on a 150-metre-high hill with a signal height of 161 metres. Sadly the tower is very dilapidated and doomed to further decay. In Mgarr, a southern harbour town on Gozo, there stands a small beacon at the end of each of the harbour piers. The same fate facing the Giordan Lighthouse also threatens the black and white striped lighthouse on Delimara Point in southeast Malta, to the south of the harbour town, Marsaxlokk.

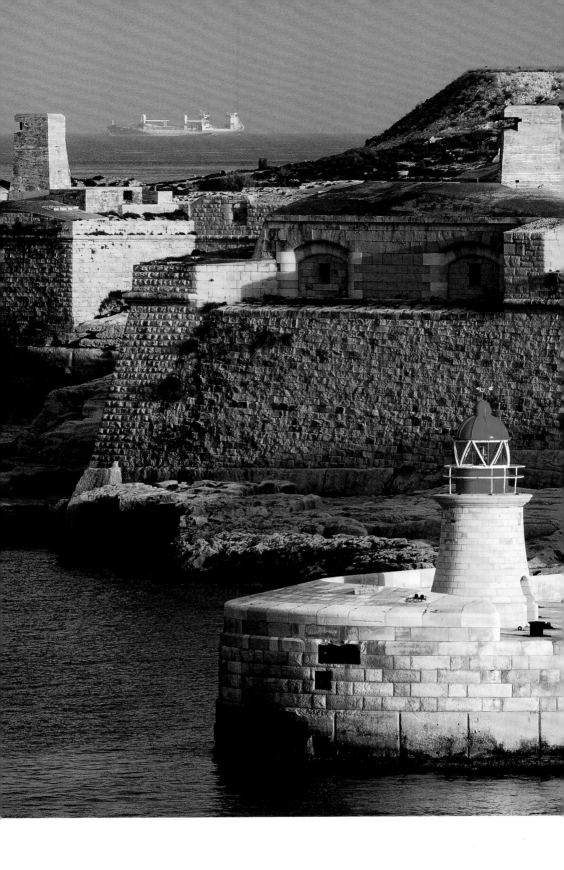

77. St Elmo Breakwater Lighthouse (East Pier, Valletta)

The island capital, Valletta, with its boulevards and Grand Harbour is absolutely worth a visit. Surrounded by many other attractions Fort St Elmo (named after the patron saint of the seafarer) together with the National War Museum and collections is very interesting. The St Elmo Breakwater Lighthouse, which is situated at the end of the west pier, is included as part of the museum. The lighthouse was built from stones in 1908 and is 14 metres high. On the east side of the Grand Harbour stands the nine-metre-high Ricasoli Lighthouse at the end of the east pier which was built at the same time. In 2012 during renovation, both lighthouses' lanterns were faithfully restored to the originals. In the dark both pier beacons ensure safe navigation for the coming and going of shipping. The St Elmo Breakwater Lighthouse is recognisable in the dark by a green flashing light, whereas

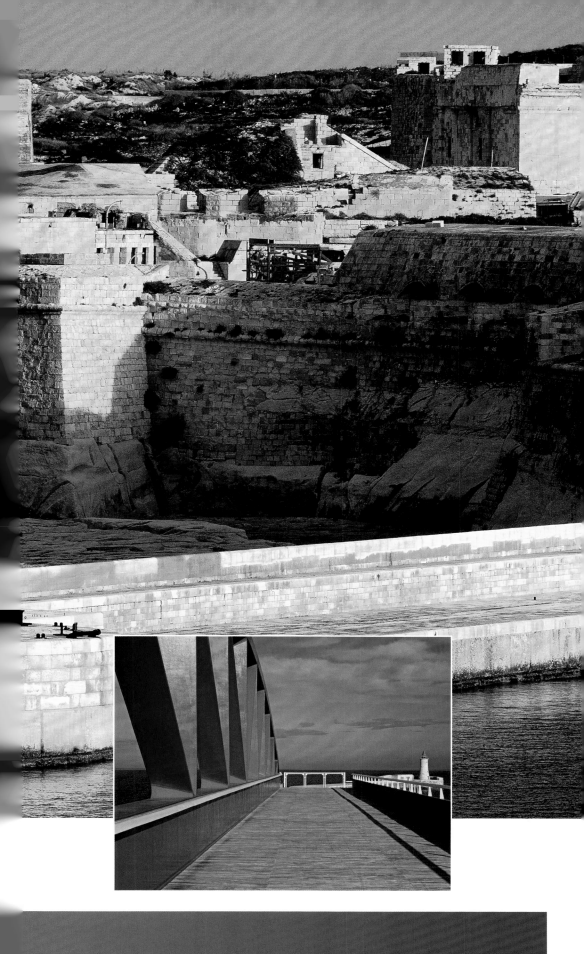

The Ricasoli Lighthouse shows a red flashing light. Both lights fit wonderfully into their environment and contribute immensely to the cityscape of Valletta. A red railway bridge was recently built on the west pier, creating a link from Fort St Elmo to this breakwater lighthouse, and is of interest to photographers. From the west pier you can also watch the coming and goings of shipping.

35°53'57"N 014°31'23"E | QFl R | 9m | 6M

APPENDIX

Pontusval Lighthouse (Brignogan, Brittany, Channel coast)

Camera equipment

For the photos of the lighthouses illustrated in this book I used, for the analogue photography, a Pentax 67 medium format single-lens reflex camera with three fixed lenses (4.0/55 mm wide-angle lens, 2.8/90 mm normal lens and a light telephoto lens with a light intensity of 2.8 and a focal distance of 165 mm).
I also used a Leica R7 SLR camera with a Vario-Elmar R3.5–4.5/28–70 mm zoom lens. In order to achieve an optimal colour saturation and a matching sharpness, I exclusively used Kodak E100VS slide film.

For the digital photography I used cameras with an APS-C-sensor (DSLR Sony Alpha 380 and SLT Sony Alpha 77II) with a full format sensor (DSLR Sony Alpha 900, SLT Sony Alpha 99 and SLT Sony Alpha 7RII) with lenses covering a light intensity of 16 mm to 400 mm.

For longer journeys on foot I kept the carrying weight as low as possible and used a Sony RX10 Bridge camera, with a light intensity of 24–200 mm and a continual light strength of 2.8, which demonstrated a brilliant image performance. Otherwise I used a Polfilter (for retouching of light reflections and optimisation of colour saturation), a grey gradient filter (for balancing light contrasts) and a tripod (to avoid image blurring and to help with image composition).

Acknowledgements

I would like to express my heartfelt gratitude to my dear wife, Heidrun, for showing great understanding and enthusiasm for my many photography excursions to the lighthouses. She also demonstrated much patience as I waited for three hours at the lighthouse at Marken (in the Netherlands) for the right light.